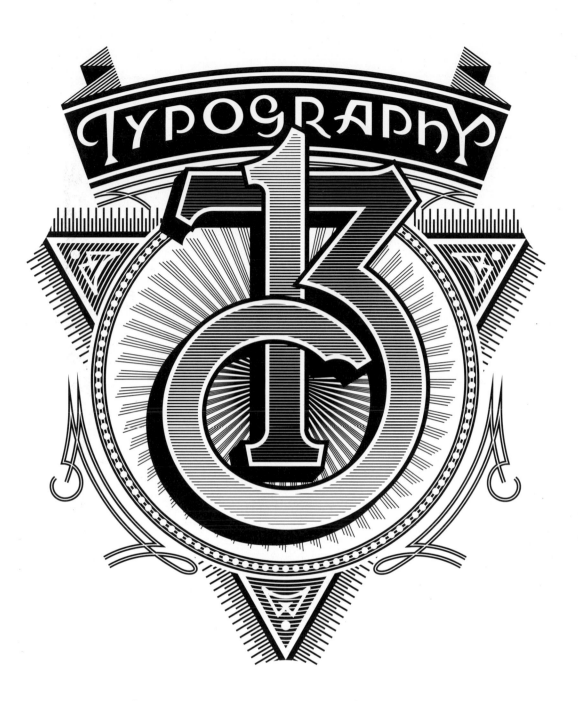

# TYPOGRAPHY 13

*The* Annual *of*
THE TYPE DIRECTORS CLUB

Watson-Guptill Publications
*New York*

First published in 1992 by Watson-Guptill Publications, a division of BPI Communications, Inc.,
1515 Broadway, New York, N.Y. 10036

The Library of Congress has cataloged this serial title as follows:
Typography (Type Directors Club [U.S])
Typography: the annual of the Type Directors Club.—1—
New York: Watson-Guptill Publications, 1980–
v.:ill.; 29 cm.

Annual.
ISSN 0275–6870 = Typography (New York, N.Y.)

1. Printing, Practical—Periodicals. 2. Graphic arts—periodicals. 1. Type Directors Club (U.S.)
Z243.A2T9a 686.2'24 81–640363
AACR 2 MARC-S
Library of Congress [8605]

Distributed outside the U.S.A. and Canada by RotoVision, S.A., Route Suisse 9,
CH-1295 Mies, Switzerland

Manufactured in Japan

First printing, 1992

1   2   3   4   5   6   7   8   9   10   /   97   96   95   94   93   92

| | |
|---|---|
| *Senior Editor* | Marian Appellof |
| *Associate Editor* | Carl Rosen |
| *Designer* | Daniel Pelavin |
| *Page Makeup* | Jay Anning |
| *Photographer* | Michael Newler |
| *Production Manager* | Ellen Greene |

# CONTENTS

# CHAIRPERSON'S STATEMENT

ALLAN HALEY is executive vice president for International Typeface Corporation (ITC). He is also editorial director for *U&lc* and chairman of the ITC Typeface Review Board. Prior to joining ITC in 1981, he was the typographic consultant to Compugraphic Corporation. An accomplished type designer, Allan Haley has created many popular faces. He is highly regarded as an educator for his efforts to raise the typographic awareness in our industry. Haley sat on the board of directors of the National Composition Association for five years, and he was one of the principal founders of the Friends of the National Printing

ALLAN HALEY

Museum. He is a member of the American Institute of Graphic Arts (AIGA), the American Center for Design, and the New York Type Directors Club, where he is the current president. He is a regular contributor to *U&lc* and *Step-by-Step Graphics*. Haley has also written two books on type and typography, *Phototypography* (Charles Scribners' Sons) and *The ABC's of Type* (Watson-Guptill).

WHO SAYS 13 is an unlucky number? I have to admit that the prospect of being the chairman of *Typography 13* did give me some pause. Then I remembered that my daughter was born on October 13th, Friday the 13th to be exact. *Typography 13*, or TDC 38, if you prefer a less controversial number, turned out to be one of the better competitions in typographic excellence of the past several years. Why? Because people are trying harder. In 1991 the economy still had not rebounded, and people who spent money on design and typography were demanding the most from their investment. As one would expect, designers rose to the challenge. As a result, the work produced and submitted to our competition was of a consistently high level.

In the race between the computer and traditional design tools (roughly akin to the race between John Henry and the steam hammer) the machine is clearly gaining ground. The good news is that the stuff created through software and electronic technology is good—very good.

Stylistically, the competition was concentrated into two camps: quiet, traditional conservatism and joyous eclecticism. Both were a delight to judge.

As it turned out, 1991, and 13, are very lucky typographic numbers. Good typography is not dead; it is, in fact, thriving in the hands of skilled and dedicated professionals.

# JUDGES

## STEVEN HELLER

Steven Heller is senior art director of the *New York Times*. He is also editor of the AIGA *Journal of Graphic Design*, Mohawk Paper Mills' *Design & Style*, and *The P Chronicles* (the latter two produced by Push Pin Editions). He is a contributing editor to *Print* and *ID* and writes frequently for *U&lc*, *Eye*, and other graphic design publications. He is director of the School of Visual Arts (SVA) symposium *Modernism & Eclecticism: A History of American Graphic Design*, and he teaches a history of communications class in the SVA MFA/Illustration program. He is the author and editor of over twenty books, including *Man Bites Man: Two Decades of Satiric Art*; *Art Against War*; *Graphic Style: From Victorian to Post-Modern*; *Innovators of American Illustration*; *Designing with Illustration*; *Graphic Wit: The Art of Humor in Design*; and the forthcoming *Borrowed Design: The Use and Abuse of Historical Form* and *The Savage Mirror: The Art of Contemporary Caricature*.

## KENT HUNTER

As creative director at Frankfurt Gips Balkind, an integrated communications agency based in New York and Los Angeles, Kent Hunter directs a team of designers on assignments that include annual reports, corporate magazines, books, posters, and, increasingly, multimedia/video presentations. The firm's clients include Time Warner, MCI, The Limited, MTV, the *New York Times*, Harcourt Brace Jovanovich, and every major film studio, and their work has been recognized by the Mead Show, AR 100, *Communication Arts*, the American Center for Design, *Graphis*, and the New York Art Directors Club.

A native Texan, Hunter graduated from Abilene Christian University in 1979 and moved to Nashville, Tennessee, where he designed a city magazine, architectural graphics, and album covers before working with Thomas Ryan Design for several years. He moved to New York in 1986.

Kent Hunter serves on the board of the New York chapter of the AIGA, and he has judged numerous design shows, gives lectures around the country, and collects folk art.

## Jeffrey Keyton

Jeffrey Keyton is the design director for MTV Networks. He is responsible for a wide array of print materials, and he has been honored by awards from the Art Directors Club, *Communication Arts*, the Society of Publication Designers, the AIGA, the Clio awards, Creativity Print, and STA 100, and he has received numerous gold and silver awards from the Broadcast Design Association. Keyton enjoys sharing his experience in a senior graphic design portfolio class that he teaches at the School of Visual Arts.

## Lorraine Louie

Lorraine Louie was born and raised in San Francisco. Upon graduating from the California College of Arts and Crafts, she began her career as a graphic designer at Jonson Pedersen Hinrichs & Shakery. As far back as she can remember, however, she had her sights set on New York City. In 1982, she came to New York in search of the "perfect" job. After six months and some decidedly "imperfect" positions, she created the ideal job by starting her own design practice.

With a lot of hard work and a little luck, Louie made a transition from corporate design to publishing. Best known for creating the Vintage Contemporary format and guiding it through an assortment of editors, authors, and art directors during the last eight years, she also lends her talents to projects as diverse as magazine, annual report, and promotional design.

Though her work centers on the thoughtful use of unique and expressive typography, clearly evident also are a combination of influences from graphic artists of the 1930s and 1940s to art movements ranging from Russian constructivism to postmodernism.

## Paula Scher

Paula Scher trained as an illustrator at the Tyler School of Art in Philadelphia and began her graphic design career producing record covers and posters at CBS Records. In 1984 she founded Koppel & Scher with Terry Koppel. The firm designs magazines, promotional materials, packaging, identity systems, books, and posters. In 1991 she became a partner at Pentagram Design.

Her designs have been collected by the Museum of Modern Art, the Zurich Poster Museum, and the Centre Georges Pompidou. She has received over 300 awards, including four Grammy nominations from the National Association of Recording Arts and Sciences and gold and silver medals from the New York Art Directors Club. Her clients have included Chase Manhattan Bank, Swatch, Columbia Records, Champion International, and Time Warner. She teaches a senior portfolio class at SVA and cochaired the AIGA 1991 national conference in Chicago with Pentagram partner Michael Bierut.

## SUMNER STONE

Sumner Stone is the designer of the ITC Stone and Stone Print families of typefaces. He is the author of *On Stone: The Art and Use of Typography on the Personal Computer*. In 1990, Sumner Stone started Stone Type Foundry Inc. in Palo Alto, California, for the purpose of designing, producing, and marketing new typeface designs. Stone Type Foundry's most recent project is Stone Print, the new typeface for

*Print* magazine, which premiered in the September-October 1991 issue.

## MAXIM ZHUKOV

Maxim Zhukov is a publication designer who is also involved in poster, exhibition, and ephemera design. He is a participant in many exhibitions and the recipient of many awards at national and international design competitions.

Born in Moscow in 1943, Zhukov graduated from the Moscow Printing Institute in 1965. Since 1962, he has worked as a freelance designer, as well as serving as design editor at Iskusstvo Art Publishers in Moscow (1965–77), graphic presentation officer at the United Nations, New York (1977–81), and art director at Mir International Science Publishers, Moscow (1982–86). He is currently chief of the Graphic Presentation Unit of the United Nations Publishing Division. Zhukov, an honorary member of the New York Art Directors Club, is the international adviser for and member of the ITC Typeface Review Board, and he is the author, with George Sadek, of *Typography: Polyglot* (Cooper Union, 1991).

WHY IS the design of *Rolling Stone* such a perennial favorite at competitions like this one? The answer is really quite simple: The designers are having fun, and we, the judges, feel and appreciate it. Of course they work hard; they may even stretch and strain for the right typographical solutions, but the reader can't tell. Indeed, this judge has no sense of the trials and pain that may go into the seemingly effortless, though wonderful, solutions selected for this annual. Wit and self-confidence are the hallmarks of *Rolling Stone*'s layouts. Compared to most other magazines entered, and even selected, in this show—some following similar mannerisms—*Rolling Stone* is the original (even though some of the solutions are borrowed from historical periods). The others are self-consciously trying to render

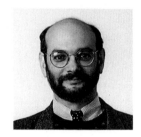

STEVEN HELLER

style. *Rolling Stone* renders intuition. No other *Rolling Stone* layout typifies this sense of intuitive play better than "Big Shot." While it helps to have a great photograph, not every designer would have taken advantage of the opportunity. But there is something else; the type isn't elegant or even beautiful. It's kind of horsey, but in just the right proportions to all the elements on the page. And one last thing: The dot on the I is just silly enough to be brilliant. It echoes the tube and anchors the type. This is not just the best, but one of many bests. *Rolling Stone* is represented so well in this annual because we jurors couldn't judge *Rolling Stone* against itself. What's better than best, or less than better? Of all the pages submitted hardly one failed to live up to my yardstick of, is it functionally quirky and still appropriate design?

{17}

Men are in crisis, whereas he is not. He does not know the meaning of "crisis." Or perhaps

MR BIG SHOT

he does, but he pretends otherwise. He is Austrian, after all, and some

By Bill Zehme

38 · ROLLING STONE, AUGUST 22ND, 1991

PHOTOGRAPH BY HERB RITTS

Magazine Spread
TYPOGRAPHY/DESIGN  Debra Bishop, New York, New York
LETTERER  Anita Karl, Brooklyn, New York
ART DIRECTOR  Fred Woodward
TYPOGRAPHIC SOURCE  Personal library
CLIENT  Rolling Stone
PRINCIPAL TYPE  Wood type
DIMENSIONS  12 x 20 in. (30.5 x 50.8 cm)

{17}

Non-design. Anti-design. Un-design. Whatever you call it, I like it. This poster is refreshing and provocative in its against-the-grain use of type and imagery. It feels hand-made and real.

Maybe I've overdosed on the design tricks of the eighties—layering, preciousness, and all the rest. Enough already . . . give me clean, simple, and honest. Less Ralph. More GAP.

I have it on very good authority that this typography was inspired by a 1941 Saint Paul, Minnesota, Yellow Pages ad for a fishing camp. Dumb, hokey, hard-sell copy set in a dumb, clunky typeface. And reversed at that. But the one-color, letterpressed

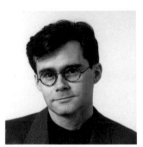

Kent Hunter

poster has a certain beauty. (Of course, the other side is printed in various metallic inks, has a tiny little sales brochure stapled onto it, and is die cut to simulate a printing plate. So much for simple and cheap . . .) It works for me.

By looking backward, this poster seems to be looking forward. Welcome to the nineties.

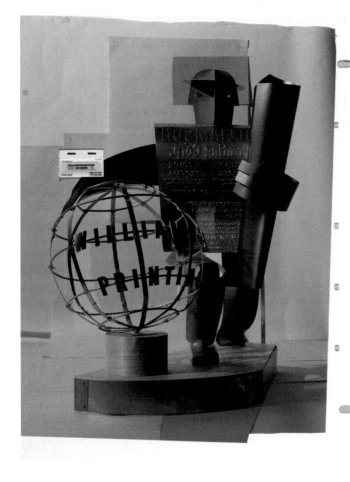

Poster

TYPOGRAPHY/DESIGN Todd Waterbury and Sharon Werner, Minneapolis, Minnesota
TYPOGRAPHIC SOURCES Dahl & Curry and Great Faces
STUDIO Duffy Design Group
CLIENT Williamson Printing Corporation
PRINCIPAL TYPES Spartan Black and Franklin Gothic Extra Condensed
DIMENSIONS 20 x 27 in. (50.8 x 68.9 cm)

THOUGHTS on my selection.

It dared to be experimental, dared to be conservative.

Intrinsically artistic through intriguing compositions and simple compositions.

JEFFREY KEYTON

Intelligent typography which took into account the meaning of their eloquent words.

All the while showing a mature acumen for typography.

All created by the future of graphic design.

STUDENTS

Campaign
TYPOGRAPHY/DESIGN  Vance Studley and various students, Pasadena, California
TYPOGRAPHIC SOURCE  Foundry Type Collection–Archetype Press
AGENCY  Art Center College of Design
STUDIO  Archetype Press
CLIENT  Art Center College of Design
PRINCIPAL TYPES  Various
DIMENSIONS  10⁵/₁₆ x 13⅛ in. (26.2 x 33.3 cm)

EVERY PIECE should win an award for all the earnest effort put into each, let alone for the achievement of getting the client to pay. So, to find one piece of "typographical greatness" seems a little absurd. It's not that I don't take my work seriously, but it's not brain surgery. Therefore, I chose a piece that affected me on an emotional level.

LORRAINE LOUIE

As a mother of two young children, I found this birth announcement particularly touching. The typography exemplified the cry of a baby with its clever use of size and style. It reminded me of the importance of expressing rather than communicating a message, which makes our career goals a little more important than just spec'ing type.

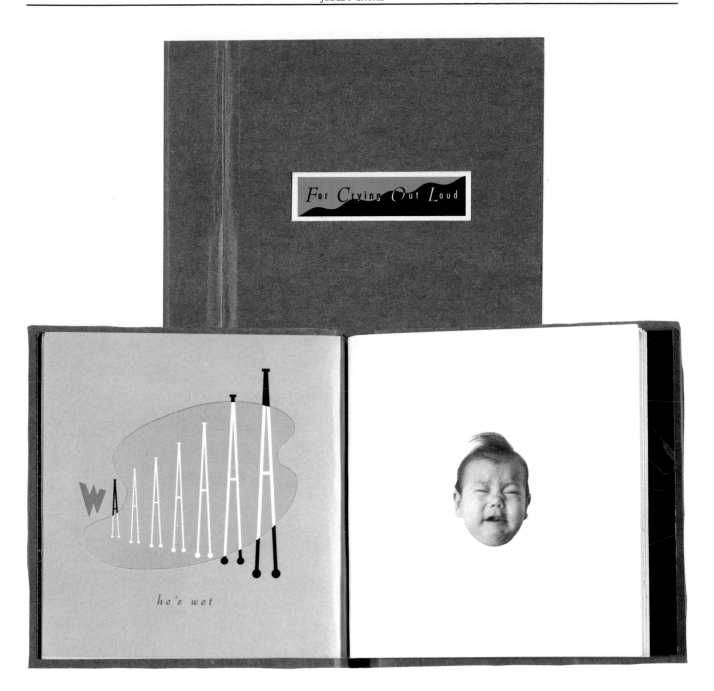

Announcement
TYPOGRAPHY/DESIGN  Art Garcia, Dallas, Texas
TYPOGRAPHIC SOURCE  In-house
STUDIO  Sullivan Perkins
CLIENTS  Beck Munson and Art Garcia
PRINCIPAL TYPE  Bernhard Modern
DIMENSIONS  4½ x 3¾ in. (11.4 x 9.5 cm)

I SELECT two choices that are polar opposites.

The Cooper Union annual report (page 89) displays amazing typographical precision. All the design decisions are exquisite. The overall feeling of the book is one of intelligence; a superb designer craftsmanship.

I select this *Rolling Stone* spread (opposite), one among many equally good ones, because it displays incredible spirit. The jumping letter forms are dumb. The color break is equally stupid, the scale is ridiculous, and the overall feeling is one of pure joy.

PAULA SCHER

The Cooper Union piece is a great example of the precise designer at work. The *Rolling Stone* spread is a great example of the designer at play.

I admire the Cooper Union piece. I love *Rolling Stone*'s.

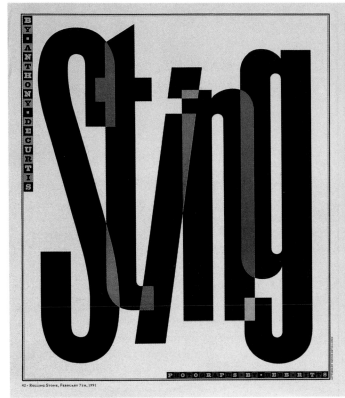

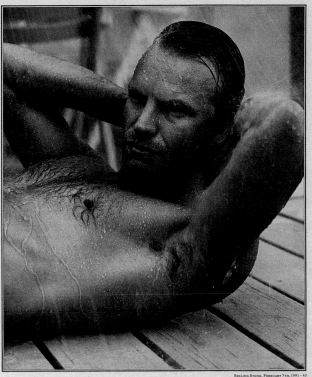

TYPOGRAPHY/DESIGN Magazine Spread
Gail Anderson, New York, New York
LETTERER Dennis Ortiz-Lopez
ART DIRECTOR Fred Woodward
CLIENT Rolling Stone
PRINCIPAL TYPE Handlettering
DIMENSIONS 12 x 20 in. (30.5 x 50.8 cm)

**S**LICKNESS connotes establishment, entrenched power structure, status quo. Now and probably always. Of the rough edges in the competition I particularly liked this big little *a*. Low budget. Gritty. Slapped together. But BIG. Out there.

I've always been a sucker for big letters. Something about having the letter creature become human size. It looks you in the face. You can see its posture. And the clothes that this letter has on are digital, sharp-edged pixels. They look the way computers feel. After manufacturing fonts on the Macintosh, I feel like I have the mental equivalent of skinned

SUMNER STONE

knuckles. It's not always appropriate to see the bytes, but they now have a big presence in our lives, and it's good to see them used with a bit of drama in an appropriate place.

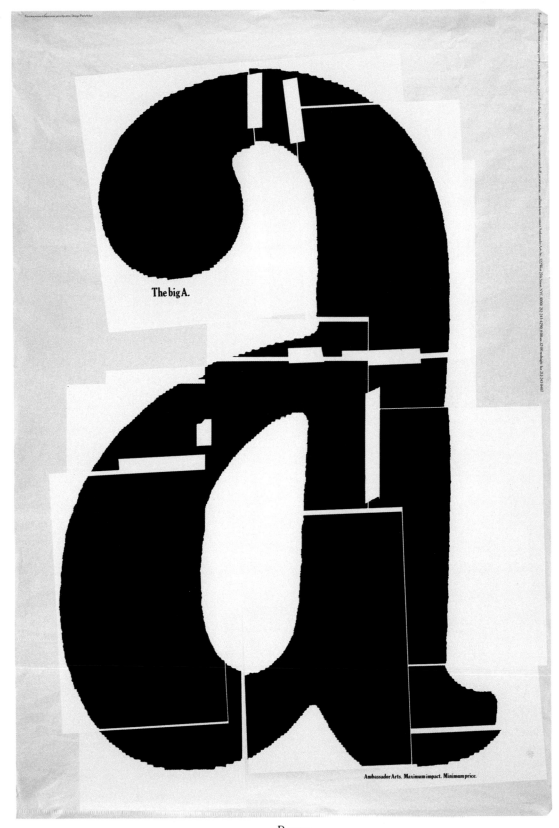

Poster
TYPOGRAPHY/DESIGN Paula Scher, New York, New York
LETTERERS Paula Scher and Ron Louie
TYPOGRAPHIC SOURCE Personal collection
STUDIO Pentagram Design
CLIENT Ambassador Arts
PRINCIPAL TYPE Cheltenham
DIMENSIONS 36 x 50 in. (91.4 x 127 cm)

THIS PIECE, entitled *26 Letters/Lettern/Lettres*, is an excellent example of one of the most significant trends in modern typography: the growing responsibility of the type and equipment manufacturers, design educators, professional societies, and conscientious typographers for maintaining standards of craftsmanship and quality.

In the trade it was always customary for the type foundries and equipment manufacturers to put out type specimen books and other occasional editions featuring fine typography and sophisticated design, and this is exactly what this piece is. Historically, however, such publications were aimed at professionals, and today the target audience has expanded dramatically, well beyond the traditional boundaries of graphic arts. These days, the innumerable newcomers to the domain of typography and graphic design, as well as the younger generation of designers, have so little knowledge of the foundations of design, and almost

MAXIM ZHUKOV

no understanding of, or appreciation for, basic values in typography.

Educating them is the higher obligation of the typographic community to the public at large, which suffers from visual pollution. It is rather regrettable that almost all entries reviewed by us showed little interest in "plain typography" with no tricks and gimmicks and special effects. I think that this is not owed merely to the image of the TDC annual competition as a contest in display typography only (which is a fact); appreciation for good text typography does not come as easily as bedazzlement with the eye-catching layouts playing up *les mots en liberté*.

I am very pleased that a number of entries produced by the Cooper Union, Linotype, Adobe, and other champions of good design got noticed by the judges and recognized for their worthy efforts in "keeping the light" of the continuing conventions and high professional tradition.

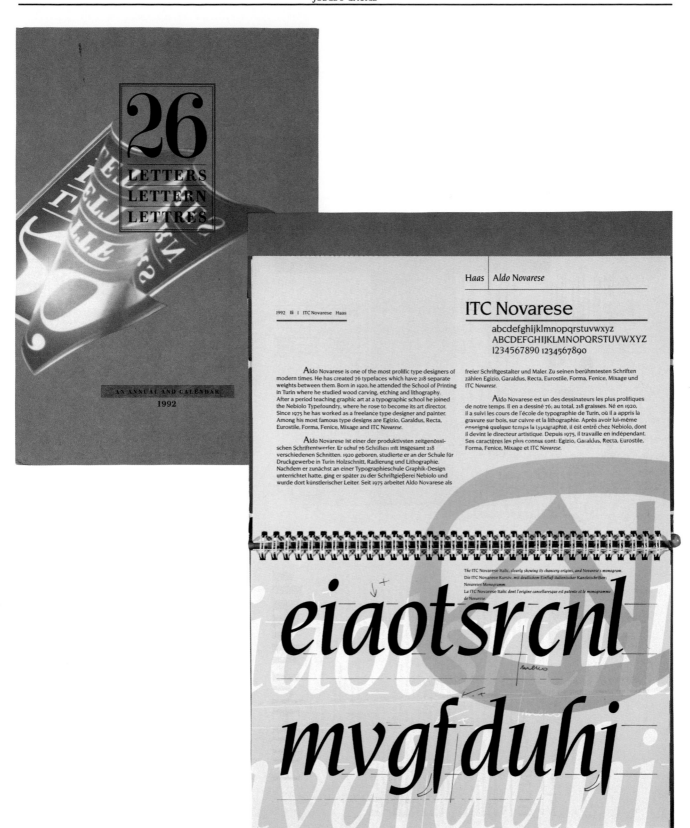

Book/Calendar
TYPOGRAPHY/DESIGN   Hans Dieter Reichert, London, England
TYPOGRAPHIC SOURCES   Various type manufacturers and St Brides Printing Library
STUDIO   Banks&Miles London
CLIENT   Typostudio Schumacher Gebler
PRINCIPAL TYPES   Bodoni Old Face and 26 other typefaces
DIMENSIONS   24½ x 12 in. (62.2 x 30.5 cm)

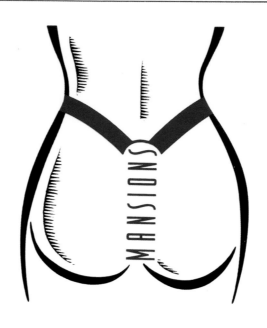

MANSIONS HOTEL. $10 A NIGHT ACCOMMODATION NEXT
DOOR TO SYDNEY'S LIVELIEST STRIP CLUBS.
18 BAYSWATER RD KINGS CROSS SYDNEY PH: (02) 358 6677.

Advertisement
TYPOGRAPHY/DESIGN  The Fotosetter and Anthony Redman, Singapore
ILLUSTRATOR  Mickey Shrubsall
TYPOGRAPHIC SOURCE  The Fotosetter Singapore
CLIENT  Mansions Hotel
PRINCIPAL TYPES  Viking and Insignia
DIMENSIONS  4½ x 4 in. (11.4 x 10.2 cm)

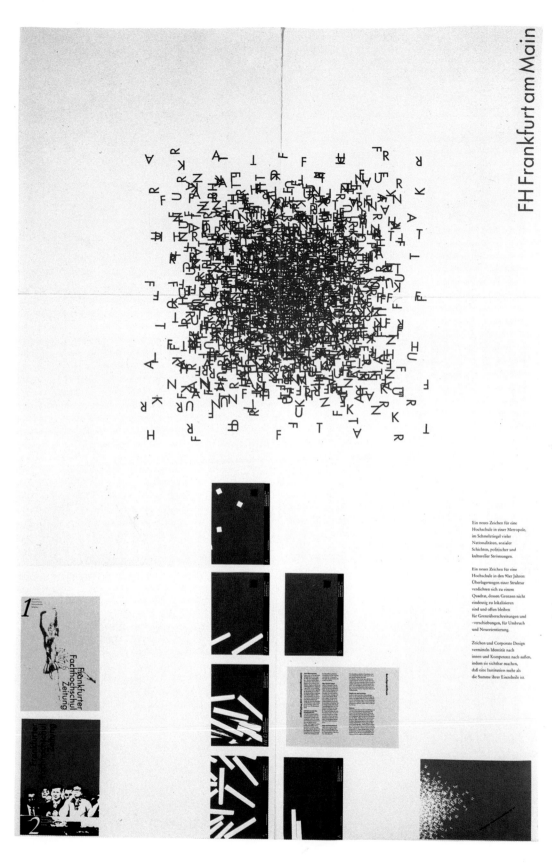

Corporate Identity

| | |
|---|---|
| TYPOGRAPHY/DESIGN | Christof Gassner, Sabine Bock, Arnim Doll, Kai Krippner, Johannes Kühn, Klaudia Schrenk, Petra Wagner, and Karin Zikeli, Darmstadt, Germany |
| TYPOGRAPHIC SOURCE | In-house |
| STUDIO | Fachhochscule Darmstadt |
| CLIENT | Fachhochscule Frankfurt am Main |
| PRINCIPAL TYPE | Futura |
| DIMENSIONS | 23⅜ x 31¹¹⁄₁₆ in. (59.4 x 80.5 cm) |

"What a great way to treat the financials..."

"...it works as such a strong statement for the cor[p
that's why I'd give 'Best of Show' to..."

ese shots mirrors
is in a way that..."

"...illu
book.
this c

# AR 100

The Sixth · Annual Report Award Show

"The photography, the typography,
the concept...everything gels in
this book..."

"...the winners weren't necessarily slick, just thoughtful.
Number of colors versus great design wasn't..."

"Beautifu

's interesting to see how many books talk
bout ecology this year...hope it's a real concern
nd not just..."

it of..."

"...great use of typography..."

| | |
|---|---|
| | Book |
| TYPOGRAPHY/DESIGN | Brock Haldeman and Steve Liska, Chicago, Illinois |
| TYPOGRAPHIC SOURCE | In-house |
| AGENCY | Liska and Associates, Inc. |
| CLIENT | Alexander Communications |
| PRINCIPAL TYPE | Bodoni |
| DIMENSIONS | 8¾ x 11¼ in. (22.3 x 28.6 cm) |

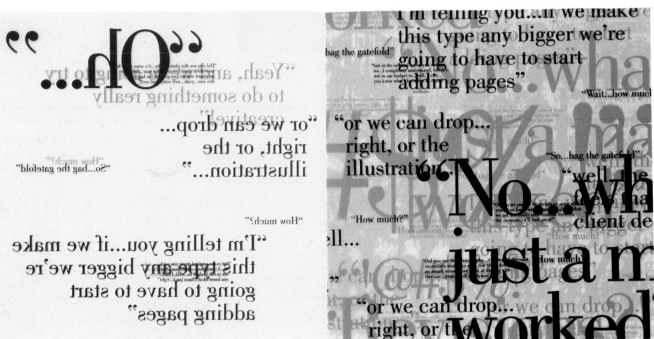

Announcement
TYPOGRAPHY/DESIGN Brock Haldeman and Steve Liska, Chicago, Illinois
TYPOGRAPHIC SOURCE In-house
AGENCY Liska and Associates, Inc.
CLIENT Alexander Communications
PRINCIPAL TYPE Bodoni
DIMENSIONS 9⁷⁄₁₆ x 9⁹⁄₁₆ in. (23.7 x 24.3 cm)

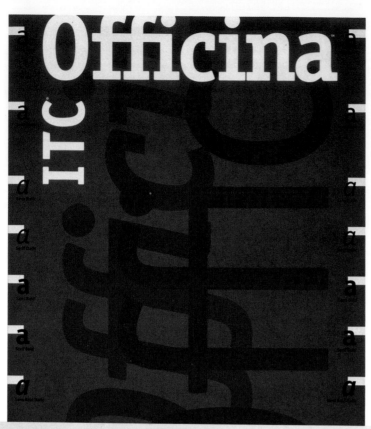

# ITC Officina

**What** developed is a different sort of type family. It has a distilled range of just two weights: Book and Bold (medium weight being unnecessary in office correspondence) with complementary Italics. In addition, ITC Officina is available in two styles: Serif and Sans. The end result is an exceptionally versatile communication tool packaged in a relatively small type family.

ITC Officina combines the honest "information only" look of a typewriter face with the benefits of better legibility, additional stylistic choices, and more economical use of space. We believe that it has admirably met both its design goals.

**ITC Officina was originally conceived as a typeface to bridge the gap between old fashioned typewriter type and a traditional typographic design. The design goal was to create a small family of type ideally suited to the tasks of office correspondence and business documentation.**

*Midway through the design, however, it became obvious that this face had capabilities far beyond its original intention. Production tests showed that ITC Officina could stand on its own as a highly legible and remarkably functional type style.*

**The European design team, under the close guidance of the Berlin designer, Erik Spiekermann, was given the directive to continue the work on ITC Officina, but now with two goals. The first was to maintain the original objective of the design: to create a practical and utilitarian tool for the office environment. And the second was to develop a family of type suitable to a wide range of typographic applications.**

Proportionally, the design has been kept somewhat condensed to make the family space economical. Special care was also taken to insure that counters were full and serifs sufficiently strong to withstand the rigors of small sizes, modest resolution output devices, telefaxing, and less than ideal paper stock.

*The italic designs could have been rendered as simple oblique romans, but cursive overtones were incorporated to provide distinction and character.*

ITC Officina is available as a *serif* or *sans serif* design, in Book and Bold weights with corresponding italics.

**Alternate numbers** have been drawn to provide additional flexibility of use.

Traits like the left-pointing serif of the "i" and "j," the tail of the lowercase "l," and the slightly heavy punctuation, which link this design to its typewriter-like cousins, also serve the dual purpose of improving character legibility.

*Only licensed ITC Subscribers and their sublicensees are authorized to reproduce, manufacture, and offer for sale the ITC typefaces shown in this issue.*

|  | |
|---|---|
| | Brochure |
| TYPOGRAPHY/DESIGN | Erik Spiekermann and Erik van Blokland, Berlin, Germany |
| TYPOGRAPHIC SOURCE | In-house |
| STUDIO | MetaDesign |
| CLIENT | International Typeface Corporation |
| PRINCIPAL TYPE | ITC Officina |
| DIMENSIONS | 8½ x 11 in. (21.6 x 27.9 cm) |

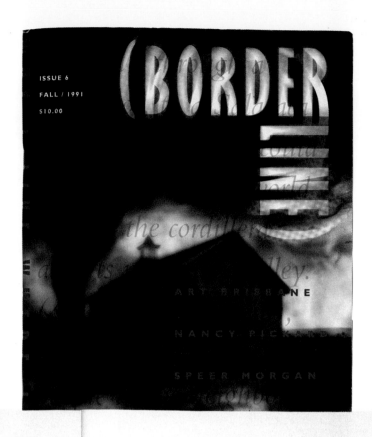

.... the

summer

of

an

excerpts from: **cows**

oral

are

history

freaky edited

of by

when David

the Ohle,

illustration

they Roger

on

kaw Martin

look and

previous

valley Susan

at Brosseau,

page

hemp with

by

you a forward

lou pickers by

William

beach S.

Burroughs

Cows Are Freaky is published by

Watermark Press, Wichita, Kansas, and

is currently available in bookstores.

**love,** a message went out from San Francisco: "Brothers and sisters, come to the Haight, to Golden Gate Park. This is where it's at." The media glommed onto the idea, and Haight-Ashbury became Hippie Town, U.S.A. It beckoned to the restless young everywhere. On the TV screen, in *Time and Life*, by word of mouth, it looked and sounded loads better than Hometown, U.S.A., and hordes of the young and the dispossessed went west to search out both high excitement and better family ties.

But what went down on the coasts was not the measure of all things. New truths were tested and new institutions founded in numerous Heartland outposts. In Kansas, virtually every town learned to support at least one hippie, often the loneliest soul around.

In these pages, Dr. Thaddeus describes one such small-town free spirit: "There was a mysterious dope dealer out in Wellington. He'd been dealing longer than anyone, and he always had acid. They could never catch him. Some of those rednecks out there were the worst loadies I've ever seen, next to Mexico City pimps. They mixed uppers, downers, acid and booze. You put any kind of pill in their hand and they'd swallow it, no questions asked. They'd drop acid and go drive tractors."

But the hotbed of Kansas hip was Lawrence, 35 miles west of Kansas City on I-70, home to the University of Kansas. Lawrence has long held a reputation among travelers as the last watering hole before the great funless stretch that yawns between Topeka and the Rockies. It is a town of 50,000-plus located in the Kaw River Valley of eastern Kansas, a pleasant haven of tree-filled valleys, rocky ledges and rolling hills. Wild marijuana fringes fields of wheat and corn, soybean and milo. By some accounts, cattle carried the pot seeds north from Texas in their hooves. By others, the local profusion of pot is a heritage of World War II when Midwestern farmers grew hemp for making rope. Covering thousands of acres, this low-grade cannabis, a.k.a. K-pot, ditchweed and headache weed, was rooted forever in the rich soil and free for the taking.

"I mean this was the matrix, the geographical matrix," says Jonah Boone, one storyteller. "The city was on the Silk Route for drugs. Large amounts passed through from both coasts and came up from Mexico. When coke came through in 1970, everything was buzzing. There was all this cash flowing out of the hemp fields. You could feel the excitement accelerating every night. We

thought of Lawrence as *Baghdad on the Kaw* (a local name for the Kansas River)."

Dope-information columns in the hip papers *Vortex* and *Reconstruction* provided
market
reports
on
Baghdad's
drug
bazaar:

all pretty good and clean

Green – $2 a hit **ACID**
**PSILOCYBIN** Blue – slightly better – $2.50–$2.75 a hit
White caps $2 a hit – not quite as good as the – Psilocybin – $2.50 a hit
**MESCALINE—NEW IN TOWN**
white caps really good dope
**GRASS** LOTS OF IT @ $15 A LID
VARIES IN QUALITY SO SHOP AROUND
**HORSE TRANQUILIZERS – $2 a cap** **BLACK HASH**
$7 a gram –$85 an ounce
ITS A DIFFERENT STONE – $60 A **KIF**
**DMMD**

As word about Lawrence spread, the town became known as a friendly place for wayward freaks. Buddy Hamlin recalls seeing a foreign station wagon on the highway, the radiator boiling over. "We decided to help. They were just lame hippies. The guy had overalls and a big beard. The girl had the typically loose, vaguely Indian dress. They're from Jersey or someplace and on their way to California. They were just helpless hippies. The guy took the latest Jethro Tull album out of his trunk. Hippies were always coming through from the East, opening their trunks. They'd say, "Have you heard of Steppenwolf out here?" And they'd get

34

36

Magazine

TYPOGRAPHY/DESIGN Mike Fink, Sherman Oaks, California
TYPOGRAPHIC SOURCES In-house and Electric Pencil
STUDIO x height
CLIENT Borderline
PRINCIPAL TYPES Gill and Bembo
DIMENSIONS 8½ x 12 in. (21.6 x 30.5 cm)

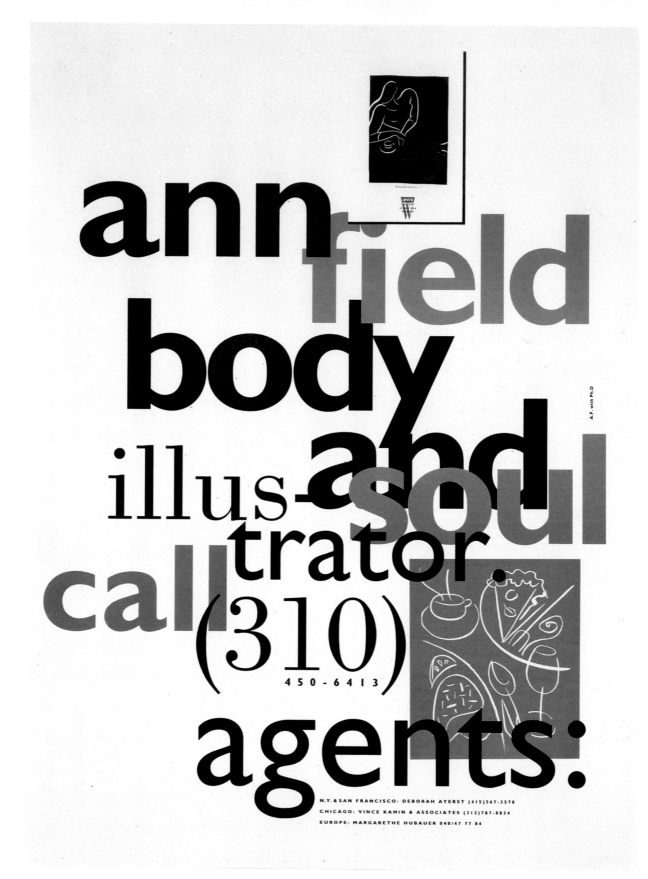

ann
field
body
illus-
trator.
call
and
soul
(310)
450-6413
agents:

A.F. with Ph.D

N.Y. & SAN FRANCISCO: DEBORAH AYERST (415)567-3570
CHICAGO: VINCE KAMIN & ASSOCIATES (312)787-8834
EUROPE: MARGARETHE HUBAUER 040/47 77 84

Advertisement
TYPOGRAPHY/DESIGN   Clive Piercy and Michael Hodgson, Santa Monica, California
TYPOGRAPHIC SOURCE   In-house
STUDIO   Ph.D
CLIENT   Ann Field
PRINCIPAL TYPES   Gill Sans and Bodoni Book
DIMENSIONS   9¼ x 13 in. (11.8 x 33 cm)

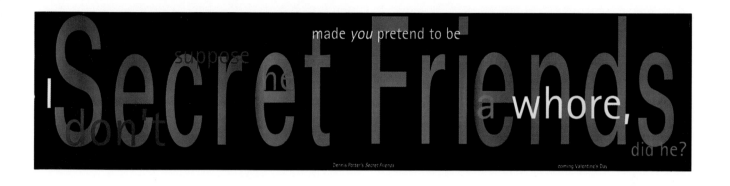

Posters

TYPOGRAPHY/DESIGN James Oliveri, New York, New York
ART DIRECTORS David Sterling and Jane Kosstrin
TYPOGRAPHIC SOURCES Typogram and E-Page
STUDIO Doublespace
CLIENT Geisler-Roberdeau
PRINCIPAL TYPE Rotis
DIMENSIONS 35½ x 48½ in. (90.2 x 123.1 cm) each

41

Television Advertisement
TYPOGRAPHY/DESIGN Nancy Laurence, New York, New York
ART DIRECTOR Dalton Padget
CREATIVE DIRECTOR Bobbi John Eggers
PRODUCER Kelly Moseley
CAMERA Cheryl Daitch
TYPOGRAPHIC SOURCES In-house and Typogram
AGENCY Saatchi & Saatchi Worldwide
STUDIO EYE Design
CLIENT Conran's Habitat
PRINCIPAL TYPE Various

Are you committed to art that makes you think

think

Then you should know about the Los Angeles Center for Photographic Studies

Brochure
TYPOGRAPHY/DESIGN Mike Fink, Sherman Oaks, California
TYPOGRAPHIC SOURCES In-house and Electric Pencil
STUDIO x-height
CLIENT Los Angeles Center for Photographic Studies
PRINCIPAL TYPE Memphis
DIMENSIONS 5¼ x 8½ in. (13.3 x 21.6 cm)

Stationery
TYPOGRAPHY/DESIGN Joy Panos, Chicago, Illinois
TYPOGRAPHIC SOURCE Master Typographers
STUDIO Laughing Dog Creative, Inc.
CLIENT Laughing Dog Creative, Inc.
PRINCIPAL TYPES Univers, Times Roman, ITC New Baskerville, and Garamond
DIMENSIONS 8½ x 11 in. (21.6 x 27.9 cm)

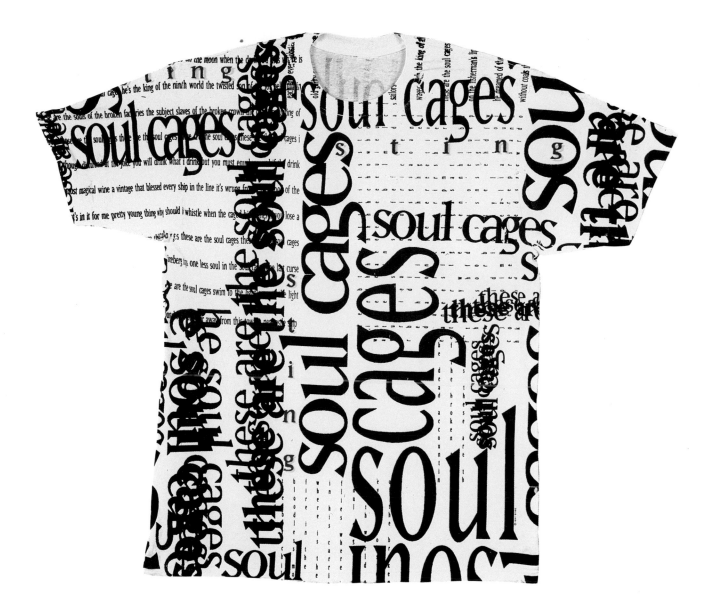

T-shirt

TYPOGRAPHY/DESIGN  Carin Rehbinder, San Francisco, California
TYPOGRAPHIC SOURCE  In-house
STUDIO  Winterland Productions
CLIENT  Sting
PRINCIPAL TYPE  Matrix

|  | Poster |
|---|---|
| TYPOGRAPHY/DESIGN | Zempaku Suzuki, Ginza, Tokyo, Japan |
| LETTERER | Zempaku Suzuki |
| TYPOGRAPHIC SOURCE | In-house |
| STUDIO | B.BI Studio Incorporated |
| CLIENT | IRc2 CORPORATION |
| PRINCIPAL TYPES | City Compact Bold and handlettering |
| DIMENSIONS | 30¼ x 41⅜ in. (76.8 x 105.1 cm) |

SALE

Campaign
TYPOGRAPHY/DESIGN Keisuke Unosawa, Setagaya-ku, Tokyo, Japan
TYPOGRAPHIC SOURCE In-house
STUDIO Keisuke Unosawa Design
CLIENT Jun Co., Ltd.
PRINCIPAL TYPE Franklin Gothic Bold
DIMENSIONS Various

47

Corporate Identity
TYPOGRAPHY/DESIGN   Sharon Werner, Minneapolis, Minnesota
LETTERERS   Lynn Schulte and Sharon Werner
TYPOGRAPHIC SOURCES   Typehouse and Dahl & Curry
STUDIO   Duffy Design Group
CLIENT   Fox River Paper Company
PRINCIPAL TYPES   Clarendon and Spartan Black
DIMENSIONS   Various

## BOND, TEXT AND COVER

(Quality)

# CIRCA '83

Swatchbook

1 — Distinctive laid finish papers available in 21 colors.

2 — Six sheets made of 50% recycled-15% post-consumer waste.

3 — Circa '83, Circa Select, and Circa Linen are color-matched to each other for maximum flexibility.

recycled sheets are - **GREEN CROSS** - certified to guarantee recycled content

# FOX RIVER PAPER CO.

200 East Washington Street, Appleton, WI 54913          For samples, call 800-543-SMPL

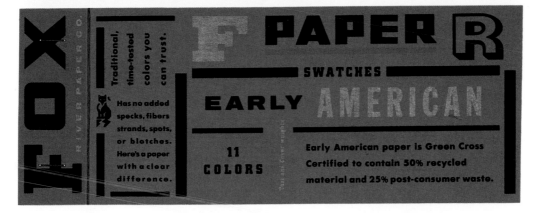

**FOX RIVER PAPER CO.**

Traditional, time-tested colors you can trust.

Has no added specks, fibers strands, spots, or blotches. Here's a paper with a clear difference.

# F PAPER R

## SWATCHES

## EARLY AMERICAN

**11 COLORS**

Early American paper is Green Cross Certified to contain 50% recycled material and 25% post-consumer waste.

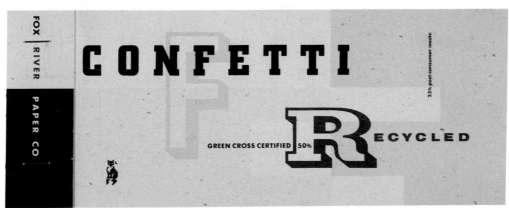

FOX | RIVER | PAPER CO

25% post-consumer waste

# CONFETTI

GREEN CROSS CERTIFIED 50% **RECYCLED**

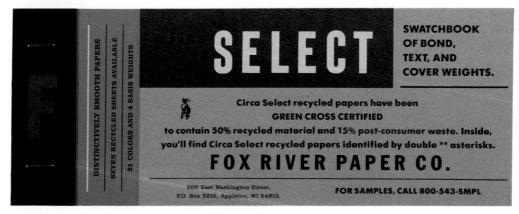

DISTINCTIVELY SMOOTH PAPERS

SEVEN RECYCLED SHEETS AVAILABLE

21 COLORS AND 4 BASIS WEIGHTS

# SELECT

**SWATCHBOOK OF BOND, TEXT, AND COVER WEIGHTS.**

Circa Select recycled papers have been **GREEN CROSS CERTIFIED** to contain 50% recycled material and 15% post-consumer waste. Inside, you'll find Circa Select recycled papers identified by double ** asterisks.

# FOX RIVER PAPER CO.

200 East Washington Street, P.O. Box 2215, Appleton, WI 54913.          FOR SAMPLES, CALL 800-543-SMPL

Corporate Identity

| | |
|---|---|
| TYPOGRAPHY/DESIGN | Sharon Werner, Minneapolis, Minnesota |
| LETTERERS | Lynn Schulte and Sharon Werner |
| TYPOGRAPHIC SOURCES | Great Faces and Typehouse |
| STUDIO | Duffy Design Group |
| CLIENT | Fox River Paper Company |
| PRINCIPAL TYPES | Spartan Black, Clarendon, and Alternate Gothic |
| DIMENSIONS | 3½ x 9 in. (8.9 x 22.9 cm) |

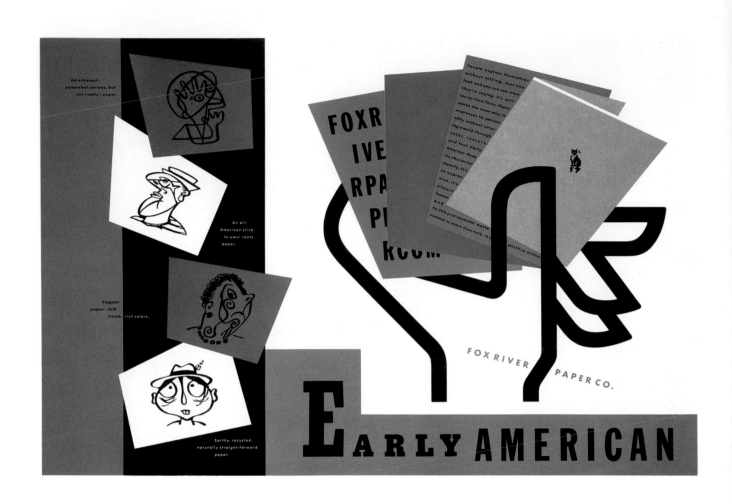

Poster
TYPOGRAPHY/DESIGN   Sharon Werner, Minneapolis, Minnesota
LETTERERS   Lynn Schulte and Sharon Werner
TYPOGRAPHIC SOURCE   Great Faces
STUDIO   Duffy Design Group
CLIENT   Fox River Paper Company
PRINCIPAL TYPES   Spartan Black, Franklin Gothic Extra Condensed, and
Stymie Extra Bold
DIMENSIONS   20 x 27 in. (50.8 x 68.9 cm)

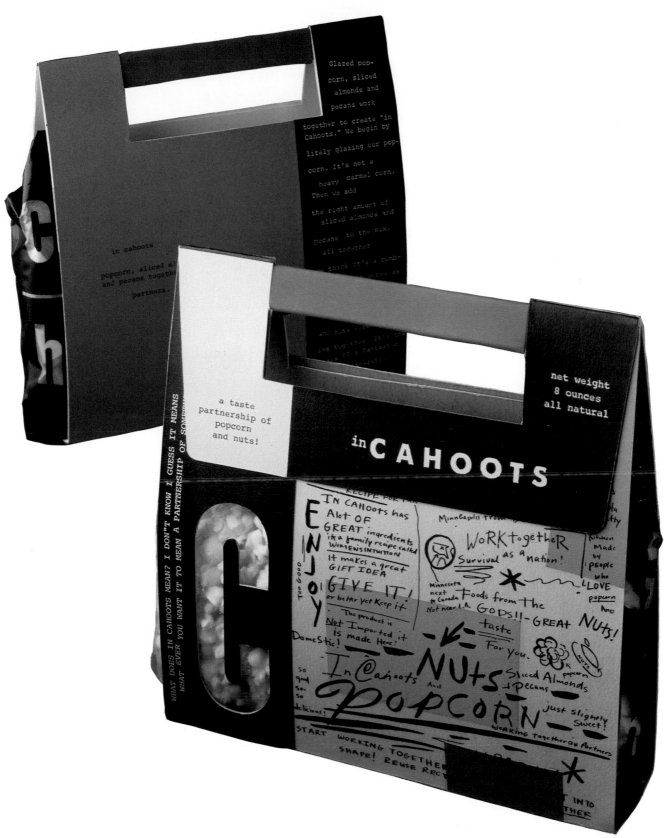

Packaging

|  |  |
|---|---|
| TYPOGRAPHY/DESIGN | Sharon Werner, Minneapolis, Minnesota |
| CALLIGRAPHER | Sharon Werner |
| WRITER | Charles Hanna |
| TYPOGRAPHIC SOURCE | Typewriter |
| STUDIO | Werner Design Werks Inc. |
| CLIENT | Deborah Wiener |
| PRINCIPAL TYPES | Typewriter and handlettering |
| DIMENSIONS | 8 x 9 x 2 in. (20.3 x 22.9 x 5.1 cm) |

Corporate Identity

| | |
|---|---|
| TYPOGRAPHY/DESIGN | Charles S. Anderson, Todd Hauswirth, and Daniel Olson, Minneapolis, Minnesota |
| TYPOGRAPHIC SOURCE | Linotypographers, Fort Worth, Texas |
| STUDIO | Charles S. Anderson Design Company |
| CLIENT | French Paper Company |
| PRINCIPAL TYPE | 20th Century |
| DIMENSIONS | 7 x 4½ x 1⅜ in. (17.8 x 11.4 x 3.5 cm) |

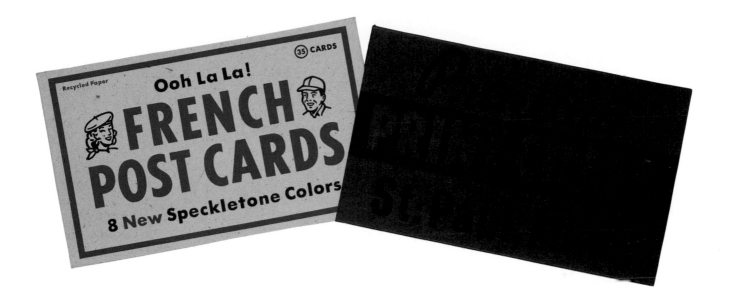

Corporate Identity

TYPOGRAPHY/DESIGN  Charles S. Anderson and Daniel Olson, Minneapolis, Minnesota
TYPOGRAPHIC SOURCE  Linotypographers, Fort Worth, Texas
STUDIO  Charles S. Anderson Design Company
CLIENT  French Paper Company
PRINCIPAL TYPE  Spartan
DIMENSIONS  3¾ x 6 in. (9.5 x 15.2 cm)

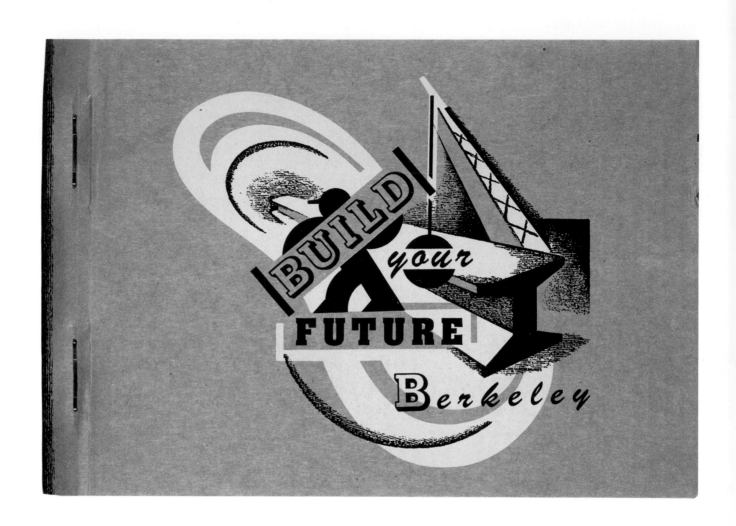

                          Brochure
       TYPOGRAPHY/DESIGN  John Sayles, Des Moines, Iowa
      TYPOGRAPHIC SOURCE  Printing Station
                 STUDIO  Sayles Graphic Design
                 CLIENT  University of California, Berkeley
          PRINCIPAL TYPE  Brush Script
             DIMENSIONS  9 x 13 in. (22.9 x 33 cm)

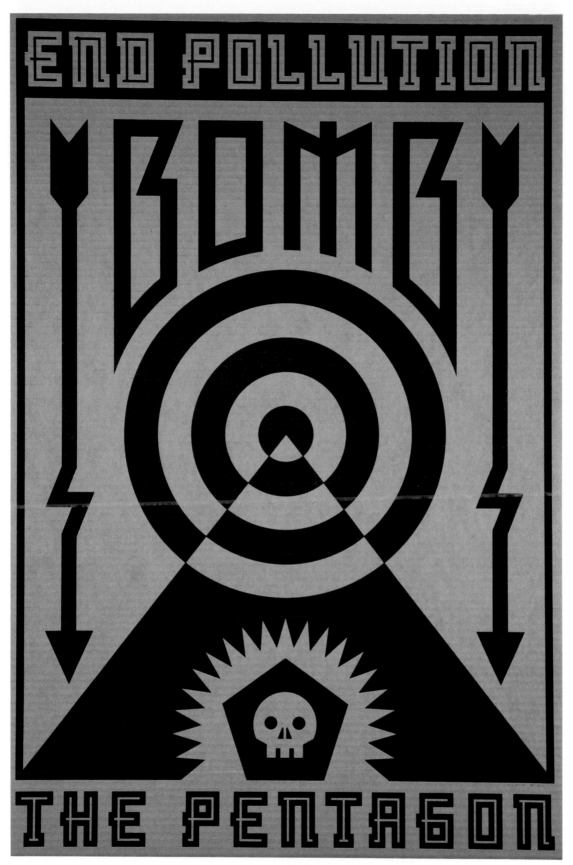

Poster
TYPOGRAPHY/DESIGN Mark Fox, San Rafael, California
LETTERER Mark Fox
TYPOGRAPHIC SOURCE In-house
STUDIO BlackDog
CLIENT BlackDog
PRINCIPAL TYPES Agit Prop! and handlettering
DIMENSIONS 24 x 36 in. (61 x 91.4 cm)

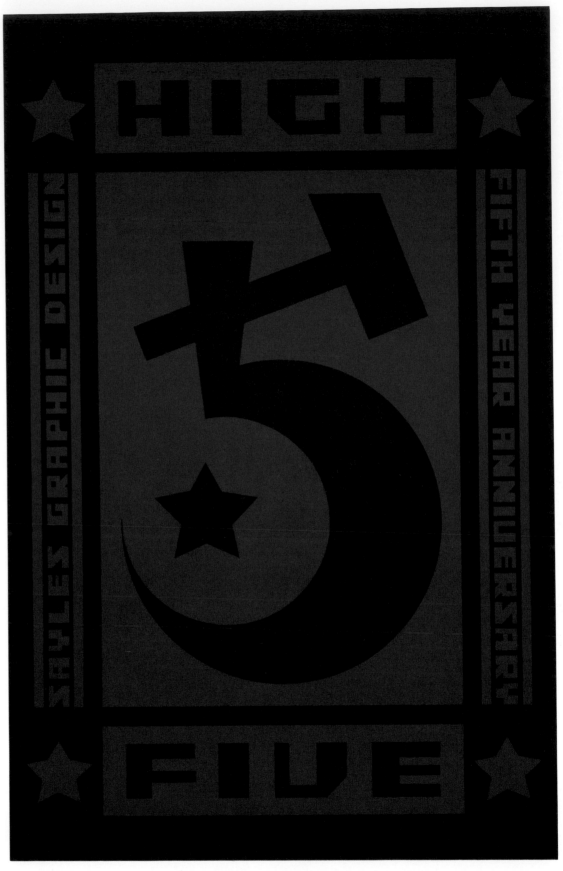

Poster
TYPOGRAPHY/DESIGN John Sayles, Des Moines, Iowa
LETTERER John Sayles
TYPOGRAPHIC SOURCE In-house
STUDIO Sayles Graphic Design
CLIENT Sayles Graphic Design
PRINCIPAL TYPE Handlettering
DIMENSIONS 26 x 40 in. (66 x 101.6 cm)

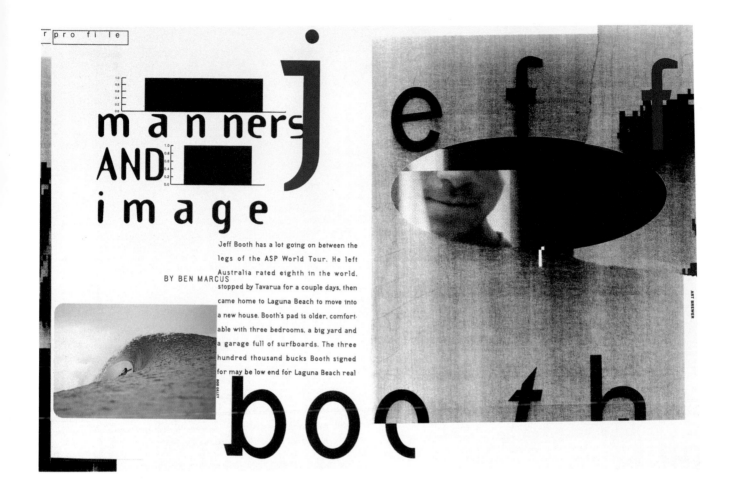

# manners AND image

**m a n ners**
**AND**
**image**

Jeff Booth has a lot going on between the
legs of the ASP World Tour. He left
Australia rated eighth in the world,
BY BEN MARCUS
stopped by Tavarua for a couple days, then
came home to Laguna Beach to move into
a new house. Booth's pad is older, comfort-
able with three bedrooms, a big yard and
a garage full of surfboards. The three
hundred thousand bucks Booth signed
for may be low end for Laguna Beach real

jeff booth

Magazine Spread
TYPOGRAPHY/DESIGN  David Carson, Del Mar, California
STUDIO  David Carson Design
CLIENT  Surfer Publications
PRINCIPAL TYPE  Template Gothic
DIMENSIONS  10 x 17 in. (25.4 x 43.2 cm)

Poster

TYPOGRAPHY/DESIGN  Daniel Olson, Charles S. Anderson, and Haley Johnson, Minneapolis, Minnesota
TYPOGRAPHIC SOURCE  P & H Photo Composition, Inc.
STUDIO  Charles S. Anderson Design Company
CLIENT  Wieden & Kennedy
PRINCIPAL TYPE  Venus
DIMENSIONS  25 x 36 in. (63.5 x 91.4 cm)

Poster

TYPOGRAPHY/DESIGN  Daniel Olson, Charles S. Anderson, and Haley Johnson,
Minneapolis, Minnesota

TYPOGRAPHIC SOURCE  P & H Photo Composition, Inc.

STUDIO  Charles S. Anderson Design Company

CLIENT  Wieden & Kennedy

PRINCIPAL TYPE  Venus

DIMENSIONS  25 x 36 in. (63.5 x 91.4 cm)

CHARLES S. ANDERSON

NEW MEMBERS...Martha Bogdanoff (Bozell, Inc.), Mary Brandt (Laser Tech Color, Inc.), Ron Head, Tina Kuntz (Harwood Marketing Group), Doug Smith (Doug Smith Photography), Carl Waters (Univ. of Texas Southwestern Medical Center).

Litho Inco
Printing a
St. Paul, M

DALLAS TEXAS

THURSDAY OCT. 24TH AT CITY PLACE

MEMBERS
FREE

COCKTAILS 6:00 PM SPEAKER 7:00

CHUCK WAGON LANTERN

FRENCH PAP
SPONSOR

non-members $10 students $3 Call 241-2017

Poster
TYPOGRAPHY/DESIGN   Charles S. Anderson, Daniel Olson, and Todd Hauswirth, Minneapolis, Minnesota
TYPOGRAPHIC SOURCE   In-house
STUDIO   Charles S. Anderson Design Company
CLIENT   Dallas Society of Visual Communications
PRINCIPAL TYPES   20th Century and Helvetica
DIMENSIONS   25⅛ x 34¾ in. (63.8 x 88.3 cm)

# Printmaking

**Richard Graf, chair, Printmaking**

# Liberal ARTS

**Ray Mondini, chair, Liberal Arts**

I have a... should be like an object, a... in the hand, a dirty stone that is crumbly with the... earth from which it was taken, a stone that so... **San Francisco** the hand which holds it, that stains the skin and marks there with its own color the lines fate already cut into the palm.

The work... stain that en... skin... the hand, enters... bloodstream... through the... and... **INSTITUTE** The work... som...dicable... ent...us and does...

| | |
|---|---|
| | Campaign |
| TYPOGRAPHY/DESIGN | James Oliveri, Klaus Kempenaars, and David Sterling, New York, New York |
| ART DIRECTORS | David Sterling and Jane Kosstrin |
| TYPOGRAPHIC SOURCE | Typogram |
| STUDIO | Doublespace |
| CLIENT | San Francisco Art Institute |
| PRINCIPAL TYPE | Franklin Gothic |
| DIMENSIONS | Various |

Catalog
TYPOGRAPHY/DESIGN Joyce Nesnadny and Ruth D'Emilia, Cleveland, Ohio
TYPOGRAPHIC SOURCE TSI: Typesetting Services, Inc.
STUDIO Nesnadny & Schwartz
CLIENT The Akron Art Museum
PRINCIPAL TYPE ITC Gamma
DIMENSIONS 8 x 10½ in. (20.3 x 26.7 cm)

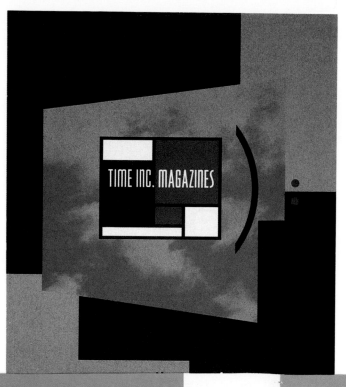

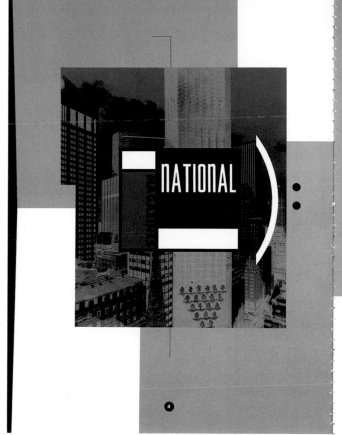

Annual Report

TYPOGRAPHY/DESIGN  Kin Yuen, New York, New York

TYPOGRAPHIC SOURCE  In-house

AGENCY  Frankfurt Gips Balkind

CLIENT  The Time Inc. Magazine Company

PRINCIPAL TYPE  Helvetica

DIMENSIONS  9 x 12 in. (22.9 x 30.5 cm)

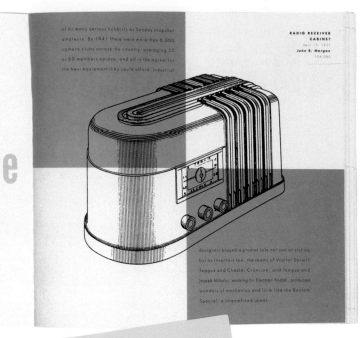

AN ILLUSTRATED HISTORY
OF AMERICAN
DESIGN PATENTS

great inventions
good intentions

ERIC BAKER
TEXT BY JANE MARTIN

|  | Book |
|---|---|
| Typography/Design | Eric Baker and Chip Kidd, New York, New York |
| Typographic Source | In-house |
| Studio | Eric Baker Design Associates, Incorporated |
| Client | Chronicle Books |
| Principal Type | Futura |
| Dimensions | 10 x 9⅝ in. (25.4 x 24.4 cm) |

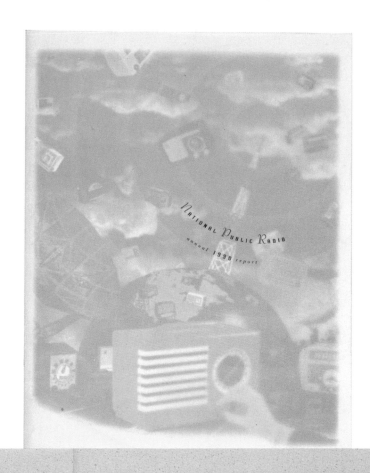

Annual Report

TYPOGRAPHY/DESIGN George Mimnaugh and Claire Cesna Amos, Baltimore, Maryland
TYPOGRAPHIC SOURCE In-house
STUDIO Rutka Weadock Design
CLIENT National Public Radio
PRINCIPAL TYPES Industria, Bodoni, and Bernhard Tango
DIMENSIONS 8½ x 11 in. (21.6 x 27.9 cm)

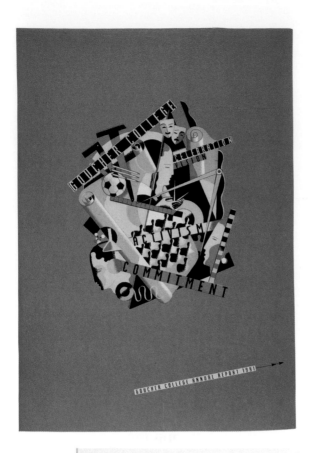

Day, held for the second year in a row, took place in March. Its purpose was two-fold: merit award candidates were interviewed by faculty teams, and all high ability accepted applicants were given a close-up view of academic opportunities at Goucher.

"Scholars' Day gives us a chance to show very bright students that other very bright students are also considering Goucher – it helps them to validate their choice," says Ms. Seraydarian. She adds that several improvements were made to this year's program, including a dinner with members of the Board of Trustees and a social event hosted by the Student Government Association. Students met with faculty and sat in on honors classes. There was a student host for each attendee.

**An Campaign Launched**

The special allocation from the Board of Trustees funded an institutional "image" advertising campaign to complement and reinforce other efforts. The campaign, limited to targeted recruitment areas, included full-page ads in Baltimore and Washington newspapers and magazines and area high school newspapers as well as in regional editions of *Time, Newsweek, Sports Illustrated,* and *U.S. News and World Report.* The Public Relations Office stepped up efforts to place articles about students in hometown newspapers and about students, faculty, and programs in

national publications. Two recruitment videos were produced. The first, entitled "Sculpting a Life," is sent to students who have inquired about Goucher, while the second video, "Goucher Because," focuses on high ability students and is sent to those who have already been accepted. "Students who have received the videos have reacted very favorably," Ms. Seraydarian says. The first video has also won awards from the Council for Advancement and Support of Education and the International Association of Business Communicators.

For the recruitment plan to work, and to continue working, the involvement of the entire Goucher community is essential. "Faculty participation in the recruitment effort was greater than ever this year," Ms. Seraydarian reports. "Faculty volunteers interviewed students, attended college fairs, wrote follow-up letters to selected prospects, and gave us feedback on the overall recruitment process." Alumni admissions representatives continued their hard work, and trustees joined in such activities as Scholars' Day and Accepted Applicants Day. Students were guides, hosts, and valuable advocates for the college. Says Becky Crouse '93, vice president of the Student Government Association, "The freshman class is superb. It is a product of student, faculty, staff, and trustee commitment. We're becoming a campus community that truly works together."

Annual Report

| | |
|---|---|
| TYPOGRAPHY/DESIGN | George Mimnaugh and Anthony Rutka, Baltimore, Maryland |
| LETTERER | Dolores Fairman |
| TYPOGRAPHIC SOURCE | In-house |
| STUDIO | Rutka Weadock Design |
| CLIENT | Goucher College |
| PRINCIPAL TYPES | Bodoni and Viking |
| DIMENSIONS | 8½ x 11 in. (21.6 x 27.9 cm) |

66

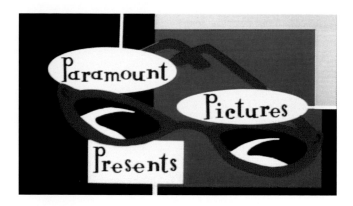 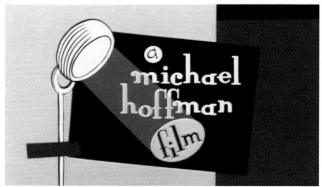

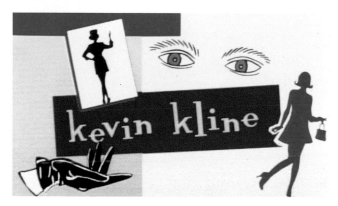 

Film Titles
TYPOGRAPHY/DESIGN  Sarajo Frieden, Los Angeles, California
LETTERER  Sarajo Frieden
STUDIO  Sarajo Frieden Studio
CLIENT  Paramount Pictures
PRINCIPAL TYPE  Handlettering

# REMEMBER
# HOW GREAT
## BEEF USED TO TASTE?

## No you don't.

Way back, before man came along and started messing with it, all beef had a taste as clean, pure and natural as the Coleman brand. But that was a long, long time ago.

That was back before hormones were used to accelerate the growth and fattening of beef cattle. Before the administering of antibiotics became frequent and commonplace. Before any scientific or technological "breakthroughs" could come between you and the taste of beef at its most basic, natural and delicious.

Today, the only thing standing between your family and that natural beef taste is a few more cents per pound. A small price to pay for a trip back in time to a taste you'll never forget.

Coleman Natural Meats, Inc., 1-800-442-8666. 5140 Race Court, Denver, Colorado 80216.

**WHERE TO BUY**
COLEMAN NATURAL BEEF

★ Purity Supreme ★
Heartland ★ Cape Ann Markets
Angelos ★ Shubes Markets ★

RAISED WITHOUT HORMONES OR ANTIBIOTICS
100% PURE AND NATURAL
**COLEMAN**
NATURAL BEEF
MEL COLEMAN, PROP.
RAISED AT THE HEAD OF THE CREEK

## MAN HASN'T MESSED WITH IT.

Advertisement
TYPOGRAPHY/DESIGN  Glen Jameson and Barry Poulter, New York, New York
TYPOGRAPHIC SOURCES  ATS and Photo-Lettering, Inc.
AGENCY  Beber Silverstein McCabe & Partners/McCabe & Company
CLIENT  Coleman Natural Meats
PRINCIPAL TYPES  Egyptian, Rockwell, and Bodoni
DIMENSIONS  Various

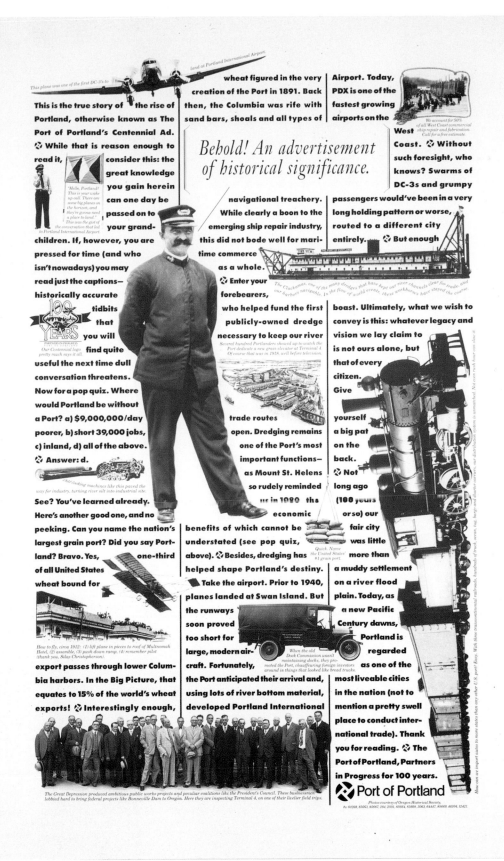

This plane was one of the first DC-3's to land at Portland International Airport.

This is the true story of the rise of Portland, otherwise known as The Port of Portland's Centennial Ad. While that is reason enough to read it, consider this: the great knowledge you gain herein can one day be passed on to your grandchildren. If, however, you are pressed for time (and who isn't nowadays) you may read just the captions—historically accurate tidbits that you will find quite useful the next time dull conversation threatens. Now for a pop quiz. Where would Portland be without a Port? a) $9,000,000/day poorer, b) short 39,000 jobs, c) inland, d) all of the above. Answer: d. See? You've learned already. Here's another good one, and no peeking. Can you name the nation's largest grain port? Did you say Portland? Bravo. Yes, one-third of all United States wheat bound for export passes through lower Columbia harbors. In the Big Picture, that equates to 15% of the world's wheat exports! Interestingly enough,

"Hello, Portland! This is your wake up call. There are some big planes on the horizon, and they're gonna need a place to land." This was the gist of the conversation that led to Portland International Airport.

100 YEARS
PARTNERS IN PROGRESS
Our Centennial logo pretty much says it all.

How to fly, circa 1912: (1) lift plane in pieces to roof of Multnomah Hotel, (2) assemble, (3) push down ramp, (4) remember pilot (thank you, Silas Christopherson).

### Behold! An advertisement of historical significance.

wheat figured in the very creation of the Port in 1891. Back then, the Columbia was rife with sand bars, shoals and all types of navigational treachery. While clearly a boon to the emerging ship repair industry, this did not bode well for maritime commerce as a whole. Enter your forebearers, who helped fund the first publicly-owned dredge necessary to keep our river trade routes open. Dredging remains one of the Port's most important functions—as Mount St. Helens so rudely reminded us in 1980, the economic benefits of which cannot be understated (see pop quiz, above). Besides, dredging has helped shape Portland's destiny. Take the airport. Prior to 1940, planes landed at Swan Island. But the runways soon proved too short for large, modern aircraft. Fortunately, the Port anticipated their arrival and, using lots of river bottom material, developed Portland International

Several hundred Portlanders showed up to watch the Port dedicate a new grain elevator at Terminal 4. Of course that was in 1918, well before television.

Quick. Name the United States' #1 grain port.

When the old Dock Commission wasn't maintaining docks, they promoted the Port, chauffeuring foreign investors around in things that looked like bread trucks.

Airport. Today, PDX is one of the fastest growing airports on the West Coast. Without such foresight, who knows? Swarms of DC-3s and grumpy passengers would've been in a very long holding pattern or worse, routed to a different city entirely. But enough boast. Ultimately, what we wish to convey is this: whatever legacy and vision we lay claim to is not ours alone, but that of every citizen. Give yourself a big pat on the back. Not long ago (100 years or so) our fair city was little more than a muddy settlement on a river flood plain. Today, as a new Pacific Century dawns, Portland is regarded as one of the most liveable cities in the nation (not to mention a pretty swell place to conduct international trade). Thank you for reading. The Port of Portland, Partners in Progress for 100 years.

We account for 50% of all West Coast commercial ship repair and fabrication. Call for a free estimate.

The Clackamas, one of the many dredges that have kept our river channels clear for trade and our harbors navigable. In the flow of world events, these workhorses have stayed the course.

Obstructing machines like this paved the way for industry, turning river silt into industrial site.

How can we export wastes to more states than any other U.S. port? Easy. With three transcontinental railroads, hundreds of truck, ocean, tug, barge and charter carriers, our distribution system is unmatched. Not even rush hour can slow it.

**Port of Portland**

Photos courtesy of Oregon Historical Society.
#s 60268, 85002, 85007, 284, 2501, 85664, 83660, 3062, 64447, 85669, 46304, 12421.

The Great Depression produced ambitious public works projects and peculiar coalitions like the President's Council. These businessmen, lobbied hard to bring federal projects like Bonneville Dam to Oregon. Here they are inspecting Terminal 4, on one of their livelier field trips.

Advertisement

TYPOGRAPHY/DESIGN  Bill Karow, Portland, Oregon
TYPOGRAPHIC SOURCE  BP&N Typesetting
AGENCY  Borders, Perrin & Norrander
CLIENT  Port of Portland
PRINCIPAL TYPE  Futura Extra Bold
DIMENSIONS  16 x 24 in. (40.6 x 61 cm)

P Q R S T U V W X Y Z

**Adobe** *Type Set*®

**How-to Booklet**

a b c d e f g h i j

D E F G H I J K L M N O P Q R S T U V W X Y Z

# Type you

A B C D E F G H I J K L M N O P Q R S T U V W X Y

s t u v w x y z

# can

a b c d e f g h i j k l m n o p q

J K L M N O P Q R S T U V W X Y Z

# use.

A B C D E F G H I J K L M N O P Q R S T U V W

A B C D E F G H I J K L M N O P Q R S T U V W X Y Z

|  |  |
|---|---|
|  | Booklet |
| TYPOGRAPHY/DESIGN | Keala Hagmann, Mountain View, California |
| ILLUSTRATORS | Min Wang, James Young, and Ewa Gavrielow |
| ART DIRECTOR | Gail Blumberg |
| TYPOGRAPHIC SOURCE | In-house |
| STUDIO | Adobe Marcom Department |
| CLIENT | Adobe Systems Incorporated |
| PRINCIPAL TYPES | Formata and ITC Berkeley Oldstyle |
| DIMENSIONS | 7½ x 9 in. (19 x 22.9 cm) |

Typographers use picas to measure or specify the length of lines. To achieve optimum readability an appropriate line length is critical. Although the ideal length is dependent on many factors, the size and style of the typeface are the most significant.

A good starting point is to determine how many characters will fit within the pica width desired. An average of 45 characters per line will yield a comfortable column width for both readability and aesthetics. Up to 10 fewer or 20 additional (35–65) characters per line will still be quite legible; however, as lines become shorter or longer, problems arise.

Lines of type with fewer than 35 characters will prove difficult to adjust. If the type is set justified, the spaces between words will vary greatly and gaps and rivers may be created. In order to avoid uneven *wordspacing* when setting type on short measures, the designer may opt for type set flush left, ragged right. While the general appearance of text will improve, a visually disturbing ragged edge may develop. In addition, rivers may also occur in flush left, ragged right type.

As the pica measure decreases, the difficulty of setting type without distracting patterns that impair readability increases. Extremely short measures break up lines of copy and create awkward phrases which cause the reader to lose concentration. As mentioned in the previous section, the use of hyphenation in flush left, ragged right type is rather inappropriate, except for extremely long words or very "natural" word breaks.

Excessive line lengths also inhibit good readability. The eye may have difficulty determining which is the next line of type to be read. A condition known as *doubling*, reading or beginning to read the same line twice, may result. Additional linespace will increase the readability.

Type set in very wide column widths is tiresome to comprehend. This may be the reason some legal contracts are set in exceedingly long pica measures. Because the text is laborious to read, one tends to sign documents which have not been fully reviewed!

Wide column widths are best set justified. Wide measures set in flush left, ragged right format or another unjustified arrangement have a nearly even, "uncomfortable" edge on the side of a column. If an unjustified edge is desired, the type must be carefully worked to create a pleasing *rag*, or edge.

Determining an ideal line length will often necessitate a change of the initially desired typeface. Sometimes a smaller type size will be required in order to obtain the ideal number of characters per line, although the smaller size may be more difficult to read. In other situations, another typeface in the same family may increase the number of characters per line. For example, *Helvetica* may need to be replaced with *Helvetica Condensed*. Choosing a typeface with a slightly smaller x-height will also increase the number of characters per line, but at the expense of greater readability.

Before undertaking a large job, refer to type specimen sheets, if available, otherwise be sure to generate or have samples set. Type specimen sheets, or sample showings, are produced by the companies that create or distribute typefaces (see page 52). A representative display of the desired typeface, size, line length, linespacing and arrangement is a valuable guide which assists the designer in making qualified decisions. Small adjustments often have a large impact on the way your message is ultimately received.

**Captions.** Captions are brief amounts of copy which can usually be handled with greater typographic experimentation, especially in terms of short line lengths. Set either flush left, ragged right or flush right, ragged left, short line lengths have become quite common in editorial design.

The reader will customarily tolerate small amounts of text set in slightly less legible, but perhaps more eye catching type styles. Captions are a most useful way to activate the page and create visual interest.

As few as 20 characters per line may be used for captions, if the designer makes provisions for long words or has the authority to occasionally alter text.

**Machine Limitations.** Excessively long lines or large type sizes which require wide pica measures can present technical problems. Although today's typesetting equipment is capable of setting type on much wider pica measures than previous technologies, line lengths over 60 picas may need special machine set-ups, odd paper sizes or additional labor. One should consult the individual responsible for producing the final proofs, or *galleys*, if any measure over 60 picas or a type size larger than 90 point is desired.

*11 point Aldus set on various line lengths.*

Every a
*3 picas*

Every art, a
*5 picas*

Every art, and eve
*7 picas*

Every art, and every sc
*9 picas*

Every art, and every science
*11 picas*

Every art, and every science redu
*13 picas*

Every art, and every science reduced to
*15 picas*

Every art, and every science reduced to a tea
*17 picas*

Every art, and every science reduced to a teachabl
*19 picas*

Every art, and every science reduced to teachable for
*21 picas*

Every art, and every science reduced to teachable form, an
*23 picas*

Every art, and every science reduced to a teachable form, and in li
*25 picas*

Every art, and every science reduced to a teachable form, and in like m
*27 picas*

Every art, and every science reduced to a teachable form, and in like manne
*29 picas*

Every art, and every science reduced to a teachable form, and in like manner ever
*31 picas*

*11/13 Aldus set justified on a 7½ pica measure contains approximately 19 characters per line (right). The measure is undesirably short, is filled with inconsistent gaps between words and is difficult to read.*

*11/13 Aldus set justified on a 23½ pica measure contains approximately 65 characters per line (far right). The wide measure is easily read and the spaces between words are far more uniform than with the shorter measure.*

Every art, and every science reduced to a teachable form, and in like manner every action and moral choice, aims, it is thought, at some good: for which reason a common and by no means a bad description of the Chief Good is, "that which all things aim at." Now there plainly is a difference in the Ends proposed: for in some cases they are acts of working, and in others certain

Every art, and every science reduced to a teachable form, and in like manner every action and moral choice, aims, it is thought, at some good: for which reason a common and by no means a bad description of the Chief Good is, "that which all things aim at." Now there plainly is a difference in the Ends proposed: for in some cases they are acts of working, and in others certain works or tangible results beyond and beside the acts of working: and where there are certain Ends beyond the actions, the works are in their nature better than the acts of working. Again, since actions and arts and sciences are many, the Ends likewise come to be many: of the healing art, for instance, health; of the ship-building art, a vessel; of the military art, victory; and of domestic management, wealth; are respectively the Ends. And whatever of such actions, arts, or sciences range under some one faculty (as under that of horsemanship the art of making bridles, and all that are connected with the manufacture of horse-furniture in general; this itself again, and every action connected with war, under the military art; and in the same way others under others), in all such, the Ends of the master-arts are more choice-worthy than those ranging under them, because it is with a view to the former that the [...] comparison it makes no difference [...] hemselves the Ends of the actions, or [...] as in the case of the arts and sciences [...] Since then of all things which may be [...] h we desire for its own sake, and with [...] thing else; and since we do not choose [...] d in view (for then men would go on [...] would be unsatisfied and fruitless), [...] ood, i.e. the best thing of all. Surely [...] al life and conduct, the knowledge of

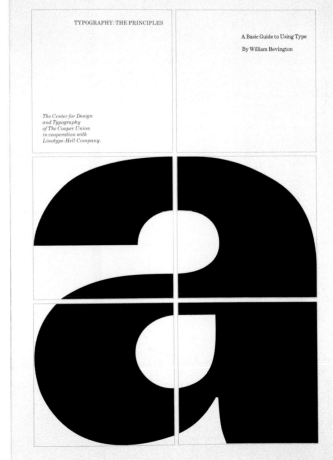

TYPOGRAPHY: THE PRINCIPLES

A Basic Guide to Using Type

By William Bevington

*The Center for Design and Typography of The Cooper Union in cooperation with Linotype-Hell Company.*

Book

TYPOGRAPHY/DESIGN William Bevington and Charles Nix, New York, New York

TYPOGRAPHIC SOURCE In-house

STUDIO The Cooper Union Center for Design and Typography

CLIENT Linotype-Hell Company

PRINCIPAL TYPE Century Expanded

DIMENSIONS 8¼ x 11¾ in. (21 x 29.8 cm)

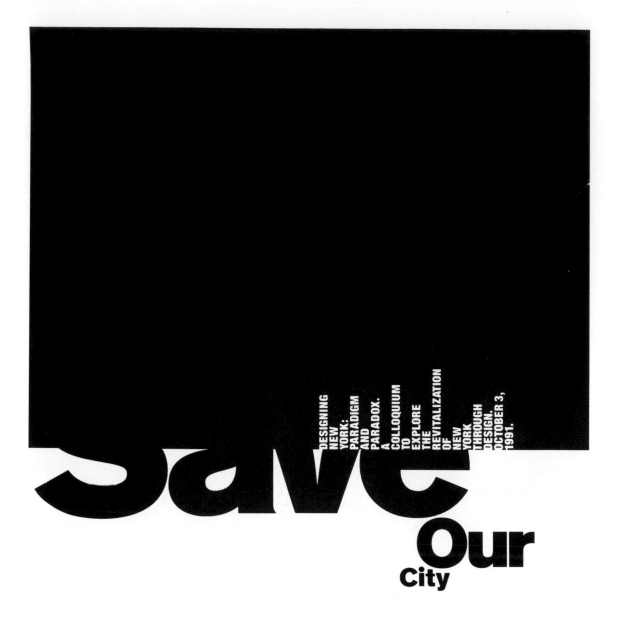

Save Our City

DESIGNING NEW YORK: PARADIGM AND PARADOX. A COLLOQUIUM TO EXPLORE THE REVITALIZATION OF NEW YORK THROUGH DESIGN. OCTOBER 3, 1991.

New York is at a critical point
in its history.
On Thursday, October 3, 1991,
a group of New York City's
leading interior architects and
designers, in co-sponsorship
with the National Institute for
Architectural Education, will
hold a breakfast symposium
entitled Designing New York:
Paradigm and Paradox.
The participants will include
Gordon David, Meyer Frucher,
Ruth Messinger and Paul Gold-
berger. The invited audience
represents a cross-section
of our city's top government
and corporate leaders.
Our conviction is that design
is crucial to New York City's
survival. The quality of our built
environment can enhance an
individual's life, affect a corpo-
ration's livelihood, and lead the
way to a revitalized metropolis.
We encourage active, ongoing
participation in this effort from
the private sector, government
and, of course, New York's
architecture and design com-
munity. To get involved, contact
the National Institute for Archi-
tectural Education, 30 West
22 Street, New York, NY 10010
for more information.
Our city's survival is at stake.
Design can make the difference.

|  |  |
|---|---|
|  | Poster |
| TYPOGRAPHY/DESIGN | Michael Bierut, New York, New York |
| TYPOGRAPHIC SOURCE | Typogram |
| STUDIO | Pentagram Design |
| CLIENT | Designing New York |
| PRINCIPAL TYPES | Helvetica Black and Akzidenz Grotesk |
| DIMENSIONS | 24 x 36 in. (61 x 91.4 cm) |

 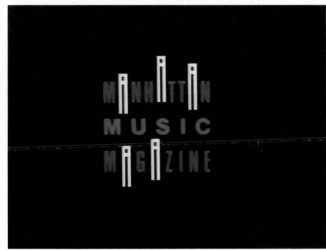

Television Titles
TYPOGRAPHY/DESIGN Keisuke Unosawa, Setagaya-ku, Tokyo, Japan
LETTERER Keisuke Unosawa
AGENCY VideoArts Japan, Inc.
STUDIO Keisuke Unosawa Design
CLIENT Japan Satellite Broadcasting, Inc.
PRINCIPAL TYPE Handlettering

Brochure
TYPOGRAPHY/DESIGN  Mike Stees and Kym Abrams, Chicago, Illinois
TYPOGRAPHIC SOURCE  Master Typographers
STUDIO  Kym Abrams Design
CLIENT  Illinois Film Office
PRINCIPAL TYPE  Bauer Bodoni
DIMENSIONS  10¾ x 10¾ in. (27.3 x 27.3 cm)

Logotype

TYPOGRAPHY/DESIGN   Dianne Cook and Supon Phornirunlit, Washington, D.C.
LETTERER   Dianne Cook
TYPOGRAPHIC SOURCE   In-house
STUDIO   Supon Design Group, Inc.
CLIENT   Harris Chair Center
PRINCIPAL TYPE   Chicago (customized)

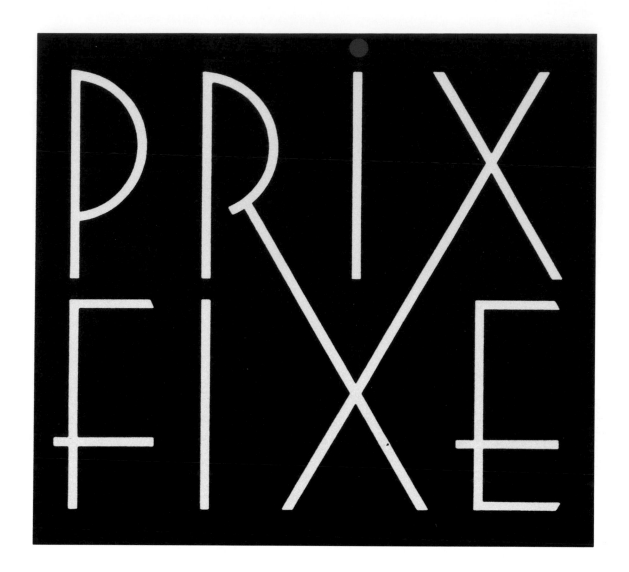

Logotype
TYPOGRAPHY/DESIGN  Louise Fili, New York, New York
LETTERER  Louise Fili, New York, New York
STUDIO  Louise Fili Ltd.
CLIENT  Prix Fixe restaurant
PRINCIPAL TYPE  Handlettering

Logotype

TYPOGRAPHY/DESIGN   Scott Feaster, Commerce, Texas
LETTERER   Scott Feaster
STUDIO   Feaster Design
CLIENT   Cobb Hatchery
PRINCIPAL TYPE   Handlettering

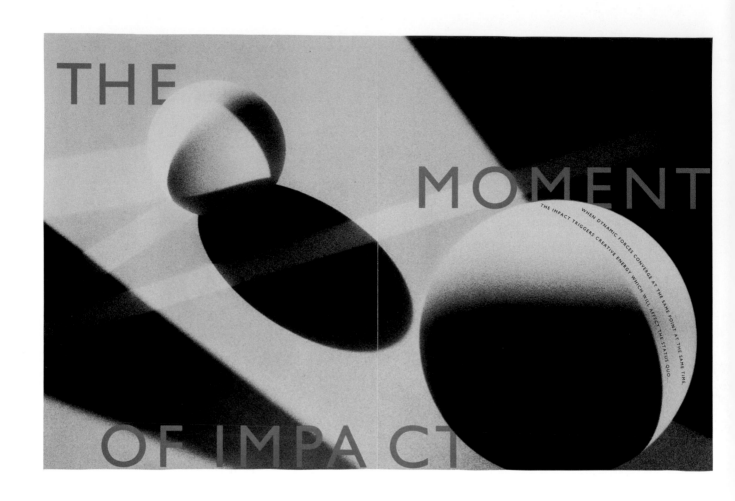

THE MOMENT OF IMPACT

THE IMPACT TRIGGERS CREATIVE ENERGY WHICH WILL AFFECT THE STATUS QUO. WHEN DYNAMIC FORCES CONVERGE AT THE SAME POINT AT THE SAME TIME.

Announcement

TYPOGRAPHY/DESIGN  Laurel Shoemaker and Cliff Morgan, New York, New York
TYPOGRAPHIC SOURCE  Paragon Typographics
AGENCY  Susan Slover Design
CLIENT  Robert Allen Contract
PRINCIPAL TYPE  Gill Sans
DIMENSIONS  5 in. diameter (12.7 cm)

# DISLOC ATIONS

## THE MUSEUM OF MODERN ART, NEW YORK

|  | |
|---|---|
|  | Book |
| TYPOGRAPHY/DESIGN | Andrew Gray, New York, New York |
| CREATIVE DIRECTOR | Stephen Doyle |
| TYPOGRAPHIC SOURCE | In-house |
| STUDIO | Drenttel Doyle Partners |
| CLIENT | Museum of Modern Art/New York |
| PRINCIPAL TYPE | Centaur |
| DIMENSIONS | 9 x 12 in. (22.9 x 30.5 cm) |

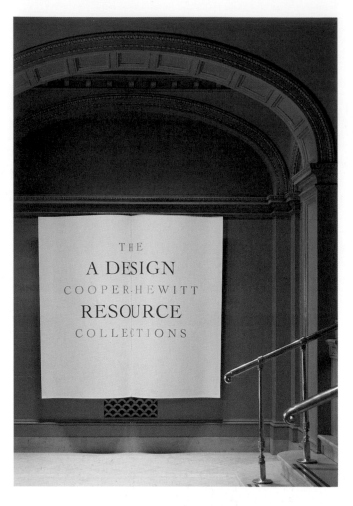

| | |
|---|---|
| | Signage |
| TYPOGRAPHY/DESIGN | Stephen Doyle and Andrew Gray, New York, New York |
| CREATIVE DIRECTOR | Stephen Doyle |
| TYPOGRAPHIC SOURCE | In-house |
| STUDIO | Drenttel Doyle Partners |
| CLIENT | The Cooper-Hewitt Museum |
| PRINCIPAL TYPE | Cochin |
| DIMENSIONS | Various |

BOESKY

*Maybe your kids need
a better role model.*

SCROOGE

A CHRISTMAS CAROL

*At the Winningstad through December 22*

THE NEW ROSE THEATRE

222.2487

Television Advertisement
TYPOGRAPHY/DESIGN Jerry Ketel, Portland, Oregon
CREATIVE DIRECTOR George Taylor
TYPOGRAPHIC SOURCE In-house
AGENCY Cyrano
STUDIO Bang Bang Bang
CLIENT New Rose Theater
PRINCIPAL TYPES Trajan and Centaur Italic (Arrighi)

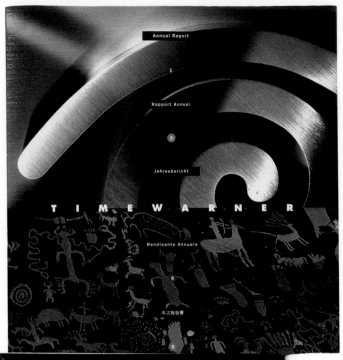

6  HBO's $52 million image advertising and programming promotion campaign, out of a total marketing budget of $150 million, was the largest in the history of the cable industry.

7  In 1990, Cinemax offered 60% more movies than Showtime, and with far less duplication of HBO's offerings. Cinemax showed more movies that *didn't* appear on HBO than Showtime showed altogether.

**5 PROGRAMMING**

| 1990 Top Films | Original Movies | Sports | Comedy | Special/Other |
|---|---|---|---|---|
| Batman | Criminal Justice • | World Championship Boxing • | Dream On • | Madonna: The Blond Ambition Tour Live • |
| Lethal Weapon 2 | El Diablo • | Wimbledon Tennis | The Kids in the Hall • | Tales from the Crypt • |
| The War of the Roses | The Image • | Inside the NFL | Comic Relief '90 | Carmen on Ice •• |
| National Lampoon's Christmas Vacation | Women & Men: Stories of Seduction • | History of the NBA • | George Carlin: Doin' It Again • | Best Hotel on Skid Row |
| Indiana Jones and the Last Crusade | By Dawn's Early Light • | | One Night Stand | Bahar • |
| Rain Man | Judgment | | Richard Lewis | Reel Sex |
| Working Girl | The Tragedy of Flight 103: The Inside Story | | Steven Wright | GunPlay |
| Twins | | | | • 7 Emmy Awards |
| | | | | • 25 Ace Awards |

Images from Tales from the Crypt, George Carlin: Doin' It Again, The Josephine Baker Story and Wimbledon.

**1 FINANCIAL HIGHLIGHTS**

| (in millions) | 1990 | 1989 |
|---|---|---|
| Revenues | $1,266 | $1,177 |
| EBITDA | $ 182 | $ 166 |

**2 OPERATING MARGIN IMPROVEMENT**

1986 ·········· 13.6%
1990 ·········· 14.4%

3  Despite burgeoning choices for TV viewers, HBO's viewing levels increased 5% on a 24-hour basis over the last five years, consistently generating the highest ratings of any cable channel. In contrast, 24-hour viewing levels for the three major broadcast network affiliates have dropped 20% over the past five years.

**4 SUBSCRIBERS**

| (in millions) | 1990 | 89 | 88 | 87 | 86 |
|---|---|---|---|---|---|
| HBO | 17.6 | 17.3 | 17.0 | 15.9 | 15.0 |
| Cinemax | 6.3 | 6.4 | 6.0 | 5.1 | 4.2 |
| Total | 23.9 | 23.7 | 23.0 | 21.0 | 19.2 |

## HBO

In 1990 Home Box Office Inc. turned in another record performance, posting a healthy 10% increase in EBITDA.

Annual Report
TYPOGRAPHY/DESIGN  Kent Hunter and Ruth Diener, New York, New York
TYPOGRAPHIC SOURCE  In-house
AGENCY  Frankfurt Gips Balkind
CLIENT  Time Warner, Inc.
PRINCIPAL TYPES  Garamond No. 3 and Franklin Gothic
DIMENSIONS  9 x 11 in. (22.9 x 27.9 cm)

In 1989, following an international search for a director and chief executive officer, the Museum of Contemporary Art succeeded in bringing Kevin E. Consey from a highly successful six-year tenure as director of the Newport Harbor Art Museum in Newport Beach, California. At Newport Harbor, Mr. Consey managed a $50-million building project for which the architect was Renzo Piano, one of the designers of the Centre Georges Pompidou in Paris. ✳ Prior to invigorating the Los Angeles art community, Mr. Consey directed a successful expansion and renovation of the San Antonio Museum of Art in Texas. ✳ Combine this experience with an exemplary list of professional credentials, including magna cum laude graduation from New York's Hofstra University and a Master of Museum Practice/Master of Arts degree from the University of Michigan, plus numerous teaching positions, and you have one of the most dynamic and visionary young directors in the contemporary art field. ✳ Jerome H. Stone, chairman of the Chicago

### CONSEY STRENGTHENS THE MCA

Contemporary Campaign and deputy chairman of the MCA board, says "Kevin Consey has an unusual combination of art expertise and business acumen that makes him almost a test-tube choice for the MCA." ✳ MCA board chairman Paul W. Oliver-Hoffmann describes Consey as "one of the new generation of museum directors, combining uncompromising artistic vision with exceptional management skills." ✳ Returning the compliments, Consey says, "This is one of the most coveted museum directorships to open in the last decade. It's an honor to be asked to assume a leadership role in a city with such fabled private collections and vibrant cultural life. I, along with the staff, trustees, and volunteers, look forward to creating what may be the nation's most exciting museum in the 1990s. I've been greatly impressed by the unified enthusiasm and passions of our trustees and of everyone connected with the museum. I've never seen this kind of devotion. I have no doubt we can accomplish our goals, ambitious as they may be."

[8]

contemporary art into the lives of thousands of students, teachers and seniors.

Exhibition-related education will be user-friendly, encouraging exploration and questioning. It will take the form of printed gallery guides and catalogues prepared for all major exhibitions, as well as docent-led gallery talks, artist talks, portable audio aids, lectures, orientation videos, and didactic wall signs. Interactive, hands-on activities for children will encourage them to become personally involved with the art on display and with various media used in creating contemporary art.

The auditorium will represent one of the MCA's most flexible facilities, serving art enthusiasts of all ages and interests through a variety of media. Many newcomers to the museum will be attracted by events taking place in the auditorium. These will include films, lectures, slide shows, seminars and conferences, as well as performing arts, poetry readings, concerts, and video and mixed media presentations.

Support Facilities

A special Orientation Room will serve to prepare students for what they are about to experience prior to their entrance into the exhibition area. Classrooms with lab space will also be available for experiential learning. A Special Event space will be equipped with full catering accommodations for members' parties, receptions, benefits, exhibition openings, conferences, and educational events. A Cafe with a view of the lake and sculpture garden will seat approximately 125 people. The Museum Store will include a gift shop, children's store, media center and greatly expanded art books section. The Library will set the standard for contemporary art libraries by offering information on all aspects of the subject and making it available through media such as slides, video-tapes, photographs, recordings, computerized storage and retrieval systems.

« **Now** is the time for the MCA's building to join the other major structures that have been added to the skyline in recent years. A new contemporary art museum will make Chicago a more attractive place to **live.** »

[9]

Brochure
TYPOGRAPHY/DESIGN  Susan Hochbaum, New York, New York
TYPOGRAPHIC SOURCES  In-house and Bembo Typographers
STUDIO  Pentagram Design
CLIENT  Museum of Contemporary Art/Chicago
PRINCIPAL TYPES  Bodoni and handlettering
DIMENSIONS  6 x 9 in. (15.2 x 22.9 cm)

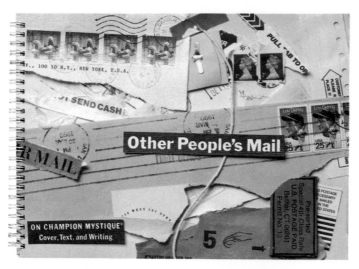

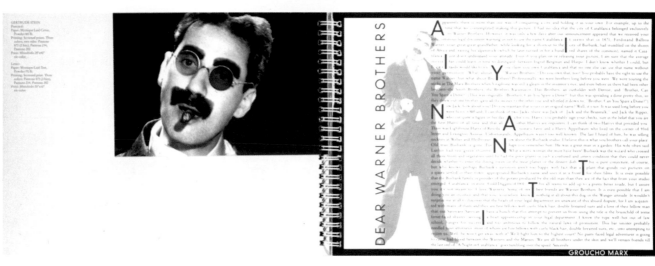

Brochure
TYPOGRAPHY/DESIGN  Paula Scher, New York, New York
LETTERERS  Paula Scher and Ron Louie
TYPOGRAPHIC SOURCES  Various
STUDIO  Pentagram Design
CLIENT  Champion International
PRINCIPAL TYPES  Various
DIMENSIONS  8½ x 11 in. (21.6 x 27.9 cm)

**BROADLY CLA**
**3 main paper**
**writing pap**
**paper, wrap**

**IT'S A GOOD EXCUSE**
**to see what's new in**
**the paper industry.**

**B**

**Good**

Brochure
TYPOGRAPHY/DESIGN Daniel Olson and Charles S. Anderson, Minneapolis, Minnesota
TYPOGRAPHIC SOURCE Linotypographers, Fort Worth, Texas
STUDIO Charles S. Anderson Design Company
CLIENT Barber-Ellis Fine Papers
PRINCIPAL TYPE 20th Century
DIMENSIONS 9¼ x 5½ in. (23.5 x 14 cm)

century while the printer was still alive, but most of the imitations were less inspired and more mechanically rigid than the originals. For example, whereas the Bodoni serif in the capitals was of the same weight as the thin stroke but joined with a very slight fillet (bracket) and the lowercase serifs were slightly concave, copies cut by his French rivals, the Didots, featured straight-edged serifs that were unbracketed.

Following Bodoni's death in 1813, his widow continued the printing office, producing the great two-volume *Manuale Tipografico* in 1818. This work is rightly considered among the finest specimen books ever produced. In 1842 the Bodoni punches and matrices were sold and placed in the Biblioteca Palatina in Parma; though the library was bombed in 1944, the punches and matrices had fortunately already been moved to a monastery south of the city.

Although Giambattista Bodoni would probably not willingly claim fatherhood to most of the types currently bearing his name, he would certainly find no fault in still being a household word in the printer's craft two centuries after he began his venture in Parma.

## ITC BODONI

### An Old Tradition With New Technology

Throughout history typeface designers have paid homage to earlier work by incorporating the style and spirit of past masterworks in their designs. Claude Garamond embodied much of the spirit of Francesco Griffo's designs in the type he created. Robert Granjon, in turn, revived the work of Garamond; and the 16th century types attributed to Christopher Plantin echo Granjon's stylistic refrain.

The type of Giambattista Bodoni has been no exception to this tradition. His fonts were certainly worth emulating; few practitioners of our craft put as much thought, care, and artistic excellence into their work.

Bodoni cut so many typefaces, and in so many sizes, that choosing a design master to work from becomes exceptionally problematic. Even among experts there is disagreement over which is the best foundation for a proper revival of Bodoni's work.

Then there is the issue of how to accurately represent Bodoni's incredibly rich stylistic palette. Much of the strength and power of Bodoni's printing is a result of his ability to use the absolutely optimum design for any given application. A Bodoni title page of twelve lines would almost always employ at least twelve different typeface designs which could differ subtly in size, weight, or proportion. If Bodoni wanted to use the equivalent of a present-day 7½ point font, he had that type at his fingertips. If he wanted something of just slightly condensed proportions, or a font minutely lighter than he was using in other lines, he had these also.

Anyone attempting to reissue Bodoni's type soon became painfully aware that it was virtually impossible to create a commercially viable product that would also satisfy the stylistic demands of a proper Bodoni revival.

12

13

|  |  |
|---|---|
|  | Book |
| TYPOGRAPHY/DESIGN | Jerry Kelly, New York, New York |
| TYPOGRAPHIC SOURCES | Stinehour Press; Darrell Hyder, Printer; and Bembo Typographers |
| STUDIO | Stinehour Press |
| CLIENT | International Typeface Corporation |
| PRINCIPAL TYPES | Bauer Bodoni, Monotype Bodoni, and Linotype Bodoni |
| DIMENSIONS | 8⅝ x 12¼ in. (21.9 x 31.1 cm) |

EVERY ART DIRECTOR
NEEDS HER OWN
TYPEFACE

EVERY ART DIRECTOR
NEEDS HIS OWN
TYPEFACE

The good news is that this same technology puts the tools of typeface manufacturing into the hands of type designers. Commissioning a new typeface, once the exclusive province of large foundries, is now a viable alternative for art directors seeking to create a distinctive identity through type. And since the commission of a new design is a one-time expense which leads to smaller typesetting bills, in many cases it pays for itself.

GRAZIA BODONI · Publication designer Roger Black commissioned this new cut of Bodoni for his redesign of the Italian fashion magazine Grazia. Based closely on the original types of Giambattista Bodoni, the font was completed on February 26, 1990—Bodoni's 250th birthday.

|  |  |
|---|---|
|  | Brochure |
| TYPOGRAPHY/DESIGN | Jonathan Hoefler, New York, New York |
| TYPOGRAPHIC SOURCE | In-house |
| STUDIO | The Hoefler Type Foundry |
| CLIENT | The Hoefler Type Foundry |
| PRINCIPAL TYPE | Hoefler Text |
| DIMENSIONS | 6 x 9 in. (15.2 x 22.9 cm) |

from the Face of the Earth, is the Concern of every Man to whom Nature hath given the Power of feeling; of which Class, regardless of Party Censure, is the A U T H O R.

P.S. The Publication of this new Edition hath been delayed, with a View of taking notice (had it been necessary) of any Attempt to refute the Doctrine of Independence: As no Answer hath yet appeared, it is now presumed that none will, the Time needful for getting such a Performance ready for the Public being considerably past.

Who the Author of this Production is, is wholly unnecessary to the Public, as the Object for Attention is the *Doctrine itself*, not the *Man*. Yet it may not be unnecessary to say, That he is unconnected with any Party, and under no sort of Influence public or private, but the influence of reason and principle.

*Philadelphia, February 14, 1776.*

Some writers have so confounded society with government, as to leave little or no distinction between them; whereas they are not only different, but have different origins. Society is produced by our wants, and government by our wickedness; the former promotes our happiness *positively* by uniting our affections, the latter *negatively* by restraining our vices. The one encourages intercourse, the other creates distinctions. The first is a pattern, the last a punisher.

Society in every state is a blessing, but government even in its best state is but a necessary evil; in its worst state an intolerable one; for when we suffer, or are exposed to the same miseries *by a government*, which we might expect in a country *without government*, our calamities is heightened by reflecting that we furnish the means by which we suffer. Government, like dress, is the badge of lost innocence; the palaces of kings are built on the ruins of the bowers of paradise. For were the impulses of conscience clear, uniform, and irresistibly obeyed, man would need no other lawgiver; but that not being the case, he finds it necessary to surrender up a part of his property to furnish means for the protection of the rest; and this he is induced to do by the same prudence which in every other case advises him out of two evils to choose the least. *Wherefore,* security being the true design and end of government, it unanswerably follows that whatever *form* thereof appears most likely to ensure it to us, with the least expense and greatest benefit, is preferable to all others.

In order to gain a clear and just idea of the design and end of government, let us suppose a small number of persons settled in some

OF THE
ORIGIN AND
DESIGN OF
GOVERNMENT
IN GENERAL
WITH CONCISE
REMARKS ON
THE ENGLISH
CONSTITUTION

——— 3

Book
TYPOGRAPHY/DESIGN Kevin B. Kuester and Brent Marmo, Minneapolis, Minnesota
TYPOGRAPHIC SOURCE Typography Plus, Dallas, Texas
STUDIO The Kuester Group
CLIENT Heritage Press, Dallas, Texas
PRINCIPAL TYPES Goudy Roman and Goudy Italic
DIMENSIONS 6¼ x 8⁵⁄₁₆ in. (15.9 x 21.1 cm)

chemistry. The endowment will ensure future maintenance and improvements. ∞ Cooper Union also received a $750,000 grant from the Howard Hughes Medical Institute for biomedical scholarship, enabling the College to continue focusing engineering research around solving problems of urgent human and social concern. ∞ While the College fortifies its financial base, it continues to receive widespread recognition as one of the nation's premier institutions of higher learning. In late 1990, *Money Magazine* designated the College as the nation's best value in education. In 1991, the magazine ranked the College "in a class by itself." ∞ In 1990, *U.S. News & World Report* placed Cooper Union third among the most competitive specialty engineering schools in the United States, describing it also as the most selective in student admissions. In 1991, the same ranking moved Cooper Union's School of Engineering up to number two in the nation. ∞ Engineering students accepted during 1990-1991 for the current academic year had the highest mean ever in SAT scores. While other schools struggle with a shrinking pool of applicants, School of Engineering applications increased by 14 percent, and the number of accepted students who chose to come to Cooper Union rose from 53 to 56 percent. This pattern stands in marked contrast to a national trend of declining admissions yields amongst universities. ∞ This year, of the prospective freshmen accepted to the Irwin S. Chanin School of Architecture, 92 percent enrolled. Recognized as one of the finest architectural institutions in the world, the School also achieved a highly successful reaccreditation in 1991. ∞ Applications to the School of Art increased by 19 percent, and a remarkable 96 percent of those admitted elected to enroll. Concurrently, the School of Art has begun an extensive review of its space requirements and of its unique generalist program. Cooper's Faculty of Humanities and Social S...

refurbished offices, including spaces for seminars, conferences and electronically supported language instruction. ∞ Dramatic technological advances and social changes worldwide presage new vistas of learning.[3] In the 200th year of the founder's birth, Cooper Union's investment of additional financial resources underscored its determination to keep pace with expanding frontiers of scholarship. ∞ In order to respond to

[3] CHANGING POPULATION, CONSISTENT MISSION

The Cooper Union this year has one of the highest proportions ever of freshman students born outside the United States: 47 percent, representing 42 countries.

Disparate as their origins may be, these students share some startling similarities. Most are among the first generation of their families to go to college. They have learned English as a second language, but they do not speak English at home or often in their neighborhood.

"The ethnic makeup of the United States and of the college-age population is changing rapidly," noted Richard Bory, dean of admissions and records. "Our admissions statistics reflect those dramatic demographic shifts; what's happening here at Cooper is a microcosm of New York City and part of the national phenomenon.

"With remarkable consistency, our undergraduate profiles show that Cooper Union is still very true to its original mission to welcome aspiring, talented immigrant and working class young people, together with middle class students—in the founder's words, 'the boys and girls of this city who had no better opportunity than I.'"

The College's recruitment efforts continue to reinforce the founder's firm commitment to merit, while broadening the geographic, social and ethnic diversity of the student body.

"The students Cooper admits have acted as their parents' translators and teachers since their arrival in this country," Bory said, "as well as being the sociological bridge between their native culture and American society.

"Our undergraduates are serious-minded, independent, strongly self-motivated and highly focused. They view themselves as Peter Cooper's trailblazers for establishing a rewarding life in this new country."

As citizens of a new America, the 1991 freshman class is also distinctive for other institutional reasons: the number of applicants and the percentage of those accepted who enrolled.

When national enrollments were declining, freshman applications to Cooper Union were up 14 percent over last year, underscoring the College's growing national visibility and appeal.

At the same time, Cooper's historic selectivity remained consistent: Of those applying, only 15 percent were accepted. Two hundred thirty-seven of those students, or 66 percent, accepted Cooper's offer. About 40 percent qualified for some form of financial aid beyond Cooper Union's full-tuition scholarships.

The Cooper Union* Annual Report 1990-91

AN ACCESSIBLE EXCELLENCE

*  THE COOPER UNION FOR THE ADVANCEMENT OF SCIENCE AND ART, established in 1859, is a private institution of higher learning where all students receive full-tuition scholarships. On the 200th anniversary of Peter Cooper's birth, his legacy continues to support degree-granting programs in Art, Architecture, and Engineering, and a tradition of public forums, cultural events, and other community activities.

| | |
|---|---|
| | Annual Report |
| TYPOGRAPHY/DESIGN | George Sadek, Charles Nix, and Mindy Lang, New York, New York |
| TYPOGRAPHIC SOURCE | In-house |
| STUDIO | The Cooper Union Center for Design and Typography |
| CLIENT | The Cooper Union |
| PRINCIPAL TYPE | Baskerville |
| DIMENSIONS | 8⅝ x 11½ in. (21.9 x 29.2 cm) |

F

VOLVME I. NVMBER II ∼ SEPTEMBER 1991

O

A s the Architecture and Design Forum begins its third-year, we are pleased with our accomplishments and look to the future with great expectation. ¶ Through Forum programs we have encouraged our members to develop a deeper understanding of architecture and design—its past, present, and future. We have made steps to learn about the Bay Area community of architects and designers. We have visited some of our professional members in their offices to see their work and share their vision; we have toured Los Angeles with some of the most respected and recognized architects and designers; and last year we launched the Department of Architecture and Design's first blockbuster show, *Visionary San Francisco*. ¶ Most importantly, because of your financial support through membership dues, we have made possible the addition of important works to the Museum's permanent collection,

R

including the Charles and Ray Eames

Room. We hope to continue this support

of the Department's acquisition program.

In addition, the Architecture and Design

Forum helped sponsor the exhibition

*Geological Architecture: The Work of*

*Stanley Saitowitz.*

Our future looks even more exciting.

We are planning more visits to local

offices, a trip to San Diego, and a very

special tour of Japan in April of 1992.

We will continue our support of the

architecture and design exhibition pro-

gram with a major gift for the upcom-

ing show *In the Spirit of Modernism*,

scheduled to open in November of this

year, which will feature the work of

*Designed by Shiro Kuramata in 1970, Side One was recently added to the architecture and design collection of the San Francisco Museum of Modern Art. Kuramata has taken a fresh look at the chest of drawers, perhaps one of the most traditional furniture themes. The cabinet escapes easy classification as furniture. In Kuramata's hands, furniture pieces become more than mere objects. They become elements of the domestic landscape, demand attention, and manifest the character of the house and its inhabitants.*

four prominent Bay Area architects.

As one of the newest additions to the

San Francisco Museum of Modern Art,

the Department of Architecture and

Design needs not only financial and

human resources, it needs friends.

That is our role. We can learn about

the Department's programs and tell

others about its acquisitions and exhi-

bitions. We can contribute our ideas

and we can make a difference.

We look forward to your continued

interest and support. Your participation

is crucial to our growth and plans

for the future.

*Mark Hornberger & Rosemary Klebahn*

*Co-Chairs, Architecture & Design Forum*

V

M

|  | Newsletter |
|---|---|
| TYPOGRAPHY/DESIGN | Mark P. Selfe, San Francisco, California |
| TYPOGRAPHIC SOURCE | Rick Binger Design |
| STUDIO | Pentagram Design |
| CLIENT | Architecture & Design Forum |
| PRINCIPAL TYPES | Bodoni and Futura |
| DIMENSIONS | 11 x 17 in. (27.9 x 43.2 cm) |

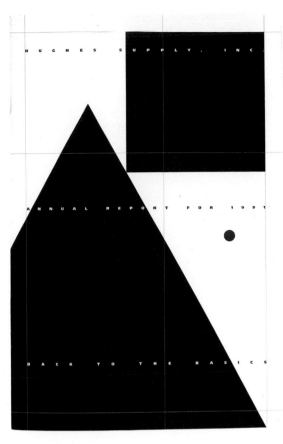

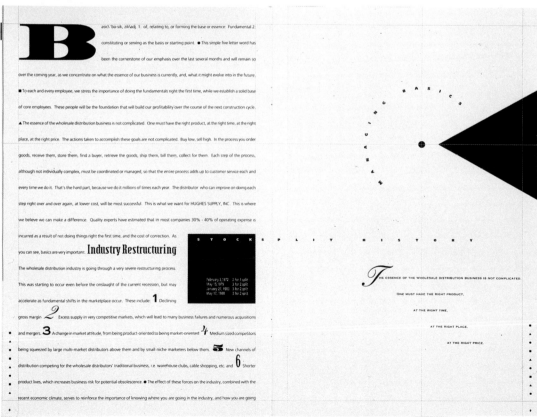

Annual Report
TYPOGRAPHY/DESIGN Alan Urban, Miami, Florida
TYPOGRAPHIC SOURCES In-house and Supertype
STUDIO Urban Taylor & Associates
CLIENT Hughes Supply, Inc.
PRINCIPAL TYPE Frutiger
DIMENSIONS 8½ x 12 in. (21.6 x 30.5 cm)

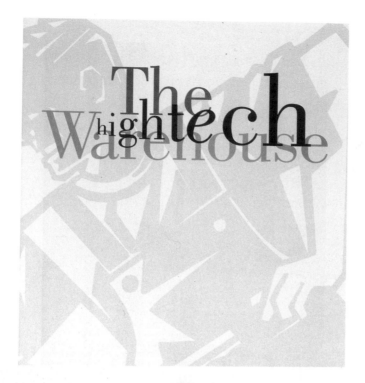

The high tech Warehouse

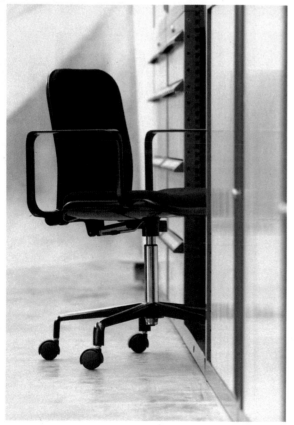

Schemmrich High Tech Warehouse

Jedem **Deutschen** stehen 22,4 Sitzgelegenheiten zur Verfügung. Das heißt allen, da ja die andern gleichzeitig nur an einem Ort sitzen können, sind jederzeit **17,02** Milliarden Möglichkeiten offen. Und nachts sogar noch ein paar **100** Millionen mehr. Es gibt eigentlich keinen Grund, einen *Stuhl* zu kaufen. **Der Markt** ist gesättigt.

Catalog

| | |
|---|---|
| TYPOGRAPHY/DESIGN | Stefan Caesar and Klaus Hesse, Düsseldorf, Germany |
| LETTERER | Stefan Caesar |
| ILLUSTRATORS | Stefan Caesar and Olaf Schulz |
| PHOTOGRAPHER | Klaus Hesse |
| TYPOGRAPHIC SOURCE | In-house |
| AGENCY | Hesse Designagentur |
| CLIENT | Schemmrich KG |
| PRINCIPAL TYPE | Bodoni |
| DIMENSIONS | 16½ x 11⅝ in. (42 x 29.7 cm) |

Annual Report
TYPOGRAPHY/DESIGN Pat and Greg Samata, Dundee, Illinois
LETTERER K. C. Yoon
TYPOGRAPHIC SOURCE In-house
STUDIO Samata Associates
CLIENT Gendex Corporation
PRINCIPAL TYPES Univers Condensed Light, Univers Black, and
Univers Thin Ultra Condensed
DIMENSIONS 7³⁄₄ x 12 in. (19.7 x 30.5 cm)

INDUSTRIALDESIGNMETALSINTERIORDESIGN

Cleveland Institute of Art

A Professional College of Art and Design

Students and teachers come together here to form a community of
artists working on their own, yet together.

At other institutions, drawing is treated as a preliminary tool for other areas of study and
not as an area of study in itself. That is not the case here.

Drawing majors master all aspects of the medium and use them to convey their ideas.
While their work in the foundation years is based on the classical means all artists must
understand – working from a model, anatomy, a perspective – the major uses this
vocabulary in innovative and personal ways. Instead of the charcoal chalks and inks of the
first years, students use unconventional materials. Majors also learn various processes of
papermaking, which increase the possibilities for innovation and personalization.

By the fifth year, students have their own studios and they define their own tasks. Here,
the work atmosphere and intensity is comparable to what you'll find in most master's
degree programs. In fact, many of our students who apply to graduate school are awarded
stipends or assistantships. Also, drawing majors may apply to painting, sculpture and
design programs and their career choices are vast. Using their electives, they can pursue
commercial art and work at graphic design studios. Of course, many work as professional
fine artists.

Catalog
TYPOGRAPHY/DESIGN   Joyce Nesnadny and Ruth D'Emilia, Cleveland, Ohio
TYPOGRAPHIC SOURCE   TSI: Typesetting Service, Inc.
STUDIO   Nesnadny & Schwartz
CLIENT   Cleveland Institute of Art
PRINCIPAL TYPE   Garamond
DIMENSIONS   10 x 8½ in. (25.4 x 21.6 cm)

noname
noname
noname

1 91

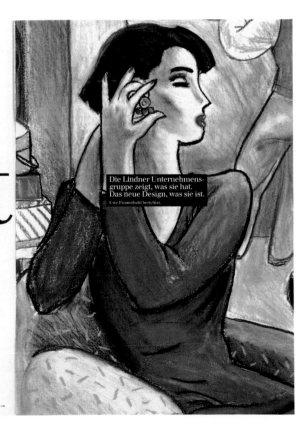

Titelstory

Die meisten Menschen erkennen heute die Marke eines Autos an seiner Linienführung und die Geschmacksrichtung einer Schokolade an der Farbe ihrer Verpackung. Worauf wir beim Autohändler und im Supermarkt achten, nehmen wir bei Dienstleistungsunternehmen ebenso wichtig.

Denn das Gesicht von Produkten und Dienstleistungen entscheidet in zunehmendem Maße über ihre Ausstrah-

# Nur der Schein trügt nicht

hung und ihren Charakter. Letztendlich über ihre Glaubwürdigkeit. Und das gilt nicht nur für Persil, Marlboro oder die Deutsche Bank, sondern auch für mittelständische Firmen wie die Lindner Unternehmensgruppe.

Ob es sich um Gäste, Besucher, Kunden oder Geschäftspartner handelt, sie alle suchen nach „emotionalen Haltepunkten", suchen Wiedererkennung und Individualität.

Ein unverwechselbarer Firmenauftritt durch ein einheitliches Unternehmensbild (Corporate Design) ist kein Luxus, sondern ein wesentlicher Wettbewerbsfaktor, der über Erfolg oder Mißerfolg mitentscheiden kann.

Die Lindner Unternehmensgruppe zeigt, was sie hat. Das neue Design, was sie ist.
Uwe Frommhold berichtet.

Magazine
TYPOGRAPHY/DESIGN  Stefan Nowak, Christine and Klaus Hesse, Düsseldorf, Germany
LETTERER  Stefan Nowak
ILLUSTRATORS  Javier de Juan and Stefan Nowak
TYPOGRAPHIC SOURCE  In-house
AGENCY  Hesse Designagentur
CLIENT  Lindner Unternehmensgruppe
PRINCIPAL TYPES  Walbaum and Frutiger
DIMENSIONS  13⅓ x 9½ in. (33.8 x 24 cm)

Advertisement
TYPOGRAPHY/DESIGN  Debi Young Mees and Neill Fox, Phoenix, Arizona
PHOTOGRAPHER  Rick Gayle
TYPOGRAPHIC SOURCE  In-house
STUDIO  Richardson or Richardson
CLIENT  The Gayle Studio
PRINCIPAL TYPES  Copperplate 33BC, Bodoni Bold, and Liberty
DIMENSIONS  8 x 11⅜ in. (20.3 x 28.3 cm)

96

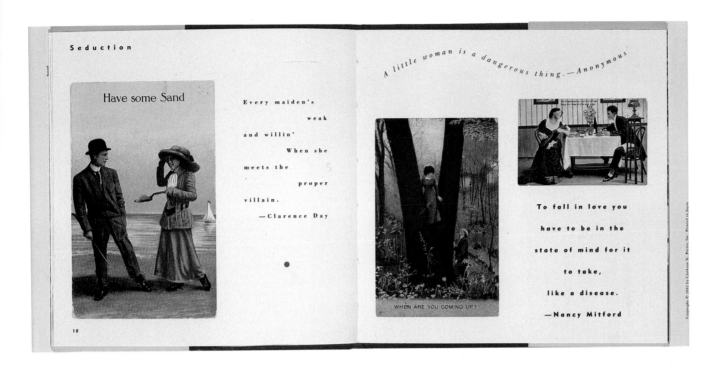

Book
TYPOGRAPHY/DESIGN Adriane Stark, New York, New York
TYPOGRAPHIC SOURCE U.S. Lithograph, typographers
STUDIO Stark Design Associates
CLIENT Clarkson N. Potter, Inc. Publishers
PRINCIPAL TYPES Bodoni, Franklin Gothic, and Metroblack No. 2
DIMENSIONS 7 x 7 in. (17.8 x 17.8 cm)

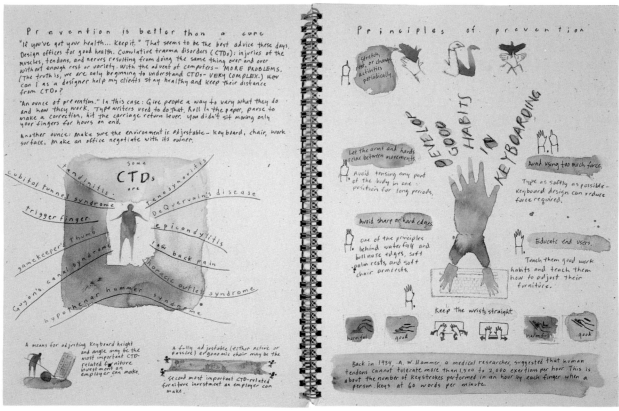

Brochure

TYPOGRAPHY/DESIGN Linda Powell, Holland, Michigan
LETTERER Linda Nelson, Grand Rapids, Michigan
TYPOGRAPHIC SOURCE Electronic Publishing Company
CLIENT Herman Miller, Inc.
PRINCIPAL TYPE Helvetica
DIMENSIONS 8½ x 11 in. (21.6 x 27.9 cm)

Sometimes energy is not readily available, because the supply of a particular resource is limited or because its price is too high. When this happens, companies often decrease their production of goods and services, at least temporarily. On the other hand, an increase in the availability of energy — or lower energy prices — can lead to increased economic output by business and industry.

Situations that cause energy prices to rise or fall rapidly and unexpectedly, as the world's oil prices have on several occasions in recent years, can have a significant impact on the economy. When these situations occur, the economy experiences what economists call a "price shock."

### Past experience with energy price shocks.
▲

Since 1970, the economy has experienced four such energy price shocks. Three of these resulted from political events that restricted the availability of oil from Middle Eastern countries.

In 1973, for example, the Organization of Petroleum Exporting Countries (OPEC) initiated an embargo on supplies of oil from Arab countries. By early 1974, oil prices had quadrupled, and the world's industrialized countries entered the most severe economic decline since the Great Depression of the 1930s.

Similarly, the Iranian revolution in 1979 and the onset of the Iran-Iraq war reduced oil production in the Middle East. Oil prices rose again, and the U.S. economy experienced another recessionary period.

▲

In 1985, however, a different type of price shock occurred. Following a period of several years when OPEC had maintained oil prices at artificially high levels, the world experienced a steep decline in oil prices. This provided a general boost to the economy, except in those areas that were heavily dependent on oil as a source of income.

More recently, the events surrounding Iraq's invasion of Kuwait in 1990 caused a disruption of oil supplies from the Middle East, as well as a rise in prices, and another economic slowdown resulted.

### How energy price shocks affect the economy.
▲

The events of the past several decades demonstrate that the price and availability of a single important energy resource — such as oil — can significantly affect the world economy. But why does this happen?

Consider the effects of a significant increase in the price of oil. When oil prices rise, companies have less of an incentive to manufacture products using production methods that rely on oil as the primary fuel. Companies may search

Brochure
TYPOGRAPHY/DESIGN  Scott Paramski, Dallas, Texas
LETTERER  Mary Lynn Blasutta
TYPOGRAPHIC SOURCE  In-house
AGENCY  Meltzer & Martin
STUDIO  Peterson & Company
CLIENT  Federal Reserves
PRINCIPAL TYPES  Gill Sans and Times Roman
DIMENSIONS  11 x 8½ in. (27.9 x 21.6 cm)

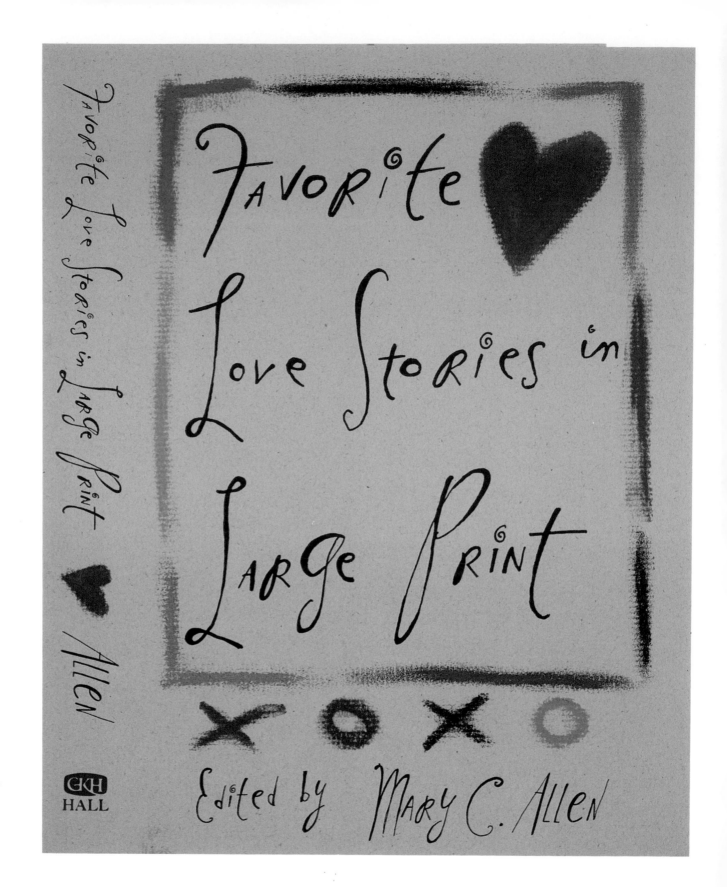

Book Cover

TYPOGRAPHY/DESIGN Linda Scharf and Barbara Anderson, Boston, Massachusetts
CALLIGRAPHER Linda Scharf
STUDIO Linda Scharf Illustration
CLIENT G. K. Hall
PRINCIPAL TYPE Handlettering
DIMENSIONS 6½ x 9½ in. (16.5 x 24.1 cm)

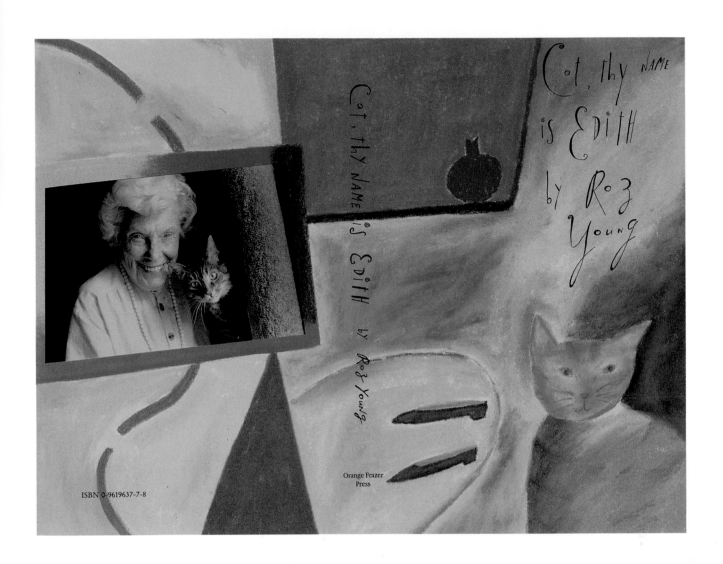

Book Cover

TYPOGRAPHY/DESIGN Linda Scharf and John Baskin, Boston, Massachusetts
CALLIGRAPHER Linda Scharf
STUDIO Linda Scharf Illustration
CLIENT Orange Frazer Press
PRINCIPAL TYPE Handlettering
DIMENSIONS 13½ x 10¼ in. (34.3 x 26 cm)

Book
TYPOGRAPHY/DESIGN  Elsi Vassdal Ellis, Bellingham, Washington
TYPOGRAPHIC SOURCE  In-house
CLIENT  EVE Press
PRINCIPAL TYPES  Various
DIMENSIONS  6 x 4 in. (15.2 x 10.2 cm)

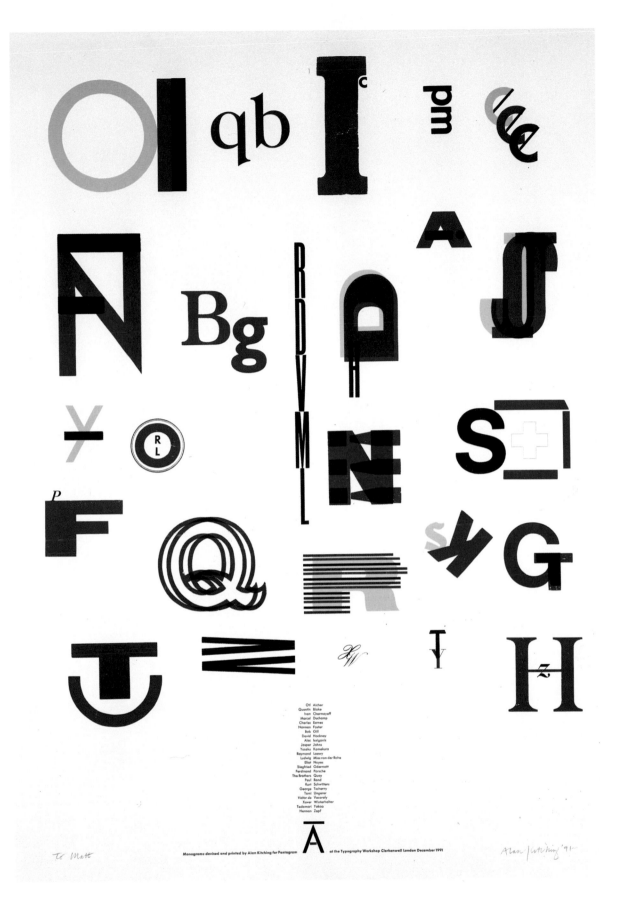

Poster

TYPOGRAPHY/DESIGN  Alan Kitching, London, England
TYPOGRAPHIC SOURCE  The Typography Workshop collection
STUDIO  The Typography Workshop
CLIENT  Pentagram Design, Ltd.
PRINCIPAL TYPE  Wood letter (letterpress)
DIMENSIONS  21 x 29¾ in. (53.3 x 75.6 cm)

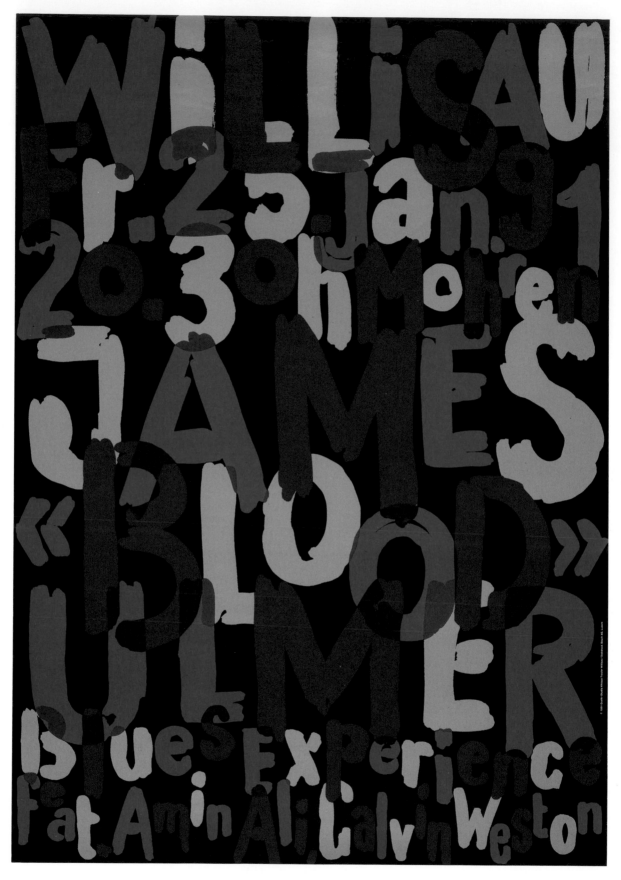

Poster

TYPOGRAPHY/DESIGN Niklaus Troxler, Willisau, Switzerland
CALLIGRAPHER Niklaus Troxler
STUDIO Niklaus Troxler Grafik-Studio
CLIENT Jazz in Willisau
PRINCIPAL TYPE Handlettering
DIMENSIONS 35¾ x 50⅜ in. (90.8 x 128 cm)

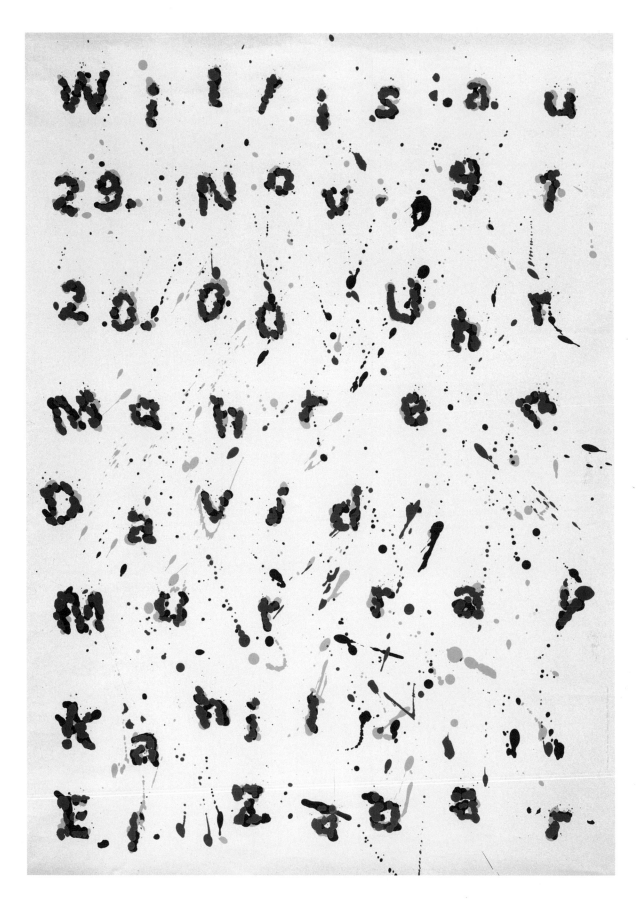

Poster

TYPOGRAPHY/DESIGN Niklaus Troxler, Willisau, Switzerland
CALLIGRAPHER Niklaus Troxler
STUDIO Niklaus Troxler Grafik-Studio
CLIENT Jazz in Willisau
PRINCIPAL TYPE Handlettering
DIMENSIONS 35⅝ x 50⅜ in. (90.5 x 128 cm)

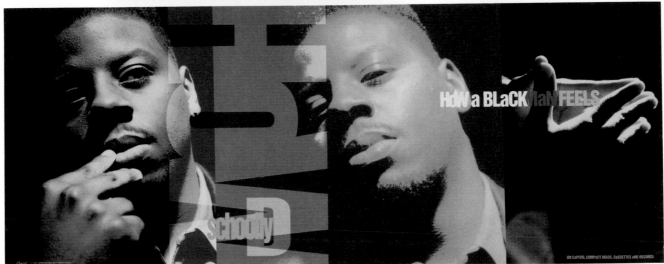

Campaign
TYPOGRAPHY/DESIGN  Heather van Haaften, Hollywood, California
LETTERER  Heather van Haaften
TYPOGRAPHIC SOURCE  In-house
STUDIO  Capitol Records Art Department
CLIENTS  Schoolly D and Capitol Records
PRINCIPAL TYPE  Helvetica Inserat (modified)
DIMENSIONS  Various

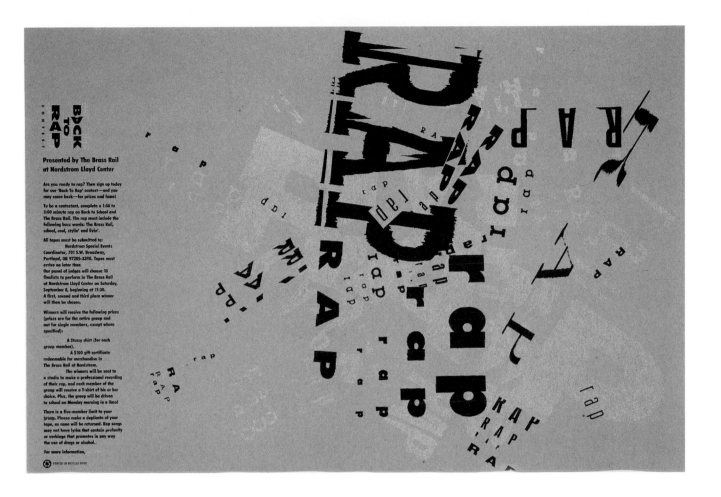

Poster
TYPOGRAPHY/DESIGN  Ken Shafer, Seattle, Washington
LETTERER  Ken Shafer
TYPOGRAPHIC SOURCE  Nordstrom Advertising Typography
STUDIO  Ken Shafer Design
CLIENT  Nordstrom
PRINCIPAL TYPE  Futura
DIMENSIONS  12 x 18 in. (30.5 x 45.7 cm)

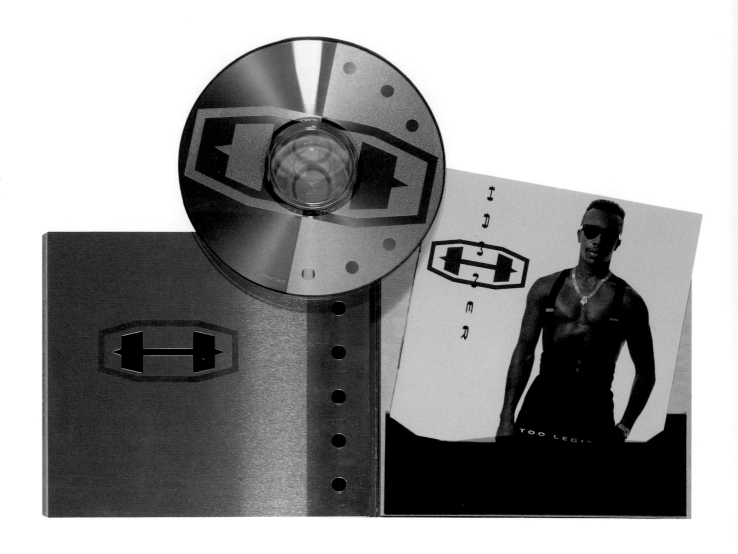

Packaging
TYPOGRAPHY/DESIGN Stephen Walker, Hollywood, California
LETTERER Stephen Walker
TYPOGRAPHIC SOURCE In-house
STUDIO Capitol Records Art Department
CLIENT Capitol Records
PRINCIPAL TYPES Futura, Matrix, and handlettering
DIMENSIONS 5⅝ x 4¹⁵⁄₁₆ in. (14.3 x 12.5 cm)

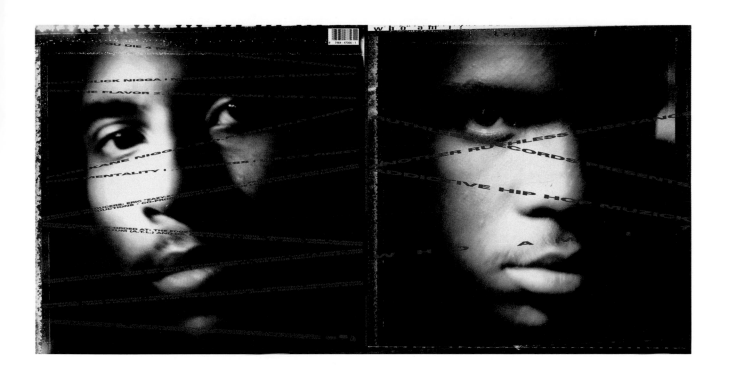

Record Album Cover

TYPOGRAPHY/DESIGN  Mary Maurer, Los Angeles, California

TYPOGRAPHIC SOURCE  Susan Leary Typography

STUDIO  Sony Music

CLIENT  Ruthless/Epic

PRINCIPAL TYPE  Akzidenz Grotesk Bold Extended

DIMENSIONS  12½ x 25 in. (31.8 x 63.5 cm)

# IMAGINE IF SADDAM HUSSEIN WERE A TYPEFACE:

# FUTURA EXTRA BOLD CONDENSED: THE MOTHER OF ALL TYPEFACES.

It's time for Art Directors the world over to boycott the use of Futura Extra Bold Condensed—the most over-used typeface in advertising history. Destroy the Great Satan of clichés and the Little Satan of naked convenience, and rally to the cause of better type selection.

Please fill out the enclosed petition and mail it to our headquarters. It will be used to sway the opinion-makers of our industry toward our just and worthy cause. Together, we can whip this mother.

**ART DIRECTORS AGAINST FUTURA EXTRA BOLD CONDENSED.**

|  |  |
|---|---|
| | Brochure |
| TYPOGRAPHY/DESIGN | Jerry Ketel, Portland, Oregon |
| TYPOGRAPHIC SOURCE | In-house |
| AGENCY | Bang Bang Bang |
| CLIENT | Art Directors Against Futura Extra Bold Condensed |
| PRINCIPAL TYPES | Futura Extra Bold Condensed and Adobe Garamond |
| DIMENSIONS | 8½ x 11 in. (21.6 x 27.9 cm) |

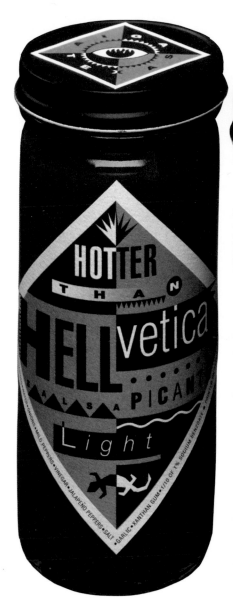
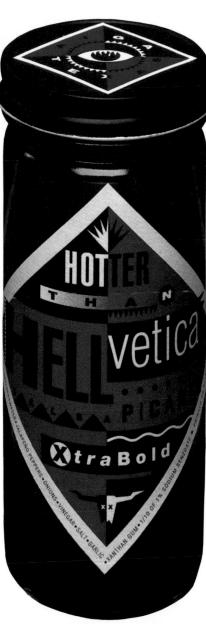
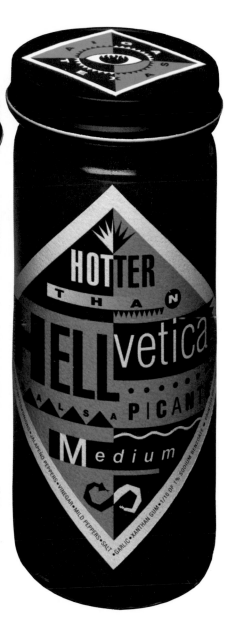

Packaging
TYPOGRAPHY/DESIGN David Kampa, Austin, Texas
TYPOGRAPHIC SOURCE R. J. L. Graphics
STUDIO Kampa Design
CLIENT American Institute of Graphic Arts/Texas
PRINCIPAL TYPE Helvetica
DIMENSIONS 5⁷/₁₆ x 2³/₈ in. (13.8 x 6 cm)

Sold on

He's being touted as the Elvis of rap: Can 5 million Vanilla Ice fans be wrong?

By David Handelman ← Photographs by Andrew Eccles

Magazine Spread

TYPOGRAPHY/DESIGN   Debra Bishop, New York, New York
LETTERER   Anita Karl, Brooklyn, New York
ART DIRECTOR   Fred Woodward
TYPOGRAPHIC SOURCE   In-house
CLIENT   Rolling Stone
PRINCIPAL TYPE   Latin Extended
DIMENSIONS   12 x 20 in. (30.5 x 50.8 cm)

112

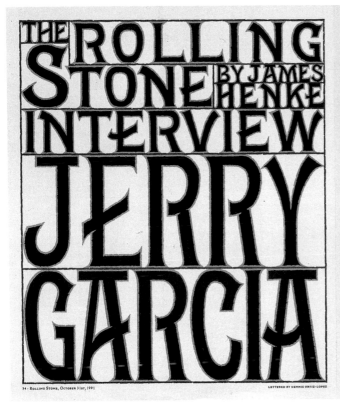

THE ROLLING STONE INTERVIEW
BY JAMES HENKE

JERRY GARCIA

34 · ROLLING STONE, OCTOBER 31st, 1991    LETTERED BY DENNIS ORTIZ-LOPEZ

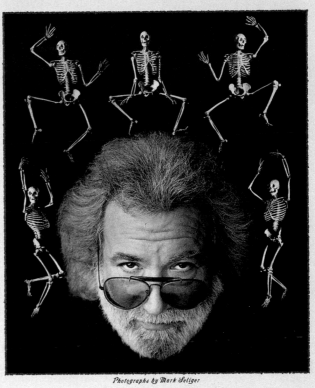

*Photographs by Mark Seliger*

Magazine Spread

| | |
|---|---|
| TYPOGRAPHY/DESIGN | Fred Woodward, New York, New York |
| LETTERER | Dennis Ortiz-Lopez |
| ART DIRECTOR | Fred Woodward |
| CLIENT | Rolling Stone |
| PRINCIPAL TYPE | Handlettering |
| DIMENSIONS | 12 x 20 in. (30.5 x 50.8 cm) |

Magazine Spread

| | |
|---|---|
| TYPOGRAPHY/DESIGN | Fred Woodward, New York, New York |
| CALLIGRAPHER | Henrik Drescher |
| ART DIRECTOR | Fred Woodward |
| CLIENT | Rolling Stone |
| PRINCIPAL TYPE | Handlettering |
| DIMENSIONS | 12 x 20 in. (30.5 x 50.8 cm) |

FATHER MATTHEW FOX EXTOLS THE JOYS OF PAS- THE SENSUAL CHRISTIAN SION AND LUST OVER THE SHAME OF ORIGINAL SIN BY LAWRENCE WRIGHT TRUE BELIEVERS

78 · ROLLING STONE, NOVEMBER 14TH, 1991

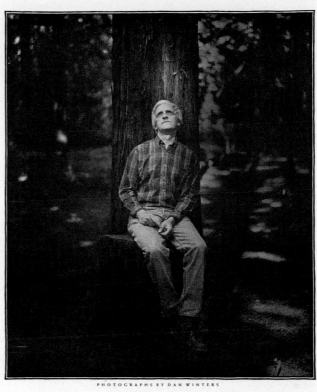

PHOTOGRAPHS BY DAN WINTERS

| | |
|---|---|
| | Magazine Spread |
| TYPOGRAPHY/DESIGN | Debra Bishop, New York, New York |
| LETTERER | Anita Karl, Brooklyn, New York |
| ART DIRECTOR | Fred Woodward |
| TYPOGRAPHIC SOURCE | Personal library |
| CLIENT | Rolling Stone |
| PRINCIPAL TYPE | Handlettering |
| DIMENSIONS | 12 x 20 in. (30.5 x 50.8 cm) |

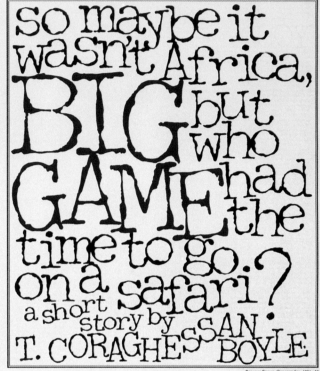

so maybe it wasn't Africa, BIG but who GAME had the time to go. on a safari? a short story by T. CORAGHESSAN BOYLE

Magazine Spread

| | |
|---|---|
| TYPOGRAPHY/DESIGN | Gail Anderson, New York, New York |
| ART DIRECTOR | Fred Woodward |
| TYPOGRAPHIC SOURCE | Personal library |
| CLIENT | Rolling Stone |
| PRINCIPAL TYPE | Typewriter |
| DIMENSIONS | 12 x 10 in. (30.5 x 25.4 cm) |

116

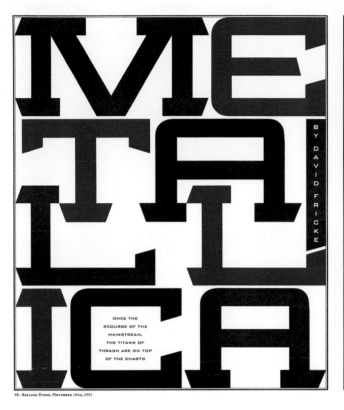

ONCE THE
SCOURGE OF THE
MAINSTREAM,
THE TITANS OF
THRASH ARE ON TOP
OF THE CHARTS

48 · ROLLING STONE, NOVEMBER 14TH, 1991

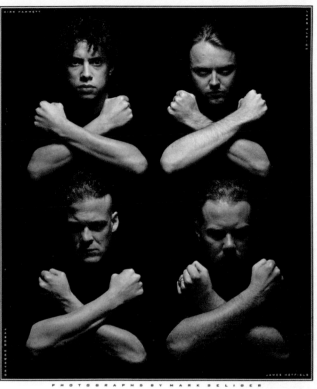

PHOTOGRAPHS BY MARK SELIGER

|  |  |
|---|---|
| | Magazine Spread |
| TYPOGRAPHY/DESIGN | Angela Skouras, New York, New York |
| LETTERER | Dennis Ortiz-Lopez |
| ART DIRECTOR | Fred Woodward |
| CLIENT | Rolling Stone |
| PRINCIPAL TYPE | Decades Gothic |
| DIMENSIONS | 12 x 20 in. (30.5 x 50.8 cm) |

117

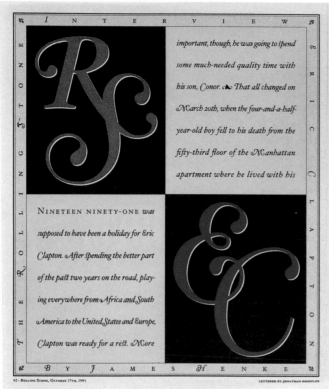

R S
E C

important, though, he was going to spend some much-needed quality time with his son, Conor. That all changed on March 20th, when the four-and-a-half-year-old boy fell to his death from the fifty-third floor of the Manhattan apartment where he lived with his

NINETEEN NINETY-ONE *was* supposed to have been a holiday for *Eric Clapton*. After spending the better part of the past two years on the road, playing everywhere from *Africa* and *South America* to the *United States* and *Europe*, *Clapton* was ready for a rest. More

THE ROLLING STONE
&ERIC CLAPTON

BY JAMES HENKE

42 · Rolling Stone, October 17th, 1991          LETTERED BY JONATHAN HOEFLER

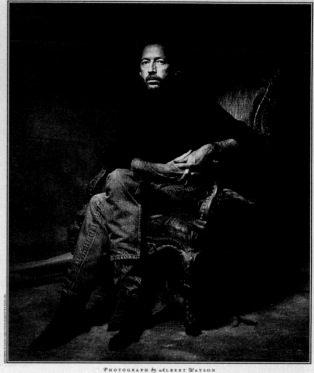

PHOTOGRAPH *by* ALBERT WATSON

Magazine Spread
TYPOGRAPHY/DESIGN  Fred Woodward, New York, New York
LETTERER  Jonathan Hoefler
ART DIRECTOR  Fred Woodward
TYPOGRAPHIC SOURCE  Jonathan Hoefler Type Foundry
CLIENT  Rolling Stone
PRINCIPAL TYPE  Hoefler Text
DIMENSIONS  12 x 20 in. (30.5 x 50.8 cm)

118

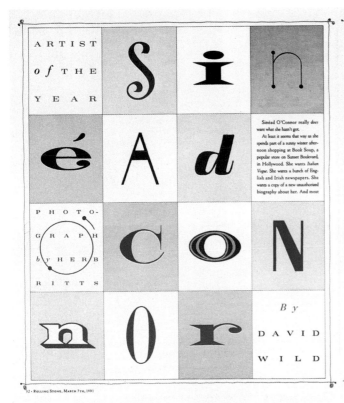

ARTIST *of* THE YEAR

Sinéad O'Connor really does want what she hasn't got.
At least it seems that way as she spends part of a sunny winter afternoon shopping at Book Soup, a popular store on Sunset Boulevard, in Hollywood. She wants *Italian Vogue*. She wants a bunch of English and Irish newspapers. She wants a copy of a new unauthorized biography about her. And most

PHOTO-GRAPH *by* HERB RITTS

*By* DAVID WILD

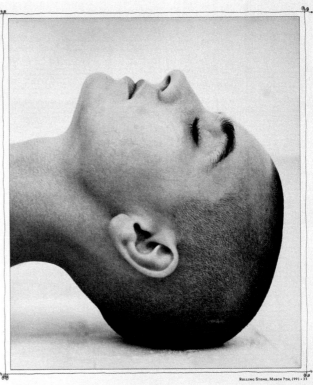

Magazine Spread
TYPOGRAPHY/DESIGN  Catherine Gilmore-Barnes, New York, New York
ART DIRECTOR  Fred Woodward
TYPOGRAPHIC SOURCES  In-house and personal library
CLIENT  Rolling Stone
PRINCIPAL TYPE  Various
DIMENSIONS  12 x 20 in. (30.5 x 50.8 cm)

119

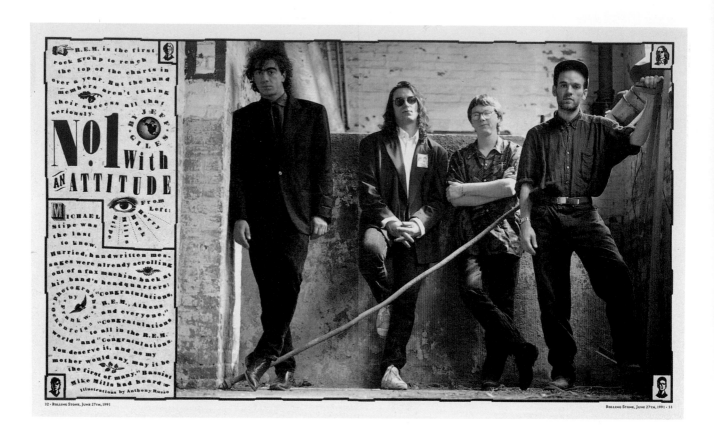

Magazine Spread

TYPOGRAPHY/DESIGN    Debra Bishop, New York, New York
ART DIRECTOR    Fred Woodward
TYPOGRAPHIC SOURCE    Personal library
CLIENT    Rolling Stone
PRINCIPAL TYPE    Roman (old wood type)
DIMENSIONS    12 x 20 in. (30.5 x 50.8 cm)

**HOW DON HEWITT KEEPS HIS RATINGS UP**

**THE 6 MINUTE**

**BY MARK HERTSGAARD**

EVERY SUNDAY NIGHT A TICK-ing stopwatch welcomes some 30 million people to another edition of *60 Minutes*, for each of the last thirteen years one of the ten most-watched shows on television. Only *I Love Lucy* (and its successor, *Here's Lucy*), with sixteen Top Ten seasons, had a longer run. Journalism that sells is, of course, not the same thing as journalism that matters, yet what has distinguished *60 Minutes* over the years is precisely how often its journalism has done both. Don Hewitt, the show's creator and exec-

utive producer, is proud of this fact: "Television says, 'You cannot be good and be popular.' I like to think we were the first broadcast to beat television at its own game." ▢ Hewitt originally conceived of *60 Minutes* as a TV version of *Life*, and looking at its old programs is much like paging through a scrapbook of the late-twentieth-century American experience. The show has acquainted viewers with a dazzling array of political leaders, shady characters, accomplished artists and amazing stories. After

**MAN**

LETTERED BY ANITA KARL.

Magazine Page
TYPOGRAPHY/DESIGN Debra Bishop, New York, New York
LETTERER Anita Karl, Brooklyn, New York
ART DIRECTOR Fred Woodward
TYPOGRAPHIC SOURCE Personal library
CLIENT Rolling Stone
PRINCIPAL TYPE Eagle Bold
DIMENSIONS 12 x 10 in. (30.5 x 25.4 cm)

121

Poster

TYPOGRAPHY/DESIGN Todd Waterbury, Minneapolis, Minnesota
TYPOGRAPHIC SOURCES Linotypographers, Fort Worth, Texas, and Great Faces
STUDIO Duffy Design Group
CLIENT Fox River Paper Company
PRINCIPAL TYPES Franklin Gothic and Venus Bold Extended
DIMENSIONS 15¾ x 23 in. (40 x 58.4 cm)

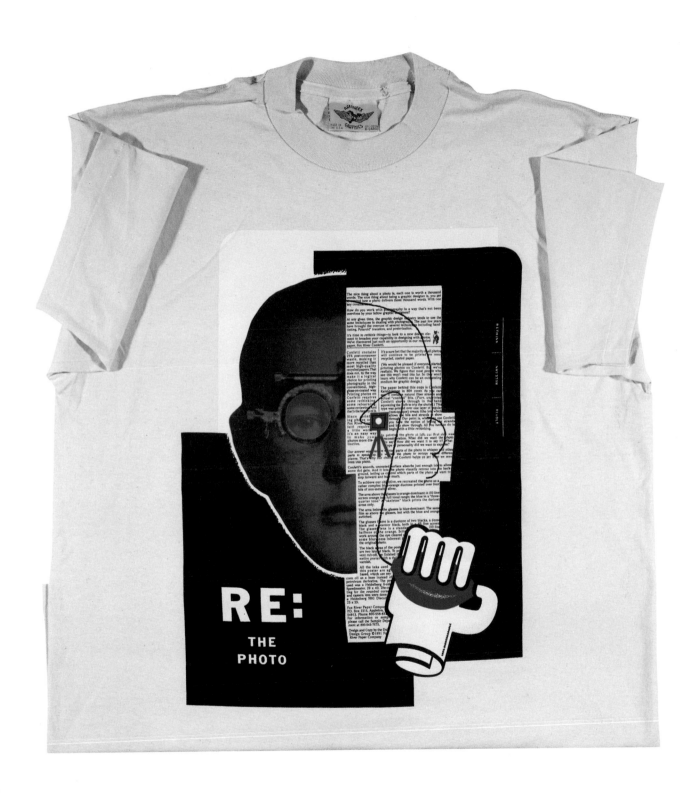

T-shirt

TYPOGRAPHY/DESIGN Todd Waterbury, Minneapolis, Minnesota
TYPOGRAPHIC SOURCES Linotypographers, Fort Worth, Texas, and Great Faces
STUDIO Duffy Design Group
CLIENT Fox River Paper Company
PRINCIPAL TYPES Franklin Gothic and Venus Bold Extended
DIMENSIONS 22 x 29 in. (55.9 x 73.6 cm)

Book
TYPOGRAPHY/DESIGN Pat and Greg Samata, Dundee, Illinois
LETTERER Jack Jacobi
TYPOGRAPHIC SOURCE In-house
STUDIO Samata Associates
CLIENT American Institute of Graphic Arts/Chicago
PRINCIPAL TYPE Copperplate
DIMENSIONS 9 x 10½ in. (22.9 x 26.7 cm)

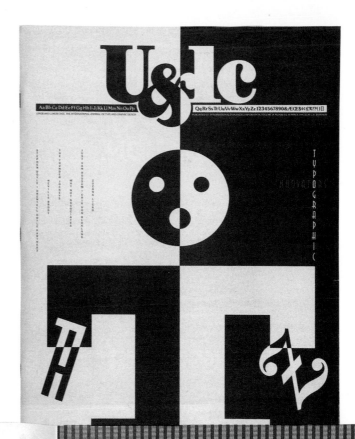

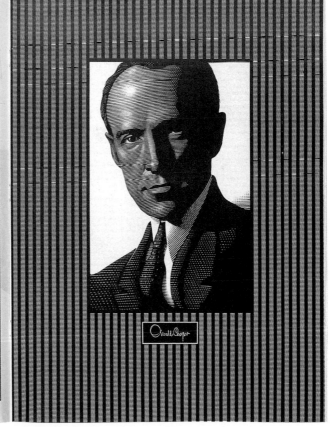

**W**hen George Jones, the distinguished type designer for Linotype back in the 1920s, came to Chicago on a business trip, he wanted to visit everything TYPOGRAPHIC MILESTONES and meet everyone who was associated with typography in that city. His guide rightly figured that a visit to a typical advertising typog- raphy studio would be of interest. The studio he chose was Bertsch & Cooper —the workplace of Oswald Cooper. & Jones' escort made some rather casual

OSW ALD COO PER

BY ALLAN HALEY   ILLUSTRATION BY MARK SUMMERS

introductions at Bertsch & Cooper prior to a half-hour tour of the business. As he left, Jones expressed thanks for the tour, but out on the street expressed deep disappointment. "But I expected to meet Mr. Cooper, the famous Mr. Oswald Cooper who designs type—where is he today?" & "Good Lord, man," his guide said, "You've been talking with him for the last half-hour!" & "Oh, I'm so dis- appointed!" Jones exclaimed. "Why didn't he tell me?" & Cooper was not long

| | |
|---|---|
| | **Magazine** |
| TYPOGRAPHY/DESIGN | Woody Pirtle, Donna Ching, Libby Carton, and Matt Heck, New York, New York |
| PRODUCTION | Pat Krugman and Jane DiBucci |
| TYPOGRAPHIC SOURCE | Various |
| STUDIO | Pentagram Design |
| CLIENTS | *U&lc* magazine and International Typeface Corporation |
| PRINCIPAL TYPES | Various ITC typefaces |
| DIMENSIONS | 10⅞ x 14⅞ in. (27.6 x 37.8 cm) |

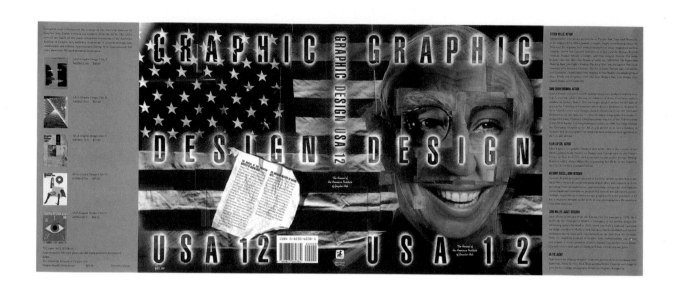

Book Cover

TYPOGRAPHY/DESIGN  John Muller, Kansas City, Missouri
CALLIGRAPHER  John Muller
PHOTOGRAPHER  Michael Regnier
TYPOGRAPHIC SOURCE  In-house
AGENCY  Muller & Co.
CLIENT  American Institute of Graphic Arts/Kansas City
PRINCIPAL TYPES  Helvetica Compressed, Kaufman BF, and handlettering
DIMENSIONS  1⁹⁄₃₂ x ½ in. (3.2 x 1.3 cm)

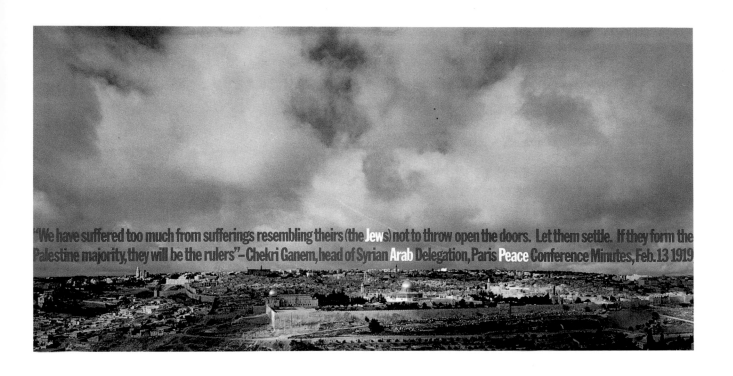

Poster

TYPOGRAPHY/DESIGN  Arnold Roston, Shrub Oak, New York
TYPOGRAPHIC SOURCE  Letraset Instant Lettering
AGENCY  Roston & Company
STUDIO  R & C Studios
CLIENT  Roston & Company
PRINCIPAL TYPE  Franklin Gothic Extra Condensed
DIMENSIONS  15¹/₁₆ x 29⁹/₁₆ in. (38.3 x 75 cm)

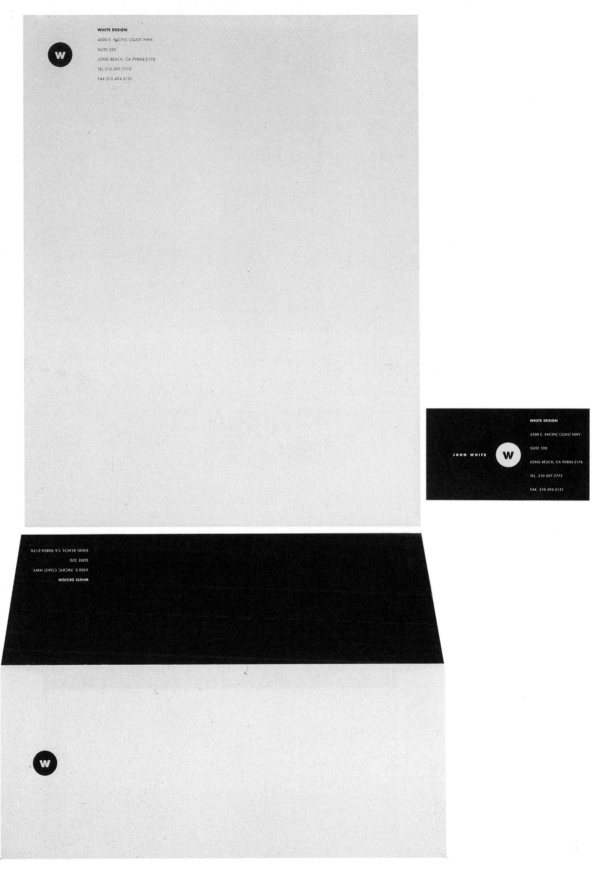

Stationery
TYPOGRAPHY/DESIGN John White and Aram Youssefian, Long Beach, California
TYPOGRAPHIC SOURCE Composition Type, Inc.
STUDIO White Design
CLIENT White Design
PRINCIPAL TYPES Futura Extra Bold, Futura Bold, and Futura Book
DIMENSIONS 8½ x 11 in. (21.6 x 27.9 cm)

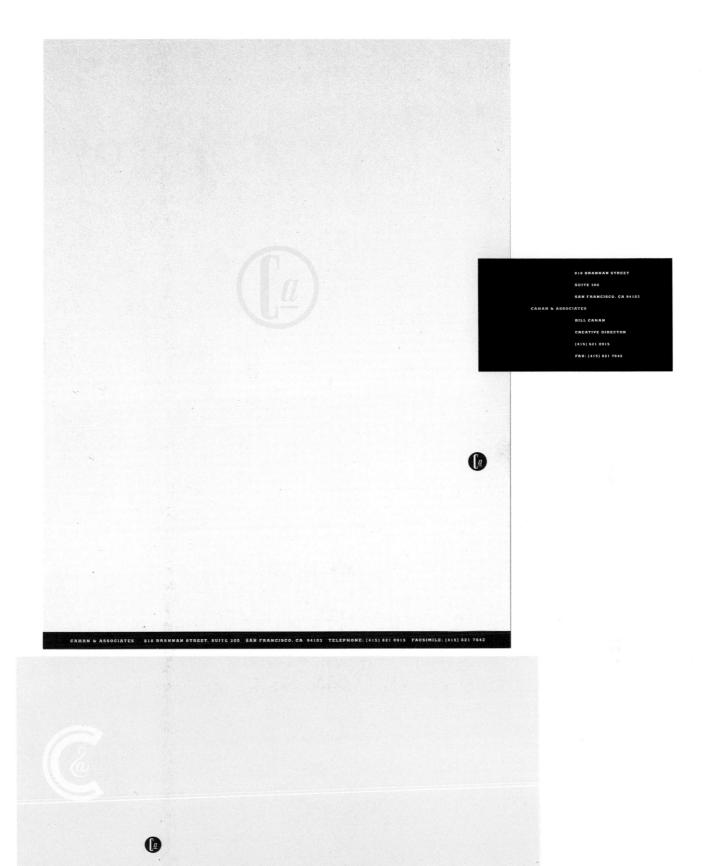

Stationery
TYPOGRAPHY/DESIGN Talin Gureghian and Stuart Flake, San Francisco, California
ART DIRECTOR Bill Cahan
TYPOGRAPHIC SOURCE In-house
AGENCY Cahan & Associates
CLIENT Cahan & Associates
PRINCIPAL TYPES Memphis Bold and handlettering
DIMENSIONS 8½ x 11 in. (21.6 x 27.9 cm)

PICAYO

PICAYO

Jose Picayo Photography  32 Morton Street  New York, New York 10014  212 989 8945

PICAYO

Stationery
TYPOGRAPHY/DESIGN  Robert Valentine, New York, New York
LETTERER  Robert Valentine
TYPOGRAPHIC SOURCE  Boro Typographers Inc.
STUDIO  Robert Valentine, Inc.
CLIENT  Jose Picayo Photography
PRINCIPAL TYPES  New Garamond and handlettering
DIMENSIONS  8¼ x 11⁹⁄₁₆ in. (21 x 29.4 cm)

P I C A Y O

Brochure
TYPOGRAPHY/DESIGN  Robert Valentine, New York, New York
LETTERER  Robert Valentine
TYPOGRAPHIC SOURCE  Boro Typographers, Inc.
STUDIO  Robert Valentine Inc.
CLIENT  Jose Picayo Photography
PRINCIPAL TYPES  New Garamond and handlettering
DIMENSIONS  25½ x 6⅞ in. (64.8 x 17.4 cm)

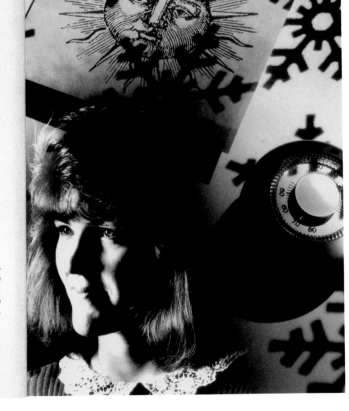

gage bonds through a public sale. Proceeds were used to retire interim borrowings and for general corporate purposes. North Shore plans another debt placement for late fiscal 1992.

This January, Peoples Energy is planning a public offering of approximately two million common shares. Proceeds will be used to provide Peoples Gas with equity funds to finance capital expenditures.

**RATE MATTERS:** In November, the Illinois Commerce Commission allowed North Shore Gas a 3.5-per-cent rate increase, or $5.3 million in additional annual revenues. Early in fiscal 1991, Peoples Gas was awarded a 2.8-per-cent increase—or $27.6 million in added revenues. In each ruling, the relief granted fell disappointingly short of the utility's request.

On a more positive note, both utilities were allowed to revise their rates to match more closely the costs and charges for service in each customer category. In North Shore's case, the commission approved a rate mechanism for recovery of environmental costs, principally to investigate and remediate sites used decades ago for manufactured gas operations.

In a mid-November rate filing, Peoples Gas sought $49.1 million in added revenues. Reasons for the request include higher operating expenses and additional capital investment devoted to utility service.

NATURAL GAS HEAT PUMP

*Innovation: Natural gas heat pumps and highly efficient gas air-conditioning units offer year-round comfort and provide us new marketing opportunities. Action: We'll soon be testing a residential heat pump and we continue to promote gas cooling through incentive awards, handled at North Shore Gas by Ann Bozarth.*

The utility also is seeking approval of a rate mechanism to recover environmental costs, similar to the one approved for North Shore.

8

|  |  |
|---|---|
| | Annual Report |
| TYPOGRAPHY/DESIGN | Pat and Greg Samata, Dundee, Illinois |
| TYPOGRAPHIC SOURCE | Total Typography |
| STUDIO | Samata Associates |
| CLIENT | Peoples Energy Corporation |
| PRINCIPAL TYPES | ITC Galliard and Univers Bold |
| DIMENSIONS | 8¼ x 11½ in. (21 x 29.2 cm) |

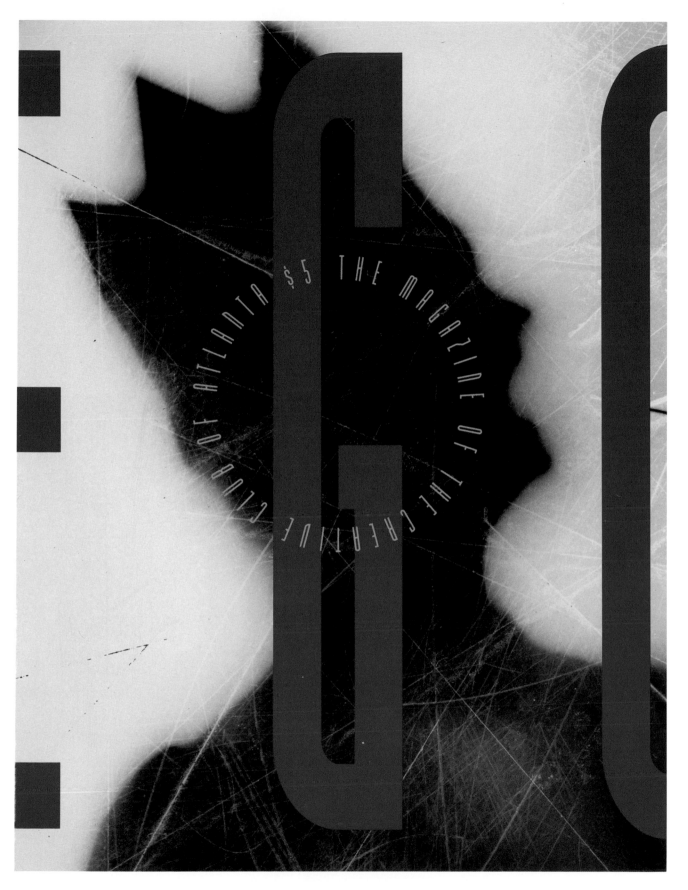

Magazine Cover

TYPOGRAPHY/DESIGN  Ted Fabella and Matt Strelecki, Atlanta, Georgia
TYPOGRAPHIC SOURCE  In-house
STUDIO  Barnstorm
CLIENT  Creative Club of Atlanta
PRINCIPAL TYPE  Modula Tall
DIMENSIONS  8½ x 11 in. (21.6 x 27.9 cm)

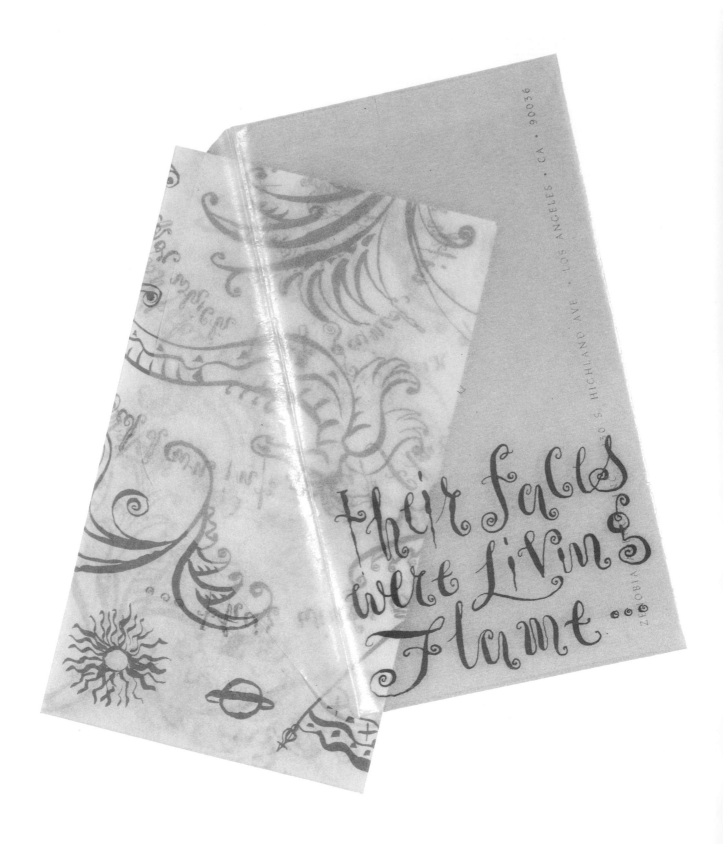

Greeting Card

| | |
|---|---|
| TYPOGRAPHY/DESIGN | Lorna Stovall, Los Angeles, California |
| CALLIGRAPHER | Lorna Stovall |
| ILLUSTRATOR | Christine Haberstock |
| TYPOGRAPHIC SOURCE | Type, Incorporated |
| STUDIO | Lorna Stovall Design |
| CLIENT | Zenobia Agency, Inc. |
| PRINCIPAL TYPES | Athenaeum and handlettering |
| DIMENSIONS | 11 x 13 in. (27.9 x 33 cm) |

Brochure

TYPOGRAPHY/DESIGN Eric Madsen, Minneapolis, Minnesota
TYPOGRAPHIC SOURCE As Soon As Possible, Inc.
STUDIO The Office of Eric Madsen
CLIENT Weyerhaeuser Paper Company
PRINCIPAL TYPE Caxton
DIMENSIONS 8 x 12 in. (20.3 x 30.5 cm)

Brochure

| | |
|---|---|
| TYPOGRAPHY/DESIGN | Belle How, San Francisco, California |
| TYPOGRAPHIC SOURCES | Eurotype and Spartan Typographers |
| STUDIO | Pentagram Design |
| CLIENT | Simpson Paper Company |
| PRINCIPAL TYPE | City |
| DIMENSIONS | 11½ x 11½ in. (29.2 x 29.2 cm) |

*M*ore than a physical
place made of
BRICK or wood,
more than rooms
full of carpets
and furniture,
home is the place
where we are
*n u r t u r e d*
and fed,
where we feel
safe and *secure*.
It's the place we
*return* to again
and a g a i n ,
the place where we
learn the foundation
of our values
and the building
blocks of RESPECT
for ourselves,
for others,
and for our environment.

[ *Home* ]

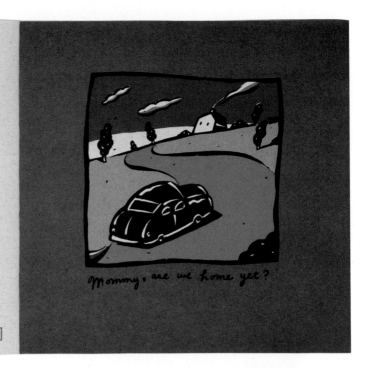

*mommy, are we home yet?*

Brochure
TYPOGRAPHY/DESIGN  Robert S. Davison and Jane C. Winsor, Boston, Massachusetts
TYPOGRAPHIC SOURCE  In-house
STUDIO  Stewart Monderer Design, Inc.
CLIENT  Stewart Monderer Design, Inc.
PRINCIPAL TYPES  Garamond No. 3 and Linoscript (manipulated)
DIMENSIONS  5¾ x 7¼ in. (14 x 18 cm)

*Once* again we present our annual rundown of people, places and things that are on the cutting edge, about to break through or rapidly earning legendary status. While putting together these selections, we've stumbled upon the following general theories on how to be hot:

Do something with Madonna. Do something you've never done before and do it really well. Play Catwoman. Have a last name that ends with *ian*. Cultivate an association with Axl Rose. And most important, say you prefer not to talk about it. After all, hotness speaks for itself.

**Lettered by Anita Karl**

ROLLING STONE, MAY 16TH, 1991 · 41

|  |  |
|---:|:---|
| | Magazine Page |
| TYPOGRAPHY/DESIGN | Gail Anderson, New York, New York |
| LETTERER | Anita Karl, Brooklyn, New York |
| ART DIRECTOR | Fred Woodward |
| CLIENT | Rolling Stone |
| PRINCIPAL TYPE | Handlettering |
| DIMENSIONS | 12 x 10 in. (30.5 x 25.4 cm) |

*Photographs by Herb Ritts*

Magazine Spread
TYPOGRAPHY/DESIGN   Gail Anderson, New York, New York
LETTERER   Anita Karl, Brooklyn, New York
ART DIRECTOR   Fred Woodward
CLIENT   Rolling Stone
PRINCIPAL TYPE   Handlettering
DIMENSIONS   12 x 10 in. (30.5 x 25.4 cm)

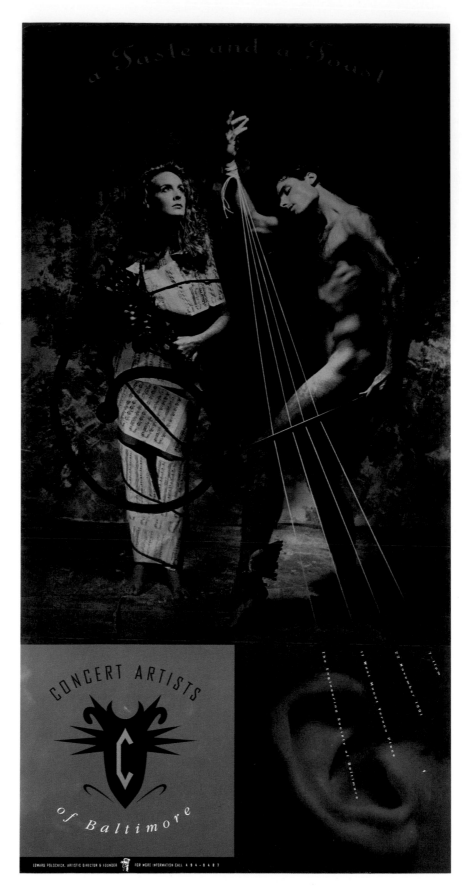

Poster

| | |
|---|---|
| TYPOGRAPHY/DESIGN | Dave Plunkert and Tim Thompson, Baltimore, Maryland |
| TYPOGRAPHIC SOURCE | In-house |
| STUDIO | Graffito |
| CLIENT | Concert Artists of Baltimore |
| PRINCIPAL TYPES | Bureau Agency Bold, Garamond Italic, and Linoscript |
| DIMENSIONS | 19½ x 38 in. (49.5 x 96.5 cm) |

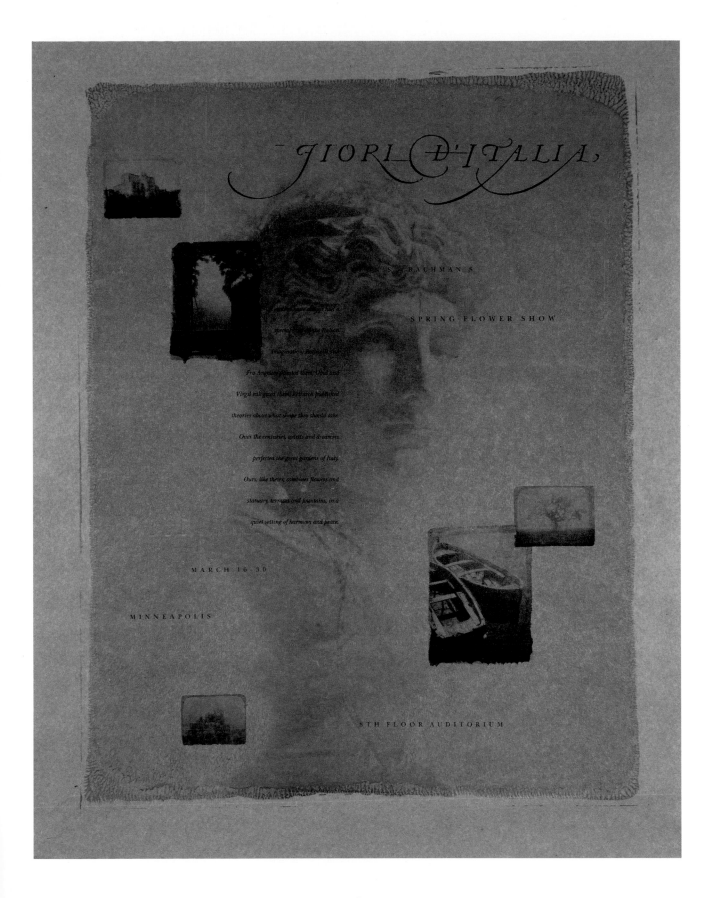

Poster

TYPOGRAPHY/DESIGN   Bill Thorburn, Minneapolis, Minnesota
CALLIGRAPHER   Todd apJones
TYPOGRAPHIC SOURCE   In house
STUDIO   Dayton's Hudson's Marshall Field's
CLIENT   Dayton's Hudson's Marshall Field's
PRINCIPAL TYPE   Baskerville
DIMENSIONS   24 x 30 in. (61 x 76.2 cm)

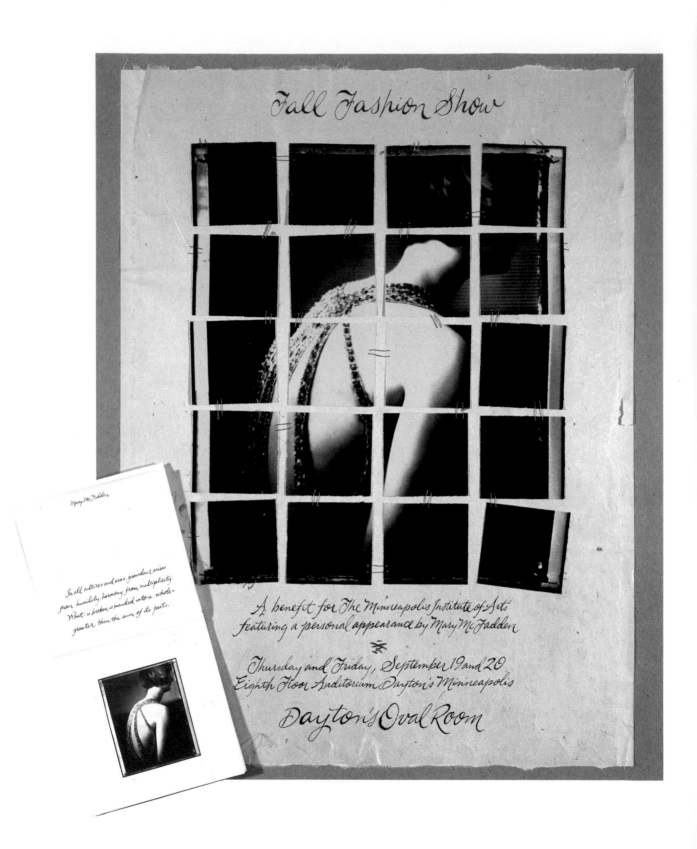

*Fall Fashion Show*

*A benefit for The Minneapolis Institute of Arts
featuring a personal appearance by Mary McFadden*

*Thursday and Friday, September 19 and 20
Eighth Floor Auditorium Dayton's Minneapolis*

*Dayton's Oval Room*

|  |  |
|---|---|
| | Campaign |
| TYPOGRAPHY/DESIGN | Bill Thorburn, Minneapolis, Minnesota |
| LETTERER | Todd apJones |
| TYPOGRAPHIC SOURCE | Todd apJones |
| AGENCY | Dayton's Hudson's Marshall Field's |
| CLIENT | Dayton's Hudson's Marshall Field's |
| PRINCIPAL TYPE | Handlettering |
| DIMENSIONS | Various |

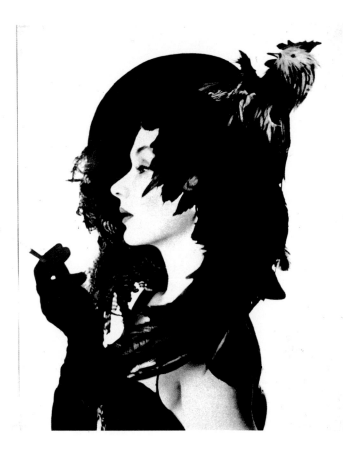



(LISA FONSSAGRIVES)

"I loved her when I first set eyes on her. We have been married for forty years. Each day is an enrichment."

(SUZANNE FARRELL)

"She is part real part apparition. I feared that film was not sensitive enough to record my enchantment. I understood Balanchine's obsession with her."

(COLETTE)

"She lay propped up by a window in the Palais Royal. Near the end of life she was still seductive. To lean my camera onto the bed I moved her small bare feet to one side. I saw that her toes were perfectly painted."

I.P.

116                    Lisa Fonssagrives

Magazine Spread
TYPOGRAPHY/DESIGN  Lucy Sisman, New York, New York
CALLIGRAPHER  Irving Penn
TYPOGRAPHIC SOURCE  In-house
CLIENT  Allure/Condé Nast Publications
PRINCIPAL TYPES  Allure Baskerville and handlettering
DIMENSIONS  9¾ x 12 in. (24.8 x 30.5 cm)

TYPOGRAPHY: POLYGLOT

A Comparative Study in
Multilingual Typesetting
by George Sadek
and Maxim Zhukov

*A Research Project of
The Center for Design & Typography
Sponsored by the
Frank Stanton Endowment for
Graphic Design
at The Cooper Union*

及其平等的和不移的权利

ن الاعتراف بالكرامة المة

нимая во внимание,ч

न्मजात गौरव और समान

πειδὴ ἡ ἀναγνώρισις τ

員の固有の尊厳と平等で

איל והכרה בכבוד הטבי

모든 사람이 태어날 때부

Vhereas recognition of 1

|  | |
| --- | --- |
|  | Book |
| TYPOGRAPHY/DESIGN | George Sadek and Charles Nix, New York, New York |
| TYPOGRAPHIC SOURCE | In-house |
| STUDIO | The Cooper Union Center for Design and Typography |
| CLIENT | Frank Stanton Endowment in Design |
| PRINCIPAL TYPE | ITC New Baskerville |
| DIMENSIONS | 8¼ x 11¾ in. (21 x 29.8 cm) |

VOLVME I. NVMBER III ~ NOVEMBER 1991

# IN THE SPIRIT OF

**S**an Francisco is beautiful"; "This city used to be much better." We have all heard these declarations. They imply that San Francisco, like all flawless jewels, should be left alone; that we see change as inherently bad; and that we fear that things can only become worse than they are. We cling to the cherished image that we have of San Francisco: a city of low buildings, buildings that are either dressed in colorful materials or somberly clad in brown shingles, their surfaces broken by bay windows. ¶ This image is a myth. In fact, throughout its history, San Francisco has been a city of constant change. Younger generations of architects have rebelled against their older colleagues. At the turn of the century, Willis Polk and Bernard Maybeck, among others, rebelled against the Victorians. In the 1920s and 1930s, William Wurster and Gardner Dailey demonstrated against ponderous classical buildings. They imported the images and lessons of the

# MODERNISM

Brochure

|  |  |
|---|---|
| Typography/Design | Linda Hinrichs, San Francisco, California |
| Typographic Sources | In house and Design & Type |
| Studio | Powell Street Studio |
| Client | San Francisco Museum of Modern Art |
| Principal Types | Futura and Bodoni |
| Dimensions | 11 x 17 in. (27.9 x 43.2 cm) |

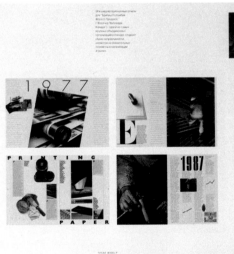

Brochure
TYPOGRAPHY/DESIGN John Van Dyke, Seattle, Washington
TYPOGRAPHIC SOURCES In-house and Typehouse
AGENCY Van Dyke Company
CLIENT John Van Dyke
PRINCIPAL TYPES Bodoni and Helvetica Modified
DIMENSIONS 11½ x 11½ in. (29.2 x 29.2 cm)

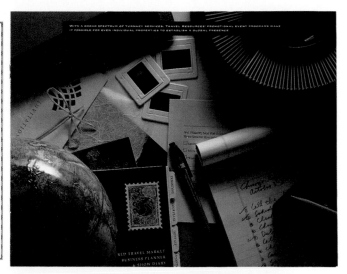

TRADITIONALLY, ENTERING THE INTERNATIONAL MARKET might have been a financial impossibility for independent hotels and small management groups. Today, it's a necessity you can comfortably attain through Travel Resources' promotional event programs. Press receptions, trade shows, product introductions, and customer receptions are created and produced entirely by our staff on behalf of member properties. Participation in these events is your key to reaching a global audience. More precisely, it serves as your introduction to those individuals who influence site selection, and as a result, impact your business. We offer access to these events on a turnkey basis. Allowing you to enter select pre-qualified markets in a highly cost-effective manner.

Our marketing personnel can assist you in developing and implementing direct response mailings, cooperative advertising programs, and public relations events.

Travel Resources promotional events create top-of-mind awareness of your property among influential decision makers.

With Travel Resources, your property can participate in major domestic and international trade shows, a critical means of worldwide promotion.

Brochure

| | |
|---|---|
| TYPOGRAPHY/DESIGN | Paul Black, Dallas, Texas |
| CALLIGRAPHER | Paul Black |
| TYPOGRAPHIC SOURCE | Creative Type |
| AGENCY | Joiner, Rowland, Serio, Koeppel |
| STUDIO | The Design Group, JRSK |
| CLIENT | Travel Resources Management Group |
| PRINCIPAL TYPE | Sabon |
| DIMENSIONS | 11 x 8½ in. (27.9 x 21.6 cm) |

Catalog

TYPOGRAPHY/DESIGN  Vincent Winter, Paris, France
TYPOGRAPHIC SOURCE  Ere Nouvelle
STUDIO  Vincent Winter Design
CLIENT  Ere Nouvelle
PRINCIPAL TYPE  Walbaum Standard
DIMENSIONS  6⁵⁄₁₆ x 4½ in. (16 x 10.8 cm)

Designer's One-Liners

communicate. Erik Spiekermann **Designers should avoid designing for designers.** William Golden    Outside of designers, nobody gives a damn what happens to design or designers. George Nelson

Book
TYPOGRAPHY/DESIGN Michael Skjei, Minneapolis, Minnesota
TYPOGRAPHIC SOURCE Pentagram Press
STUDIO M. Skjei Design Co.
CLIENT Shay, Shea, Hsieh & Skjei Publishers
PRINCIPAL TYPE Gill Sans
DIMENSIONS 6 x 8½ in. (15 x 21 cm)

149

# CHICAIGAO

---

*AIGA in Chicago*

*A publication of the Chicago Chapter, the American Institute of Graphic Arts.*

---

*Winter & Spring 1991*

**Practicing Responsible Design: An Agenda for Change**
*This issue of* AIGA in Chicago *looks at the unique and influential role designers can play in helping the environment—and help their own businesses in the process.*

|  |  |
|---|---|
|  | Newsletter |
| TYPOGRAPHY/DESIGN | Carl Wohlt, Chicago, Illinois |
| LETTERER | Carl Wohlt |
| TYPOGRAPHIC SOURCES | Alphatype and Shore Typographers, Inc. |
| STUDIO | Crosby Associates Inc. |
| CLIENT | American Institute of Graphic Arts/Chicago |
| PRINCIPAL TYPES | Alpha Bodoni Book and H.B. Univers 85 |
| DIMENSIONS | 11 x 17 in. (27.9 x 43.2 cm) |

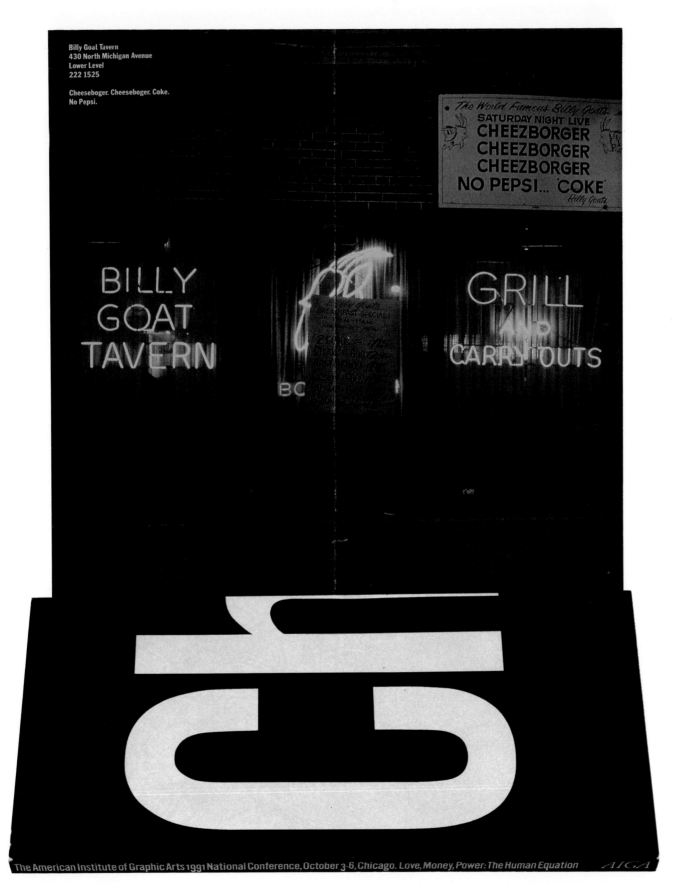

Guide Book

TYPOGRAPHY/DESIGN Kym Abrams and Sam Silvio, Chicago, Illinois
TYPOGRAPHIC SOURCE Master Typographers
STUDIO Kym Abrams Design and Sam Silvio Design
CLIENT American Institute of Graphic Arts/Chicago
PRINCIPAL TYPE Franklin Gothic Bold Condensed
DIMENSIONS 5 x 10 in. (12.7 x 25.4 cm)

151

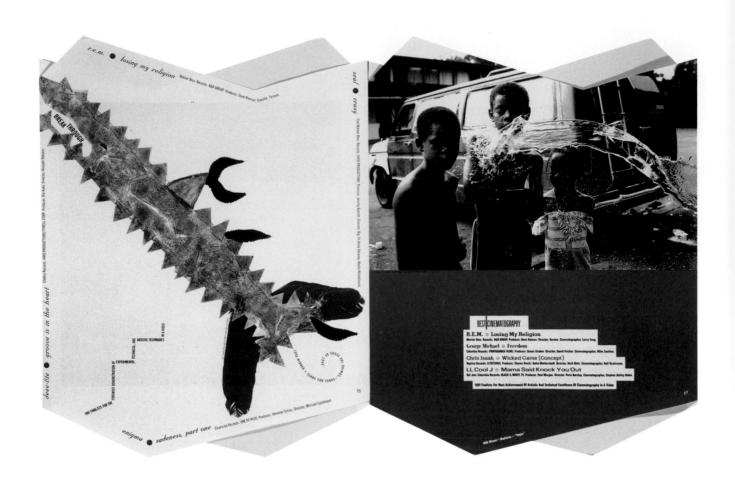

Catalog
TYPOGRAPHY/DESIGN Stacy Drummond and Steve Byram, New York, New York
TYPOGRAPHIC SOURCE Expertype/Graphic Word
AGENCY MTV Networks Creative Services
CLIENT MTV: Music Television
PRINCIPAL TYPE Times Roman
DIMENSIONS 12 x 15 in. (30.5 x 38.1 cm)

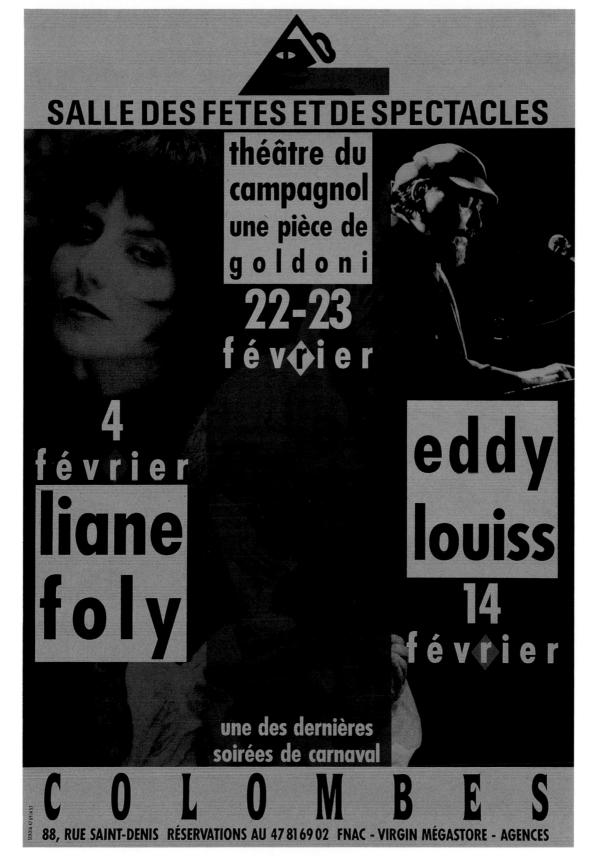

Poster
TYPOGRAPHY/DESIGN  Michèle Forest, Colombes, France
CALLIGRAPHER  Michèle Forest
TYPOGRAPHIC SOURCE  In-house
STUDIO  Sékoia
CLIENT  Salle de Spectacles de Colombes
PRINCIPAL TYPE  Futura
DIMENSIONS  15¾ x 23⅝ in. (40 x 60 cm)

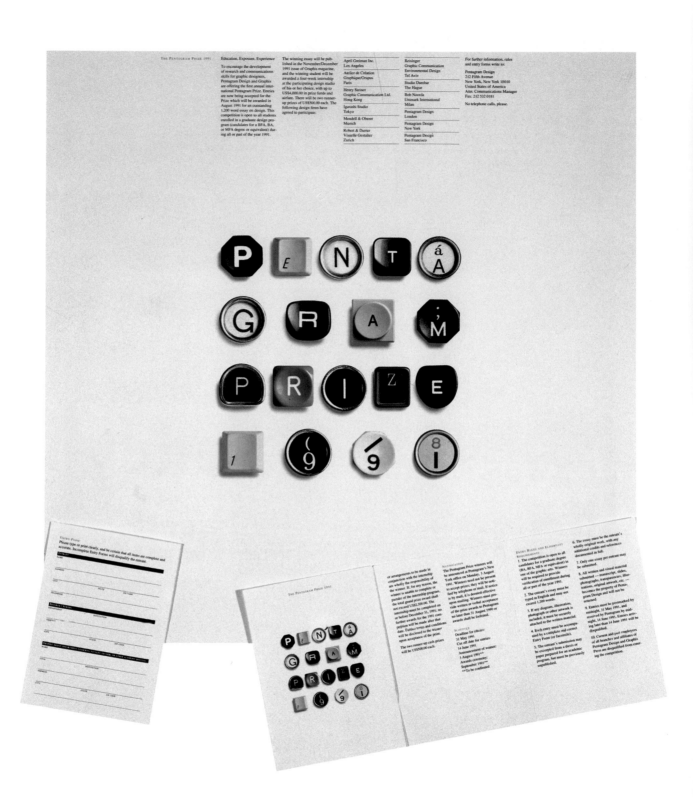

Campaign

| | |
|---|---|
| TYPOGRAPHY/DESIGN | John Klotnia, New York, New York |
| TYPOGRAPHIC SOURCES | Typogram and typewriter keys courtesy of Marjorie Chester |
| STUDIO | Pentagram Design |
| CLIENT | Pentagram Design |
| PRINCIPAL TYPE | Times Roman |
| DIMENSIONS | Various |

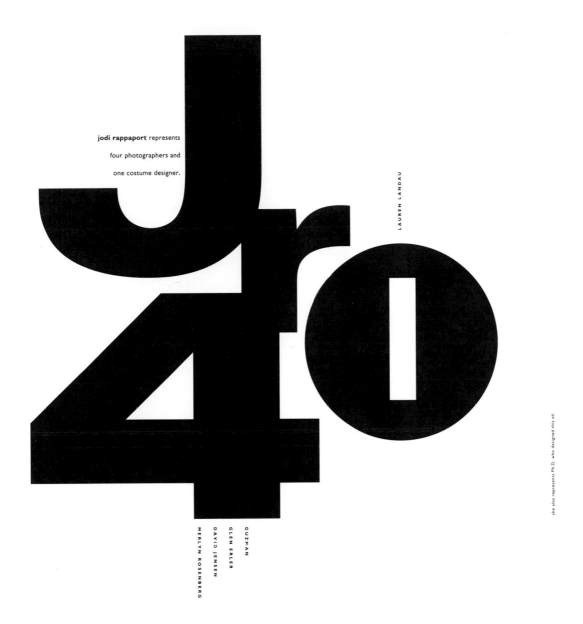

jodi rappaport represents four photographers and one costume designer.

LAUREN LANDAU

she also represents Ph.D. who designed this ad

MERLYN ROSENBERG
DAVID JENSEN
GLEN ERLER
GUZMAN

5410 WILSHIRE BLVD. #1008 LOS ANGELES CA. 90036 (213) 934-8633 FAX (213) 934-0690

| | |
|---|---|
| | Advertisement |
| TYPOGRAPHY/DESIGN | Clive Piercy and Michael Hodgson, Santa Monica, California |
| TYPOGRAPHIC SOURCE | In-house |
| STUDIO | Ph.D |
| CLIENT | Jodi Rappaport |
| PRINCIPAL TYPES | Univers 83 and Gill Sans Bold |
| DIMENSIONS | 9¼ x 13 in. (11.8 x 33 cm) |

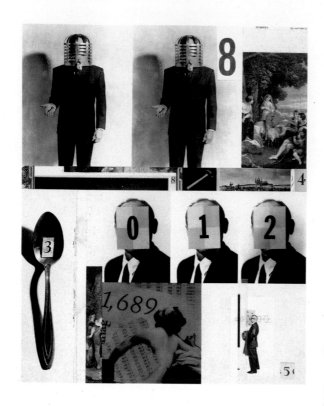

# 7HE NUM8ER5 1RAP

By Donald A. Curtis

*Illogical thinking could put American business down for the count.*

**7**echnology has exponentially expanded our ability to communicate in the Information Age, and businesspeople have become comfortable with managing information systems to meet their business needs.

However, when it comes to the raw material of electronic and personal communication—logical reasoning and judgement—I contend that many businesspeople aren't proficient. They too often manage using measures that misrepresent reality. They're misguided by faulty logic, which creates in them a ceaseless need to quantify and leads straight to the numbers trap.

The road to the trap starts with bad thinking. We all have been to meetings at which bad logic is used by intelligent people. They inadvertently use false assumptions and rely on negative proof—if you cannot prove this idea is bad it must be good—a practice that long has been unacceptable in science and law and has no place in business.

Another illogical thinker might argue for a course of action simply because a problem exists. It's a "my-idea-is-good-because-we-must-do-*something*" argument.

For successful problem solving, of course, solutions must compete. The existence of the problem is not an argument for any particular solution.

|  | Magazine |
| --- | --- |
| TYPOGRAPHY/DESIGN | Robert Petrick, Chicago, Illinois |
| TYPOGRAPHIC SOURCE | The Typesmiths, Incorporated |
| STUDIO | Petrick Design |
| CLIENT | Ameritech Corporation |
| PRINCIPAL TYPE | Futura Bold Extra Condensed |
| DIMENSIONS | 8⅛ x 10¾ in. (20.6 x 27.3 cm) |

156

A Child's
Treasury
of
Smart-Ass
Remarks

"LOOKING AT YOU, SHAW, PEOPLE WOULD THINK THERE WAS A FAMINE IN ENGLAND."

Heartily obese carnivore G. K. Chesterton:

Lean vegetarian George Bernard Shaw:

"AND LOOKING AT YOU, CHESTERTON, PEOPLE WOULD THINK YOU WERE THE CAUSE OF IT."

|  | Brochure |
|---|---|
| TYPOGRAPHY/DESIGN | Michael Bierut, Dorit Lev, and Anne Cowin, New York, New York |
| TYPOGRAPHIC SOURCE | Characters Typographic Services, Inc. |
| STUDIO | Pentagram Design |
| CLIENT | Gilbert Paper |
| PRINCIPAL TYPE | Various |
| DIMENSIONS | 4 x 6 in. (10.2 x 15.2 cm) |

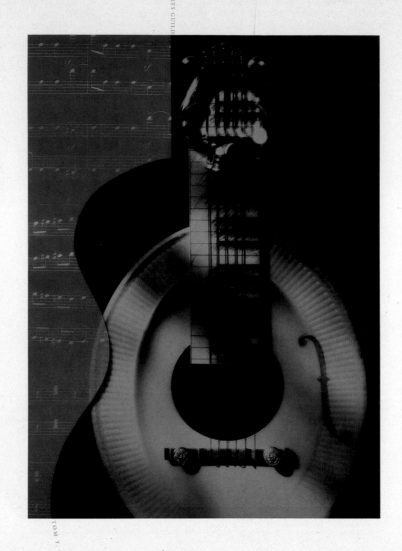

PERFORMING ARTS LIVE SERIES

PALS SERIES OF THE CREATIVE ARTS GUILD

TOM T. HALL • ANDREAS HAEFLIGER • SAVANNAH SYMPHONY • THE DUTTON FAMILY • U.S. ARMY FIELD BAND AND CHORUS • THE PLATTERS

Poster
TYPOGRAPHY/DESIGN  Russ Ramage, Dalton, Georgia
TYPOGRAPHIC SOURCE  In-house
STUDIO  DESIGN!
CLIENT  Creative Arts Guild
PRINCIPAL TYPES  Frutiger Ultra Black and Adobe Garamond
DIMENSIONS  17 x 22 in. (43.2 x 55.9 cm)

158

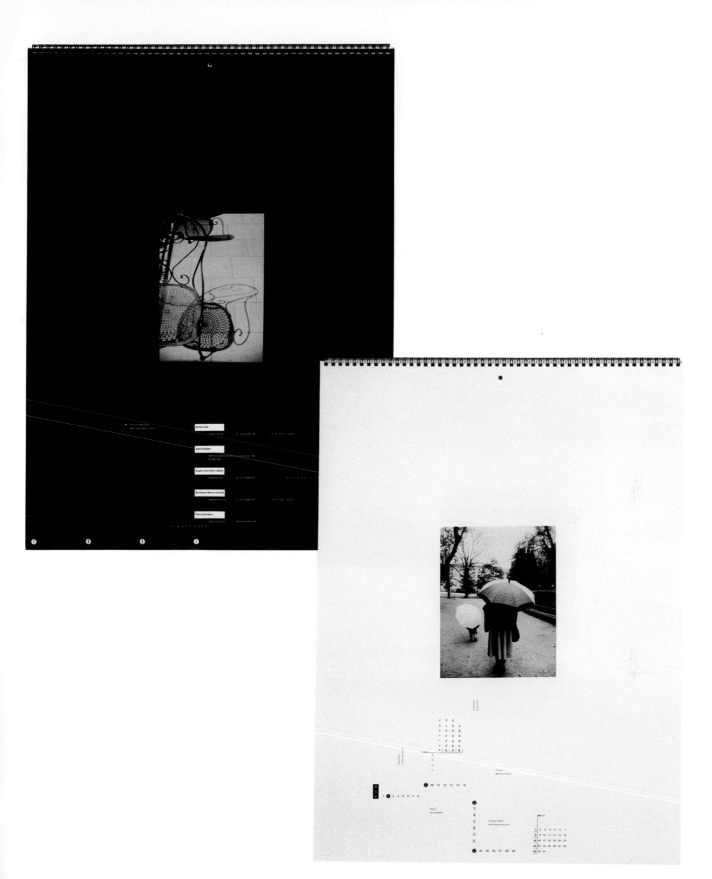

Calendar

TYPOGRAPHY/DESIGN Sandi King, Glenda Rissman, Peter Scott, and Malcolm Waddell,
Toronto, Ontario, Canada

TYPOGRAPHIC SOURCES In-house and Cooper and Beatty

STUDIO Eskind Waddell

CLIENTS Barbara Cole, Eskind Waddell, Graphic Specialties Ltd.,
Mackinnon Moncur Ltd., and Provincial Papers

PRINCIPAL TYPE Univers

DIMENSIONS 17 x 23 in. (43.2 x 58.4 cm)

 An Ojibwe from Minnesota, Leroy Fairbanks, Jr. is a veteran of three wars — World War II, the Korean War and the Vietnam War. His headdress includes a feather for each war. Indian ceremonies honoring warriors for their courage did not end with the nineteenth century. With these and many other customs, Indian people have continued to draw on well-established traditions to deal with the sometimes unsettling events and challenges of the twentieth century. Rather than choose between assimilation or complete separation, they built a middle ground, resting partly on tradition and partly on change.

## NOVEMBER

US WEST

| Sunday | Monday | Tuesday | Wednesday | Thursday | Friday | Saturday |
|--------|--------|---------|-----------|----------|--------|----------|
| 1 | 2 | 3 Election Day | 4 | 5 | 6 | 7 |
| 8 | 9 | 10 | 11 Veteran's Day | 12 | 13 | 14 |
| 15 | 16 | 17 | 18 | 19 | 20 | 21 |
| 22 | 23 | 24 | 25 | 26 Thanksgiving | 27 | 28 |
| 29 | 30 | | | | | |

© 1991 U S WEST, Inc.

Calendar
TYPOGRAPHY/DESIGN   Steve Wedeen, Albuquerque, New Mexico
TYPOGRAPHIC SOURCE   In-house
STUDIO   Vaughn/Wedeen Creative Inc.
CLIENT   U S WEST Communications
PRINCIPAL TYPES   Viking and Garamond No. 3
DIMENSIONS   18 x 15¹⁵⁄₁₆ in. (45.7 x 40.5 cm)

1 2 3 4 **5 6** 7 8 9 10 11 **12** 13 14 15 16 17 18 **19** 20 21 22 23 24 25 **26** 27 28 29 30 31

Calendar

|  |  |
|---|---|
| TYPOGRAPHY/DESIGN | Friedrich Don, Freiberg am Neckar, Germany |
| PHOTOGRAPHER | Franz Wagner |
| TYPOGRAPHIC SOURCE | Steffen Hahn, Foto Satz Etc. |
| AGENCY | Wagner Siebdruck |
| CLIENT | Wagner Siebdruck |
| PRINCIPAL TYPE | ITC Goudy Sans Book |
| DIMENSIONS | 23⅜ x 33⅟₁₆ in. (59.4 x 84 cm) |

161

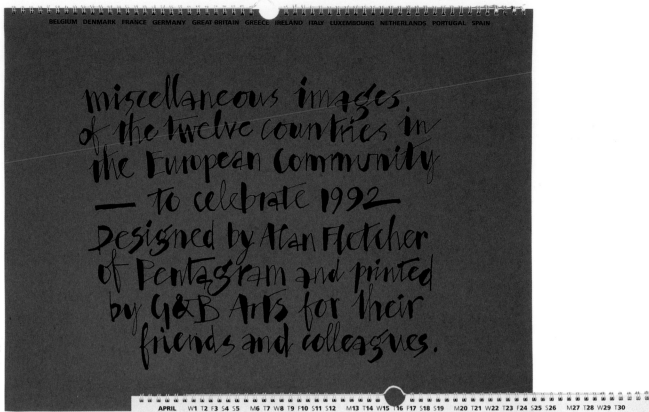

BELGIUM DENMARK FRANCE GERMANY GREAT BRITAIN GREECE IRELAND ITALY LUXEMBOURG NETHERLANDS PORTUGAL SPAIN

miscellaneous images of the twelve countries in the European Community — to celebrate 1992 — Designed by Alan Fletcher of Pentagram and printed by G&B Arts for their friends and colleagues.

APRIL W1 T2 F3 S4 S5 M6 T7 W8 T9 F10 S11 S12 M13 T14 W15 T16 F17 S18 S19 M20 T21 W22 T23 F24 S25 S26 M27 T28 W29 T30

hysterical sunset – Naples

|  |  |
|---|---|
|  | Calendar |
| TYPOGRAPHY/DESIGN | Alan Fletcher, London, England |
| TYPOGRAPHIC SOURCE | In-house |
| STUDIO | Pentagram Design, Ltd. |
| CLIENT | 9 + B Printers |
| PRINCIPAL TYPES | Frutiger Light and Frutiger Bold |
| DIMENSIONS | 15 x 20 in. (38.1 x 50.8 cm) |

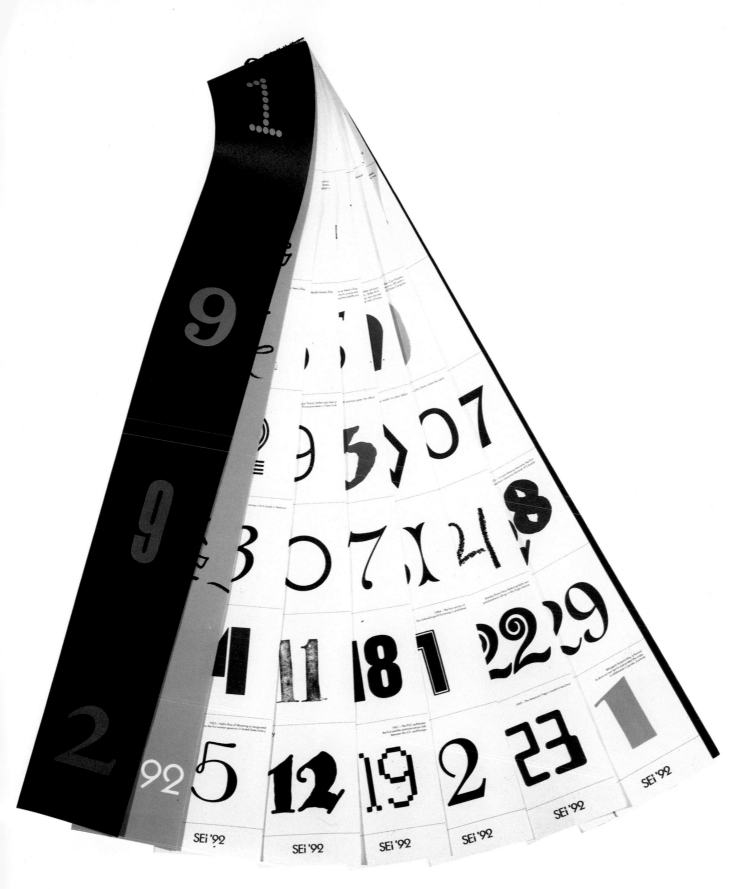

|  | Calendar |
|---|---|
| TYPOGRAPHY/DESIGN | George Tscherny, New York, New York |
| CALLIGRAPHERS | Elizabeth Laub, Michelle Novak, and George Tscherny |
| TYPOGRAPHIC SOURCES | Various |
| STUDIO | George Tscherny, Inc. |
| CLIENT | SEi Corporation |
| PRINCIPAL TYPES | Futura and handlettering |
| DIMENSIONS | 4⅞ x 38 in. (12.4 x 96.5 cm) |

Calendar

TYPOGRAPHY/DESIGN   Akio Okumura and Katsuji Minami, Kitaku, Osaka, Japan

TYPOGRAPHIC SOURCE   Letraset

STUDIO   Packaging Create, Inc.

CLIENT   Packaging Create, Inc.

PRINCIPAL TYPE   ITC Souvenir Medium

DIMENSIONS   14⅛ x 11⅜ in. (36 x 29 cm)

164

Packaging

TYPOGRAPHY/DESIGN  Haley Johnson and Daniel Olson, Minneapolis, Minnesota
TYPOGRAPHIC SOURCE  May Typography
STUDIO  Charles S. Anderson Design Company
CLIENT  Cloud Nine, Inc.
PRINCIPAL TYPE  Venus
DIMENSIONS  3 x 6 in. (7.6 x 15.2 cm)

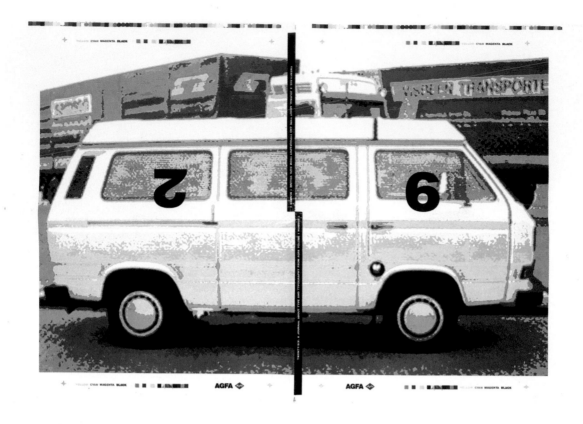

Magazine

| | |
|---|---|
| TYPOGRAPHY/DESIGN | Gary Koepke, Magnolia, Massachusetts |
| CREATIVE DIRECTOR | Peter M. Miller |
| TYPOGRAPHIC SOURCE | In-house |
| AGENCY | Altman & Manley/Eagle Advertising |
| CLIENT | Agfa Corporation |
| PRINCIPAL TYPE | Helvetica |
| DIMENSIONS | 17¾ x 23 in. (45.1 x 58.4 cm) |

A modern Italian Old Style Face.
Eine moderne italienische Antiqua.
*Une antique italienne moderne.*

Calligraphic faces for today's design.
Historische Schriften für unsere Zeit.
*La typographie avant Gutenberg.*

# GUARDI

55 ABCDEFGHIJKLMNOPQRSTUVWXYZ
abcdefghijklmnopqrstuvwxyz
ABCDEFGHIJKLMNOPQRSTUVWXYZ
1234567890  1234567890

56 *ABCDEFGHIJKLMNOPQRSTUVWXYZ*
*abcdefghijklmnopqrstuvwxyz*
*1234567890  1234567890*

75 ABCDEFGHIJKLMNOPQRSTUVWXYZ
abcdefghijklmnopqrstuvwxyz
1234567890  1234567890

76 *ABCDEFGHIJKLMNOPQRSTUVWXYZ*
*abcdefghijklmnopqrstuvwxyz*
*1234567890  1234567890*

95 ABCDEFGHIJKLMNOPQRSTUVWXYZ
abcdefghijklmnopqrstuvwxyz
1234567890  1234567890

96 *ABCDEFGHIJKLMNOPQRSTUVWXYZ*
*abcdefghijklmnopqrstuvwxyz*
*1234567890  1234567890*

Type before Gutenberg

100 B.C.  HERCULANUM
ABCDEFGHIJKLMNOPQRSTUVWXYZ
ABCDEFGHIJKLMNOPQRSTUVWXYZ
1234567890

HERCULANUM

300 A.D.  OMNIA
ABCDEFGHIJKLMNOPQRSTUVWXYZ
1234567890

OMNIA

800 A.D.  Carolina
ABCDEFGHIJKLMNOPQRSTUVWXYZ
1234567890

Carolina

Clairvaux

1300 A.D.  Clairvaux
ABCDEFGHIJKLMNOPQRSTUVWXYZ
abcdefghijklmnopqrstuvwxyzß
1234567890

San Marco
ABCDEFGHIJKLMNOPQRSTUVWXYZ
abcdefghijklmnopqrstuvwxyzß
1234567890

San Marco

1440 A.D.  Duc de Berry
Gutenberg  ABCDEFGHIJKLMNOPQRSTUVWXYZ
abcdefghijklmnopqrstuvwxyzß
1234567890

Duc de Berry

1500 A.D.

This series is a revival of six distinctive calligraphic faces that cover 1500 years of typographic history. They can be used on any PostScript-compatible application and output device.

Diese sechs Schriften symbolisieren 1500 Jahre Schriftgeschichte. Kalligraphie auf Tastendruck mit besonderer Aussagekraft.

Ces six polices symbolisent 1500 ans d'histoire de la typographie. La calligraphie pour le design et pour la typographie d'aujourd'hui.

Linotype
LIBRARY

ovation.
ische Innovation.
*on hollandaise.*

ABCDEFGHIJKLMNOPQRSTUVWXYZ
abcdefghijklmnopqrstuvwxyz
ABCDEFGHIJKLMNOPQRSTUVWXYZ
1234567890  1234567890

ABCDEFGHIJKLMNOPQRSTUVWXYZ
abcdefghijklmnopqrstuvwxyz
ABCDEFGHIJKLMNOPQRSTUVWXYZ
1234567890  1234567890

ABCDEFGHIJKLMNOPQRSTUVWXYZ
abcdefghijklmnopqrstuvwxyz
1234567890  1234567890

ABCDEFGHIJKLMNOPQRSTUVWXYZ
abcdefghijklmnopqrstuvwxyz
ABCDEFGHIJKLMNOPQRSTUVWXYZ
1234567890  1234567890

ABCDEFGHIJKLMNOPQRSTUVWXYZ
abcdefghijklmnopqrstuvwxyz
ABCDEFGHIJKLMNOPQRSTUVWXYZ
1234567890  1234567890

ABCDEFGHIJKLMNOPQRSTUVWXYZ
abcdefghijklmnopqrstuvwxyz
ABCDEFGHIJKLMNOPQRSTUVWXYZ
1234567890  1234567890

*PMN Caecilia 86*  ABCDEFGHIJKLMNOPQRSTUVWXYZ
abcdefghijklmnopqrstuvwxyz
ABCDEFGHIJKLMNOPQRSTUVWXYZ
1234567890  1234567890

Linotype
LIBRARY

|  |  |
|---|---|
|  | Poster |
| TYPOGRAPHY/DESIGN | Dorit Lecke and Wolfgang Hanauer, Offenbach, Germany |
| TYPOGRAPHIC SOURCE | In-house |
| AGENCY | Hochschule für Gestaltung |
| CLIENT | Linotype-Hell AG, Font Marketing Department |
| PRINCIPAL TYPES | Frutiger Roman, Frutiger Italic, and Frutiger Bold |
| DIMENSIONS | 27½ x 27½ in. (70 x 70 cm) |

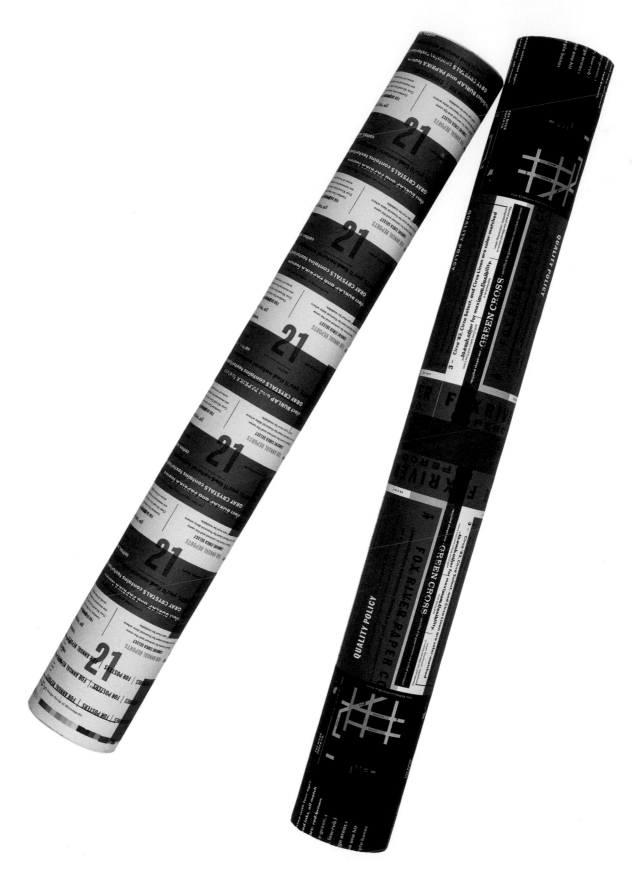

|  | Packaging |
|---|---|
| TYPOGRAPHY/DESIGN | Sharon Werner, Minneapolis, Minnesota |
| TYPOGRAPHIC SOURCE | Great Faces |
| STUDIO | Duffy Design Group |
| CLIENT | Fox River Paper Company |
| PRINCIPAL TYPES | Spartan Black, Clarendon, and Alternate Gothic |
| DIMENSIONS | Various |

168

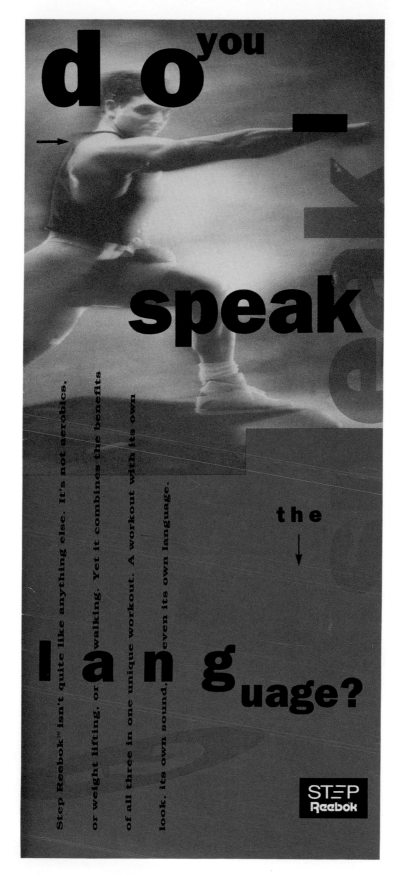

Brochure

| | |
|---|---|
| TYPOGRAPHY/DESIGN | Loid Der, Culver City, California |
| TYPOGRAPHIC SOURCE | In-house |
| AGENCY | The Mednick Group |
| CLIENT | Reebok International Ltd. |
| PRINCIPAL TYPES | Franklin, Bookman, and ITC Galliard |
| DIMENSIONS | 9½ x 4½ in. (24.1 x 11.4 cm) |

KOWLOON
DEVELOPMENT
COMPANY
LIMITED

九 龍 建 業
有 限 公 司

ANNUAL REPORT

1 9 9 0

一九九零年年報

Annual Report
TYPOGRAPHY/DESIGN  Colin Tillyer, Hong Kong
TYPOGRAPHIC SOURCES  In-house and Modern Type Typesetting Limited
STUDIO  Graphicat Limited
CLIENT  Kowloon Development Company Limited
PRINCIPAL TYPES  Times Roman and Sau Lai
DIMENSIONS  11¼ x 8¼ in. (28.6 x 21 cm)

Campaign

| | |
|---|---|
| TYPOGRAPHY/DESIGN | Bill Thorburn, Minneapolis, Minnesota |
| CALLIGRAPHERS | Todd apJones and Vicky Rossi |
| TYPOGRAPHIC SOURCE | In-house |
| STUDIO | Dayton's Hudson's Marshall Field's |
| CLIENT | Minneapolis Chamber Symphony |
| PRINCIPAL TYPE | Bodoni |
| DIMENSIONS | 18 x 24 in. (45.7 x 61 cm) |

Diploma
TYPOGRAPHY/DESIGN  Rebeca Méndez, Pasadena, California
TYPOGRAPHIC SOURCE  Patrick Reagh Printer, Los Angeles
STUDIO  Art Center Design Office
CLIENT  Art Center College of Design
PRINCIPAL TYPE  Gill Sans
DIMENSIONS  14½ x 7 in. (36.8 x 17.8 cm)

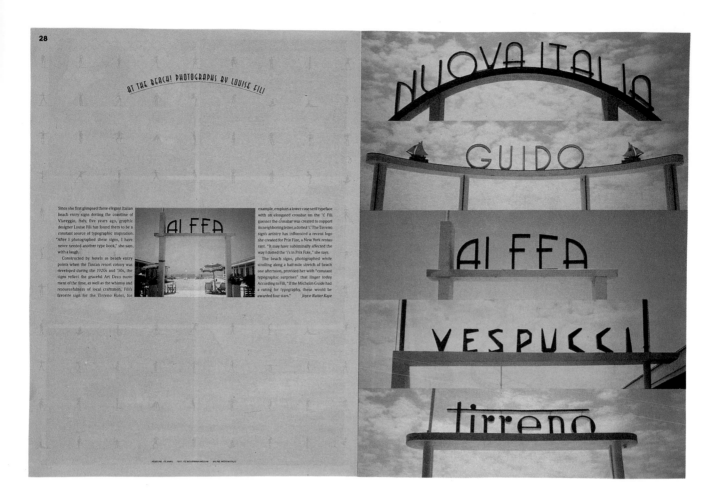

Magazine Spread

TYPOGRAPHY/DESIGN  Walter Bernard, Milton Glaser, and Frank Baseman,
New York, New York

PRODUCTION  Pat Krugman and Jane DiBucci

TYPOGRAPHIC SOURCE  In-house

STUDIO  WBMG, Inc.

CLIENT  *U&lc* magazine

PRINCIPAL TYPE  ITC Weidemann Medium

DIMENSIONS  11 x 14⅝ in. (27.9 x 37.1 cm)

**MTC**
METROPOLITAN
TRANSPORTATION
COMMISSION

Joseph P. Bort MetroCenter
101 Eighth Street
Oakland, California 94607-4700
Tel: 415.464.7700
FAX: 415.464.7848

**Commission Roster**
*Alameda County,* Edward R. Campbell
*Cities of Alameda County,* David S. Karp
*Contra Costa County,* Robert I. Schroder
*Cities of Contra Costa County,* Steve Weir
  (Vice Chair to Feb. 1991, Chair beginning Feb. 1991)
*Marin County,* Robert B. Stockwell (to Feb. 1991)
  Karen Kunze (beginning Feb. 1991)
*Napa County,* Fred Negri
*City and County of San Francisco,* Harry G. Britt
*San Francisco Mayor's Appointee,* Doris Kahn
  (to Feb. 1991)
  Rubin Glickman (beginning Feb. 1991)
*San Mateo County,* Tom Nolan
*Cities of San Mateo County,* Jane Baker
  (Vice Chair beginning Feb. 1991)
*Santa Clara County,* Rod Diridon
  (Chairperson to Feb. 1991)
*Cities of Santa Clara County,* James T. Beall, Jr.
*Solano County,* James Spering
*Sonoma County,* William R. Lucius (to Feb. 1991)
  Peter C. Foppiano (beginning Feb. 1991)
*Association of Bay Area Governments,* Dianne McKenna
*S.F. Bay Conservation and Development Commission,*
  Angelo J. Siracusa
*State Business, Transportation and Housing Agency,*
  Preston W. Kelley
*U.S. Department of Transportation,*
  William P. Duplissea
*U.S. Department of Housing and Urban Development,*
  Gordon H. McKay

**MTC Management Staff**
*Executive Director,* Lawrence D. Dahms
*Deputy Executive Director,* William F. Hein
*General Counsel,* Francis F. Chin
*Accounting,* Dorothy Neely
*Allocations and Assistance,* Jay Miyazaki
*Legislation and Finance,* Hank Dittmar
*Planning,* Chris Brittle
*Transit Coordination,* Joel Markowitz
*Administrative Services,* Gloria Mims
*Technical Services,* Marilyn Reynolds

Inside:

▶ **War on Smog Tops Agenda**
MTC hopes to shift consumer behavior by
making alternatives to the automobile more
readily available and attractive.

▶ **Charting a Course for the Next Century**
The Bay Vision 2020 Commission
circulates a draft report calling for a new
regional growth management agency.

▶ **High-Stakes Game in Washington**
MTC joins with organizations around
the country to build a national consensus
on future directions for federal spending
programs.

▶ **Transit Systems Get in Sync**
MTC makes strides in tying the region's
24 public transit systems together, with
a universal ticket on the horizon that
will be valid on most of the region's bus,
rail and ferry systems.

▶ **MTC Overhauls Basic Policy**
The *Regional Transportation Plan* is
undergoing its first major overhaul since
its original adoption in 1973.

▶ **Special pull-out feature**
20th anniversary timeline and financial tables.

# At a Crossroads

Message From the Executive Director

February 1991 marks the 20th anniversary of the Metropolitan Transportation
Commission – an occasion that invites reflection on the events that led to the
creation of a regional transportation planning agency for the nine-county San
Francisco Bay Area, and the parallels between then and now. ✒ Looking back, an
important catalyst was a map drawn by the Bay Area Transportation Study
Commission in 1969 that literally crisscrossed the Bay Area with new freeways,
violating precious wetlands, spectacular open spaces and peaceful neighborhoods.
Thankfully, lawmakers in Sacramento had the wisdom to question that direction,
and to instead fashion MTC to develop a more imaginative approach to serving the
travel needs of the Bay Area's burgeoning population. In the ensuing two decades,
the Commission has come a long way toward balancing transportation invest-
ments and fostering public transit. But as we head into the 1990s on the last stretch
to a new millennium, the region is again at a crossroads where vital decisions must
be made about our future course. ✒ We must determine which of many paths we
want to take to clear Bay Area skies, as mandated by recent stringent state air
quality legislation. We need to resolve the ongoing debate on whether and how
to strengthen regional institutions to better address the interrelated problems
of growth, traffic congestion and smog. Internally, we are overhauling the
*Regional Transportation Plan*, MTC's central policy statement, to reflect the issues,
goals and values of the 1990s. The nation as a whole is also at a turning
point, with 1991 being the year when Congress will rewrite federal transporta-
tion policy to ensure mobility in the next century. ✒ With that, I invite you to
turn the page. We tell you where we have been – via a special pull-out 20th anni-
versary timeline – and where we are headed in these turbulent, challenging times.

*Lawrence D. Dahms*
.......................................
Lawrence D. Dahms

Annual Report
TYPOGRAPHY/DESIGN   Nancy E. Koc, San Francisco, California
TYPOGRAPHIC SOURCE   In-house
STUDIO   Koc Design
CLIENT   Metropolitan Transportation Commission
PRINCIPAL TYPES   Gill Sans and Perpetua
DIMENSIONS   17 x 22 in. (43.2 x 55.9 cm)

174

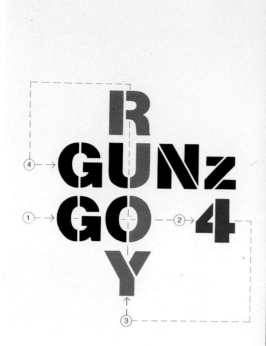

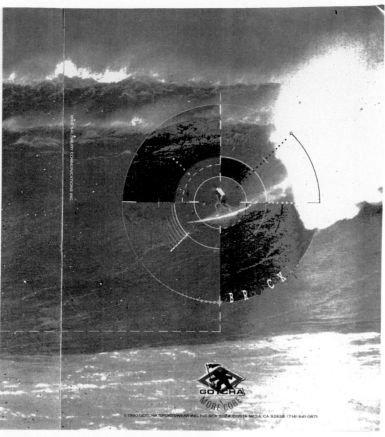

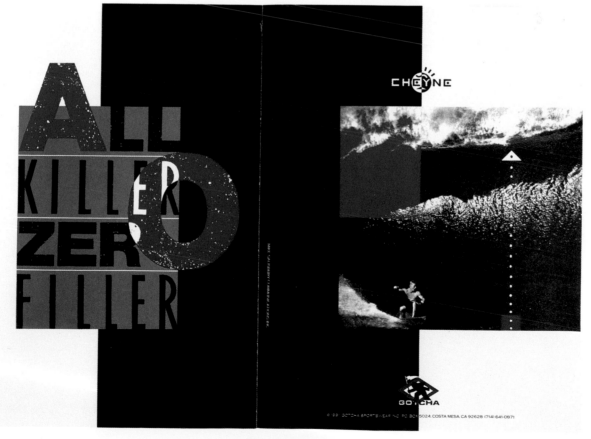

Advertisement

TYPOGRAPHY/DESIGN Mike Salisbury and Damien Gallay, Torrance, California
TYPOGRAPHIC SOURCES CCI Typographers and various magazines and newspapers
STUDIO Mike Salisbury Communications, Inc.
CLIENT Gotcha Sportswear
PRINCIPAL TYPES Helvetica and various
DIMENSIONS 14 x 10 in. (35.6 x 25.4 cm)

拡張する美術 BEYOND THE FRAME

アメリカン・アート 1960-1990　　AMERICAN ART 1960-1990

|  |  |
|---|---|
|  | **Book** |
| TYPOGRAPHY/DESIGN | Karen Salsgiver, New York, New York |
| TYPOGRAPHIC SOURCES | In-house and Nakamura Seiko Printing, Inc. |
| STUDIO | Salsgiver Coveney Associates Inc. |
| CLIENT | Amway (Japan) Limited |
| PRINCIPAL TYPE | Garamond No. 3 |
| DIMENSIONS | 11¾ x 8¼ in. (29.8 x 21 cm) |

謹賀新年
A Merry Christmas and a Happy New Year. Jan. 1st, 1992

Greeting Card

TYPOGRAPHY/DESIGN   Tetsuyuki Kokin and Takao Hayashi, Komae, Tokyo, Japan
TYPOGRAPHIC SOURCE  Typebank
CLIENT              Typebank
PRINCIPAL TYPES     Typebank Gothic Heavy and Gill Sans Medium
DIMENSIONS          5⅞ x 3¹⁵⁄₁₆ in. (15 x 10 cm)

**LOSE YOUR FRIENDS**

**POLLUTE THE AIR**

**BRONCHIAL PROBLEMS**

A
N
D

MAYBE EVEN WORSE

Ministry of Health

Poster
TYPOGRAPHY/DESIGN   Gordon Tan, Jim Aitchison, and Heintje Moo, Singapore
TYPOGRAPHIC SOURCE   The Fotosetter Singapore
AGENCY   Ketchum Advertising Singapore
CLIENT   Ministry of Health Singapore
PRINCIPAL TYPE   Compacta
DIMENSIONS   15 x 23⅝ in. (38.1 x 60 cm)

# PUFF PUFF
# PUFF PUFF
# COUGH PUFF
# PUFF COUGH
# COUGH PUFF
# COUGH COUGH
# COUGH COUGH
# COUGH COUGH

 BAD HABITS DIE HARD

 Ministry of Health

Poster
TYPOGRAPHY/DESIGN Gordon Tan, Jim Aitchison, and Heintje Moo, Singapore
TYPOGRAPHIC SOURCE The Fotosetter Singapore
AGENCY Ketchum Advertising Singapore
CLIENT Ministry of Health Singapore
PRINCIPAL TYPE Compacta
DIMENSIONS 15 x 23⅝ in. (38.1 x 60 cm)

eintausendneunhundertzweiundneunzig

Promotion
TYPOGRAPHY/DESIGN  Heribert Birnbach, Bonn, Germany
TYPOGRAPHIC SOURCES  In-house and Typostudio Friedrich GmbH, Cologne
STUDIO  Birnbach Design, Studio für Konzeption and visuelle Gestaltung
CLIENT  Birnbach Design
PRINCIPAL TYPE  Modula
DIMENSIONS  8¼ x 4⅛ in. (21 x 10.5 cm)

Logotype
TYPOGRAPHY/DESIGN Brett Wickens, London, England
COMPUTER RESEARCH Marc Wood and Stephen Wolstenholme
ART DIRECTOR Peter Saville
TYPOGRAPHIC SOURCE In-house
STUDIO Pentagram Design Ltd.
CLIENT Parco, Japan
PRINCIPAL TYPE Neue Helvetica 96

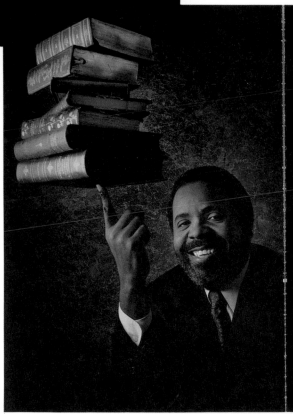

Annual Report

TYPOGRAPHY/DESIGN **Pat and Greg Samata, Dundee, Illinois**
TYPOGRAPHIC SOURCE **Total Typography**
STUDIO **Samata Associates**
CLIENT **HMO America Inc.**
PRINCIPAL TYPES **Univers 65 and Garamond**
DIMENSIONS **8 x 11½ in. (20.3 x 29.2 cm)**

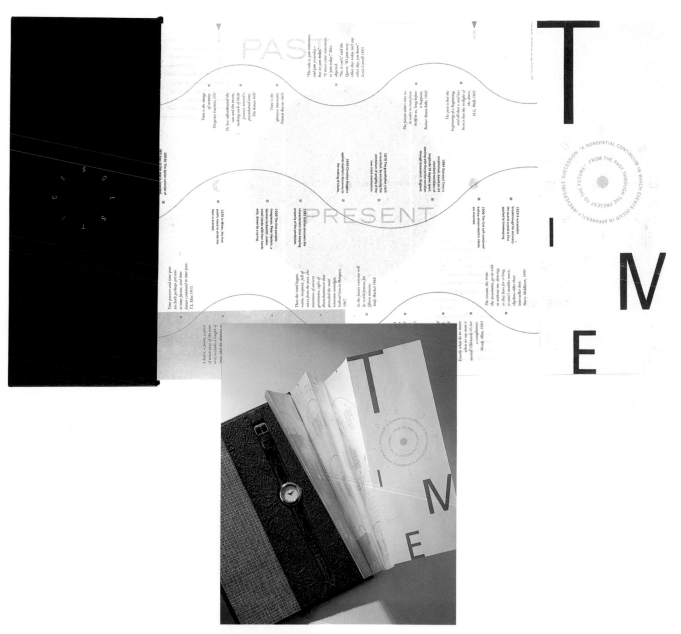

Packaging
TYPOGRAPHY/DESIGN  Laurel Shoemaker, New York, New York
TYPOGRAPHIC SOURCE  Paragon Typographics
AGENCY  Susan Slover Design
CLIENT  SM Grotell
PRINCIPAL TYPES  Copperplate, Perpetua, and Trade Gothic
DIMENSIONS  4 x 10⅛ x ¾ in. (10.2 x 25.7 x 1.9 cm)

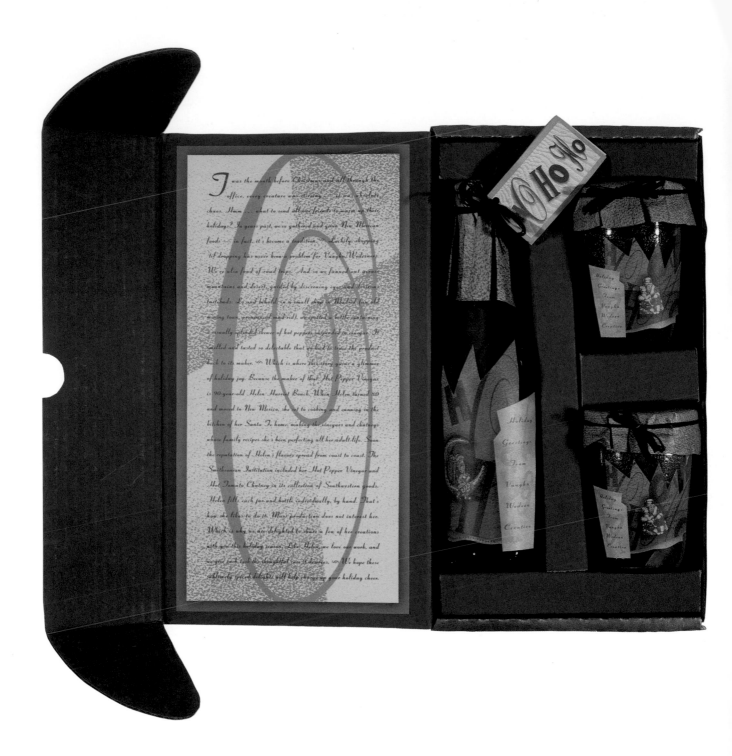

Packaging

| | |
|---|---|
| Typography/Design | Dan Flynn, Albuquerque, New Mexico |
| Illustrator | Bill Gerhold |
| Art Directors | Dan Flynn, Steve Wedeen, and Rick Vaughn |
| Printer | Albuquerque Printing |
| Typographic Source | In-house |
| Studio | Vaughn/Wedeen Creative Inc. |
| Client | Vaughn/Wedeen Creative Inc. |
| Principal Types | Various |
| Dimensions | Various |

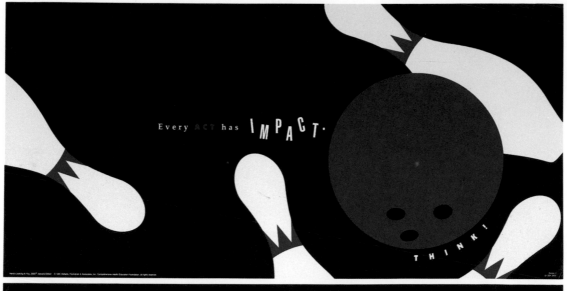

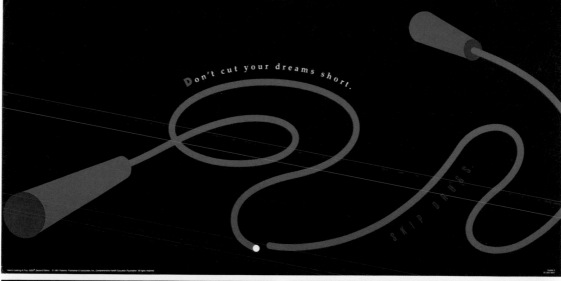

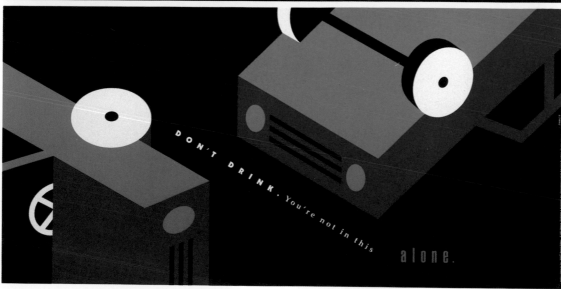

Poster
TYPOGRAPHY/DESIGN  Hornall Anderson Design Works, Seattle, Washington
TYPOGRAPHIC SOURCES  In-house and Thomas & Kennedy
STUDIO  Hornall Anderson Design Works
CLIENTS  Roberts, Fitzmahan & Associates and Comprehensive Health
Education Foundation
PRINCIPAL TYPES  Palatino, Helvetica, and Kabel
DIMENSIONS  Various

Kunsthalle Düsseldorf

skulpt
turale
ereign
nisse

4 Altstadt

Telefon (02 11) 89 96 24 40

Dienstag bis Sonntag 11–18 U
Montag geschlossen

Liz Bachhuber
Nan Hoover
Gisela Kleinlein
Julia Lohmann
Inge Mahn
Franziska Megert

27. Juli–15. September 1991

| | |
|---|---|
| | Campaign |
| TYPOGRAPHY/DESIGN | Monika Hagenberg, Düsseldorf, Germany |
| LETTERER | Monika Hagenberg |
| TYPOGRAPHIC SOURCE | Druckerei Heinrich Winterscheidt |
| STUDIO | Monika Hagenberg |
| CLIENT | Staedtische Kunsthalle Düsseldorf |
| PRINCIPAL TYPE | Baskerville |
| DIMENSIONS | Various |

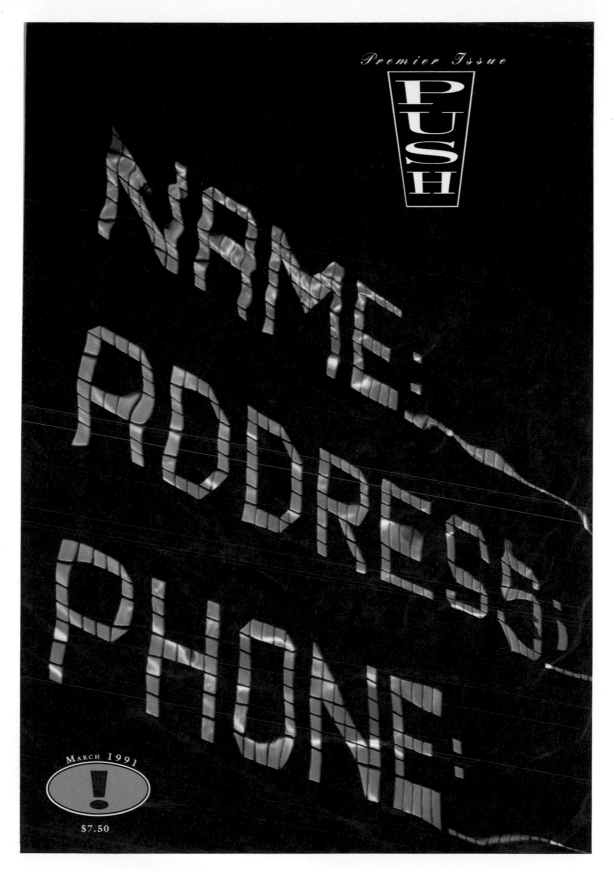

Magazine Cover

TYPOGRAPHY/DESIGN Lloyd Ziff and Giovanni C. Russo, New York, New York
LETTERERS Ann Pomeroy and Giovanni C. Russo, New York, New York, and Edward Ruscha-Pool, Los Angeles, California
TYPOGRAPHIC SOURCE RE:DESIGN
STUDIO Lloyd Ziff Design Group, Inc.
CLIENT PUSH! Communications
PRINCIPAL TYPES Bauer Bodoni, Kuenstler Script, and handlettering
DIMENSIONS 12½ x 8⅞ in. (22.5 x 31.8 cm)

187

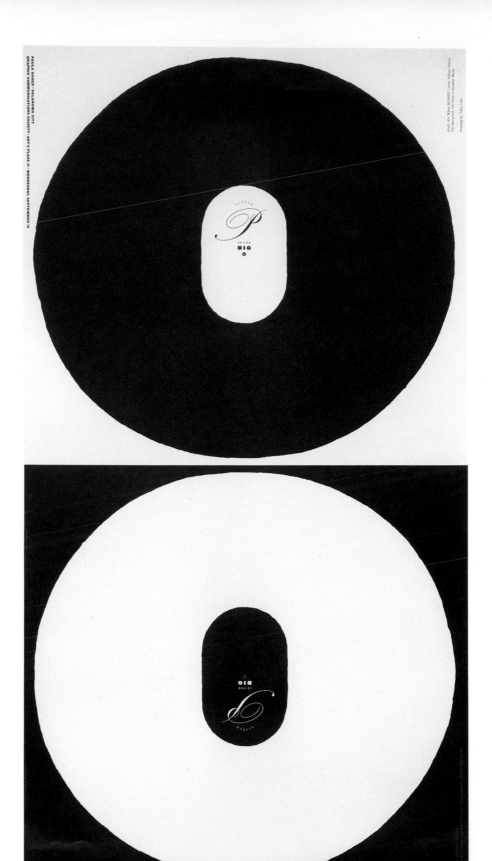

Poster
TYPOGRAPHY/DESIGN Paula Scher, New York, New York
LETTERERS Paula Scher and Ron Louie
TYPOGRAPHIC SOURCE Personal collection
STUDIO Pentagram Design
CLIENTS Art Directors Club/Oklahoma City and Tulsa
PRINCIPAL TYPE Wood type
DIMENSIONS 20 x 40 in. (50.8 x 101.6 cm)

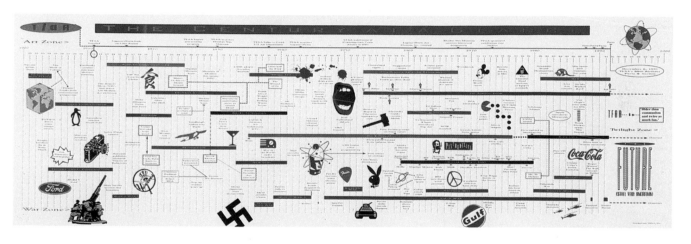

Invitation

| | |
|---|---|
| TYPOGRAPHY/DESIGN | Mike Hicks, Austin, Texas |
| TYPOGRAPHIC SOURCE | In-house |
| STUDIO | Hixo, Inc. |
| CLIENT | Texas Fine Arts Association |
| PRINCIPAL TYPE | Goudy |
| DIMENSIONS | 5¹¹⁄₁₆ x 9 in. (14.4 x 22.9 cm) |

Book Cover
TYPOGRAPHY/DESIGN Yukichi Takada, Osaka, Japan
LETTERER Yukichi Takada
TYPOGRAPHIC SOURCE In-house
STUDIO I. F. Planning Inc.
CLIENT I. F. Architects Inc.
PRINCIPAL TYPES Helvetica and handlettering
DIMENSIONS 8¼ x 11¾ in. (21 x 29.8 cm)

Advertisement
TYPOGRAPHY/DESIGN  Kenneth R. Ashworth, Jr., New York, New York
TYPOGRAPHIC SOURCE  In-house
AGENCY  J. Walter Thompson/New York
CLIENT  The Font Company
PRINCIPAL TYPES  Times New Roman and Caslon 337
DIMENSIONS  10¾ x 14⅝ in. (27.3 x 37.1 cm)

*Genesis*

*Cross Pointe Paper Corporation*

Brochure
TYPOGRAPHY/DESIGN Paul Wharton, Ted Riley, and Ann Merrill, Minneapolis, Minnesota
TYPOGRAPHIC SOURCE As Soon As Possible, Inc.
STUDIO Little & Company
CLIENT Cross Pointe Paper Corporation
PRINCIPAL TYPE Emigré Elektrix Light
DIMENSIONS 9½ x 11½ in. (24.1 x 29.2 cm)

It's the point part of view that matters. Where you go in your own mind when you see what you see. Your perspective, that's the point of view.

Book
TYPOGRAPHY/DESIGN Steve Gibbs, Dallas, Texas
LETTERER Steve Gibbs
STUDIO Gibbs Baronet
CLIENT Photocom
PRINCIPAL TYPE Handlettering
DIMENSIONS 11 x 11 in. (27.9 x 27.9 cm)

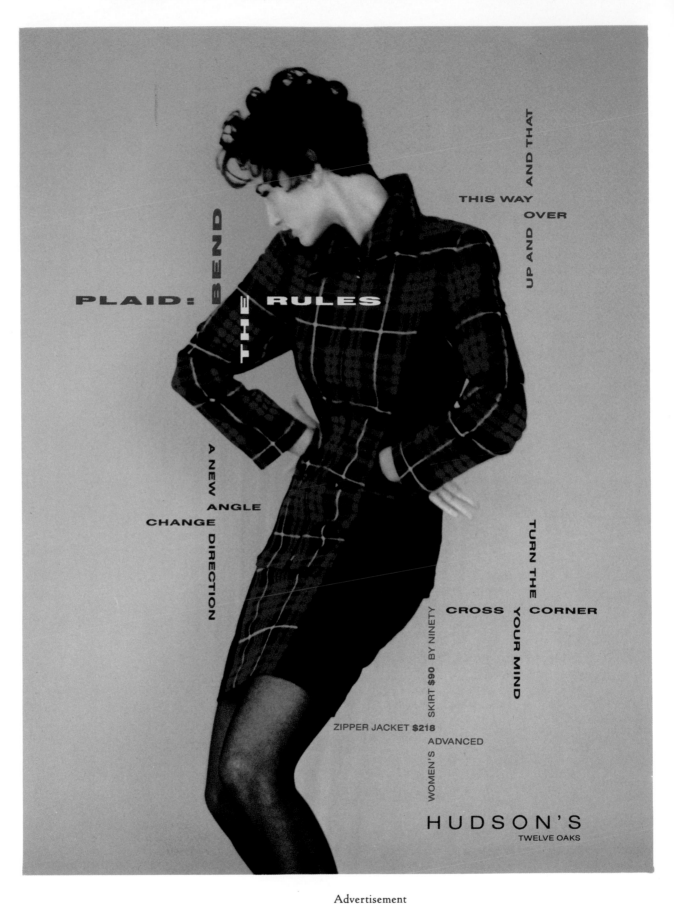

Advertisement

TYPOGRAPHY/DESIGN Shannon Pettini, Minneapolis, Minnesota
TYPOGRAPHIC SOURCE In-house
AGENCY Dayton's Hudson's Marshall Field's
CLIENT Dayton's Hudson's Marshall Field's
PRINCIPAL TYPE Triumverate Extended
DIMENSIONS 8 x 10⅞ in. (20.3 x 27.6 cm)

Progressive's largest service business is providing underwriting and claim service for various state Commercial Auto Insurance Plans. In 1990, we serviced $129.2 million of premiums written, 33% more than 1989. Total 1990 service revenues of $45.3 million were 61% more than 1989, and service profits increased 11% to $4.2 million.

Progressive's financial strategy is to build shareholder value by operating and investing conservatively, unless we identify an opportunity with risks that we understand and believe we can prudently manage. We take little note of, and do nothing to influence, the day-to-day stock price. We reserve very conservatively, report results as they occur and do not "manage" earnings, and rely on our detailed published information to inform the investing public and security analysts. We measure financial performance over consecutive five-year periods. We invest so as to maintain capital adequate to support all the insurance premium we can profitably write. We welcome shareholders who share these attitudes.

Progressive Partners manages our investments and capital structure. Progressive Partners is a group of investment professionals, located in New York City, headed by our Chairman, Alfred Lerner. Progressive Partners combines the culture and advantages of independent money managers with the advantages of an in-house investment staff. Total investment income was $159.7 million in 1990, compared to $168.1 million in 1989. Because 1990 was a difficult year in financial markets, Progressive Partners is to be commended for their penchant for liquidity and avoidance of the losses and risks suffered by others who invested in junk bonds or real estate. During the year, we repurchased 2,253,996 of our common shares at an average price of $42.85 per share.

### Core Values Evolve

Progressive's Core Values are pragmatic statements of what works best for us in the real world. Core Values govern our decisions and behavior. Growth and change constantly give us new knowledge and perspective, requiring that we regularly review and sometimes refine our Core Values to keep them consistent with new circumstances and make them more understandable to our people.

We define the Excellence Core Value as "constantly improving quality." In 1990, after two years of experimenting, Progressive embraced a Quality process that teaches our people to understand how their tasks affect customers and how to change their processes to meet or exceed customers' highest expectations. The revised Excellence Core Value includes our commitment to Quality.

For many Progressive people, our Core Values are also their personal values. Profit is essential to Progressive's health and our peoples' enjoyment of work. The revised Profit Core Value reflects the importance to us of the personal health and happiness of our people and customers, and the importance to all of us of the health of our communities and environment. Progressive is particularly concerned about the impact of auto accidents on society's health and happiness. In 1990, this concern, along with the commitment to health articulated in our Core Values, caused us to commit to improving automobile safety.

### Consumer Needs Drive Business Strategy Evolution

Last year's letter to shareholders said, "Proposition 103, which was passed on November 8, 1988 by a narrow majority of California voters, was intended to require premium rollbacks and other significant changes...Legislative inaction, California Supreme Court ambiguousness and the Insurance Commissioner's indecisiveness make it difficult to predict how and when this unprecedented, highly political situation will be resolved." Little clear progress toward a resolution was made in 1990.

Inertia and special interests inhibit improving the United States auto insurance system to benefit consumers. Progressive flourished by operating within the system, filling the needs of consumers most insurers chose not to serve, but doing little to change the system.

We hope Proposition 103 is the shock required to motivate change in auto insurance. Many auto insurers validly blamed lawyers, doctors, regulators, legislators, manufacturers, repairers and consumer fraud for the situation. In 1990, Progressive accepted as a reality consumers' dislike and mistrust of auto insurance companies and focused on finding answers rather than assigning blame. Consumers feel auto insurance costs are both too high and unfairly distributed, that they are often treated badly by auto insurers, that they do not understand the economics of their insurance transaction and that auto insurers are inadequate advocates for auto safety and loss prevention.

Progressive's strategy for the nineties is to deal directly with these consumer concerns. For example, emphasis on safe driving can lead to reductions in the frequency and severity of accidents and corresponding reductions in total system costs and premiums. Our 1989 annual report received great recognition for creatively highlighting the horrors caused by drinking and driving. During 1990, we established a new management position charged with coordinating and expanding our contributions to improving auto safety. Based on extensive research on vehicle accident performance, the value of safety features such as air bags and anti-lock brakes, and other safety considerations, we chose the Ford Taurus, Mercury Sable and Volvo 240 for our company-car fleet. In 1991, we will provide safe-driving training to our employees, focus on determining what makes a car safe and promote auto safety generally.

A major objective is to develop and deliver service, especially claim service, that will exceed consumers' wildest expectations and literally delight our customers. Superb claim service can lower costs by reducing unnecessary medical treatment, auto repair costs, litigation and fraud and can

to earn your trust,    your respect,    and    your dollars with good products,

|  | Annual Report |
| --- | --- |
| Typography/Design | Mark Schwartz and Joyce Nesnadny, Cleveland, Ohio |
| Typographic Source | TSI: Typesetting Services, Inc. |
| Studio | Nesnadny & Schwartz |
| Client | The Progressive Corporation |
| Principal Type | Garamond |
| Dimensions | 8½ x 11 in. (21.6 x 27.9 cm) |

Poster
TYPOGRAPHY/DESIGN  Gordon Tan and Neil French, Singapore
TYPOGRAPHIC SOURCE  The Fotosetter Singapore
AGENCY  The Ball Partnership Singapore
CLIENT  Cycle and Carriage/Mitsubishi Motors
PRINCIPAL TYPES  Corporate Face and handlettering
DIMENSIONS  24 x 10 in. (61 x 25.4 cm)

196

Brochure
TYPOGRAPHY/DESIGN  Eric Thoelke, St. Louis, Missouri
TYPOGRAPHIC SOURCE  The Composing Room
AGENCY  The Puckett Group
STUDIO  Toky Design
CLIENT  Pagoda Trading Company
PRINCIPAL TYPES  Franklin Gothic and Garamond No. 3
DIMENSIONS  8½ x 14 in. (21.6 x 35.6 cm)

Book
TYPOGRAPHY/DESIGN Rex Peteet and Don Sibley, Dallas, Texas
CALLIGRAPHERS David Beck and Tom Hough
TYPOGRAPHIC SOURCE Typography Plus
STUDIO Sibley/Peteet Design
CLIENT Heritage Press
PRINCIPAL TYPES Bernhard and Kabel
DIMENSIONS 6¼ x 6¼ in. (15.9 x 15.9 cm)

Brochure
TYPOGRAPHY/DESIGN John Van Dyke, Seattle, Washington
TYPOGRAPHIC SOURCES In-house and Typehouse
AGENCY Van Dyke Company
CLIENT Mead Corporation
PRINCIPAL TYPES Helvetica Bold Modified and Coronet Script
DIMENSIONS 9 x 9 in. (22.7 x 22.7 cm)

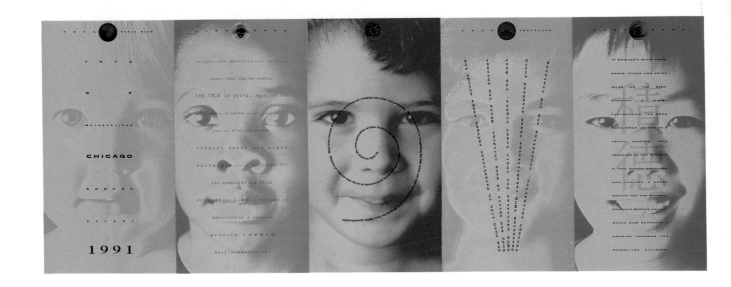

Annual Report

TYPOGRAPHY/DESIGN  Pat and Greg Samata, Dundee, Illinois
LETTERERS  K. C. Yoon and Jack Jacobi
TYPOGRAPHIC SOURCE  In-house
STUDIO  Samata Associates
CLIENT  YMCA of Metropolitan Chicago
PRINCIPAL TYPES  Copperplate, Caslon, Univers Black, Courier, and
Univers Condensed
DIMENSIONS  6¼ x 12 in. (15.9 x 30.5 cm)

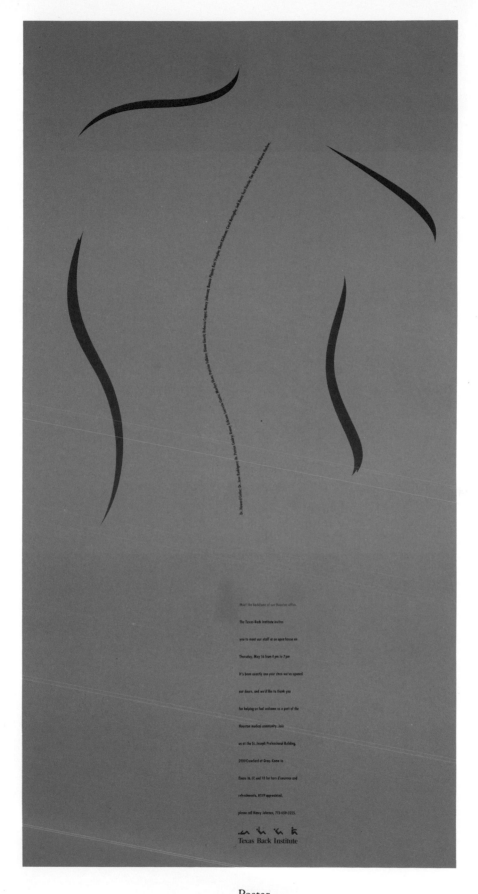

Poster

| | |
|---|---|
| TYPOGRAPHY/DESIGN | Tiffany Taylor, Dallas, Texas |
| TYPOGRAPHIC SOURCE | In-house |
| STUDIO | Eisenberg and Associates |
| CLIENT | Texas Back Institute |
| PRINCIPAL TYPE | Futura Bold Condensed |
| DIMENSIONS | 16½ x 24 in. (41.9 x 61 cm) |

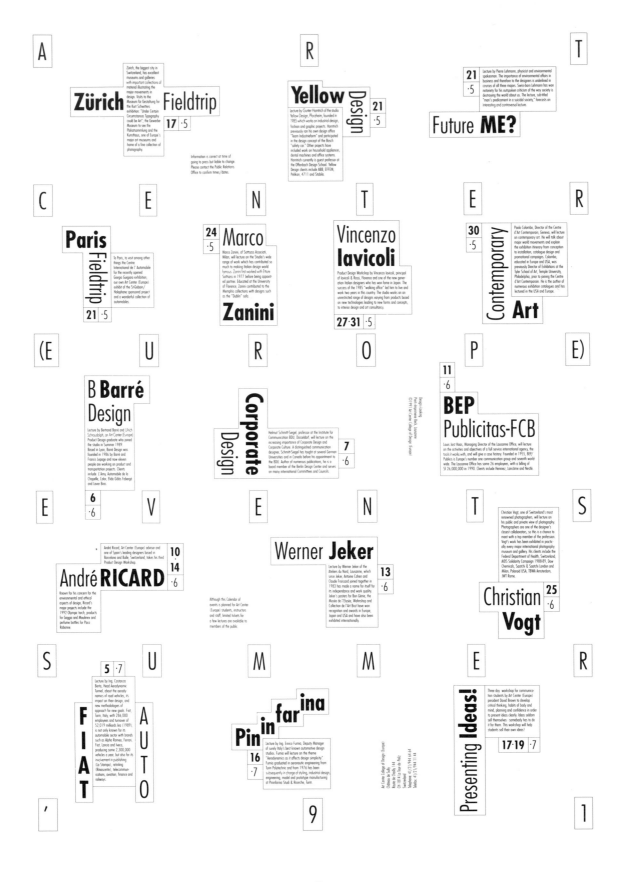

**Poster**

TYPOGRAPHY/DESIGN Looking, Los Angeles, California
TYPOGRAPHIC SOURCE In-house
STUDIO Looking
CLIENT Art Center College of Design/Europe
PRINCIPAL TYPES Futura Condensed Bold and Futura Condensed Light
DIMENSIONS 16⁹⁄₁₆ x 23³⁄₈ in. (42.1 x 59.4 cm)

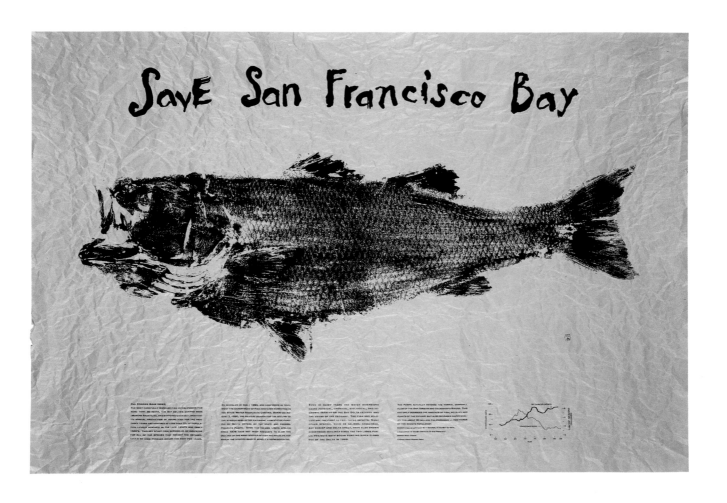

Poster

| | |
|---|---|
| TYPOGRAPHY/DESIGN | Doug Akagi and Kimberly Powell, San Francisco, California |
| LETTERERS | Kimberly Powell and Doug Akagi |
| TYPOGRAPHIC SOURCE | In-house |
| STUDIO | Akagi Design |
| CLIENT | Akagi Design |
| PRINCIPAL TYPES | Copperplate Gothic and handlettering |
| DIMENSIONS | 24 x 36 in. (61 x 91.4 cm) |

AIGA Conference in Chicago 1991
30/30 Presentation (30 Designers in 30 Minutes)
Steff Geissbuhler

My 60 second lecture is entitled:
"Reading Between the Lines" –
A Typo-Psycho Analysis

After staring at the words - This ONE jumped out at me –
no matter how you look at it – it's only ONE minute!

If you flush it left –
LOVE is short –
however MONEY & POWER are justified  —
OOOEE!

If you put LOVE between MONEY & POWER —
you get a better rag!

If LOVE is bigger than MONEY & POWER —
it's all justified.

If POWER is condensed –
your LOVE overextended and
MONEY is short and tight —
you're probably trying too hard.

If you take LOVE, MONEY, and POWER
and flush it right —
it all will go down the toilet.

Slide Presentation
TYPOGRAPHY/DESIGN  Steff Geissbuhler, New York, New York
TYPOGRAPHIC SOURCE  In-house
STUDIO  Chermayeff & Geismar, Inc.
CLIENT  American Institute of Graphic Arts 1991 National Conference
PRINCIPAL TYPE  Helvetica

POSTAGE

**3 CENTS 3** · U.S. POSTAGE
1917
1917-91 U.S. Postage Multiplies By Ten.

**2 CENTS** · HARDING
1919
Now priced at 29¢ for a one-ounce First

**3 CENTS 3**
1932
Class letter, a little postage stamp is

OLYMPIC LIBERTY · JOS. KOSSUTH – GOVERNOR OF HUNGARY · **4¢** · UNITED STATES POSTAGE
1958
a big deal, and a 4¢ Crane letterhead

**5¢** U.S. POSTAGE
1963
a better value than ever. Letters have

UNITED STATES **6¢**
1968
always been a major part of business

EISENHOWER USA **8¢**
1971
communication. They are a company's

29¢

UNITED **10¢** STATES
1974
personal emissaries, and a lot of time

United States **13c**
1975
and money are invested in creating

**15¢** USA
1978
and sending them. Still, your company's

CRANE

USA 1896
1981
letterhead is likely the only part of the

Harry S. Truman · USA **20c**
1981
process that people see. So why buy

USA **22**
New England Neptune
1985
a letterhead that's less than the best?

USA **25** · LOVE
1988
Trust your investment to the one paper

**29** USA
1991
that makes economic sense. Buy Crane.

4¢

Poster
TYPOGRAPHY/DESIGN Bill Anton, New York, New York
TYPOGRAPHIC SOURCE In-house
STUDIO Chermayeff & Geismar, Inc.
CLIENT Crane & Co.
PRINCIPAL TYPE Univers
DIMENSIONS 34 x 44 in. (86.4 x 111.8 cm)

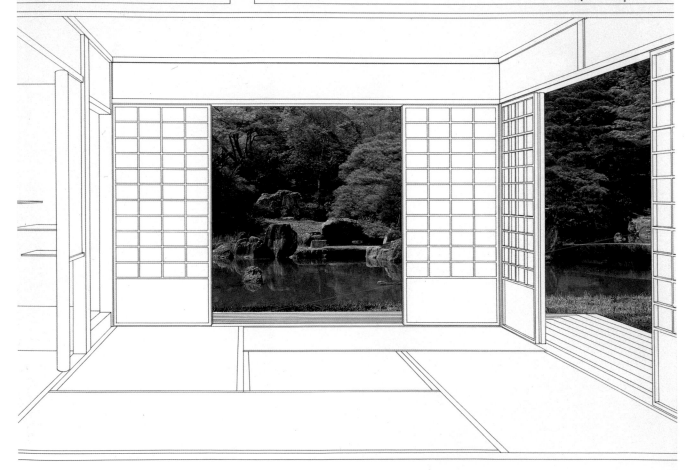

Tempel und Teehaus in Japan — The Temple and Teahouse in Japan

Werner Blaser — Birkhäuser

Book Cover

TYPOGRAPHY/DESIGN Albert Gomm, Basel, Switzerland
LETTERER Werner Blaser
STUDIO Albert Gomm swb/asq, Visueller Gestalter
CLIENT Birkhäuser Publisher
PRINCIPAL TYPES Bauer Bodoni and handlettering
DIMENSIONS 12 x 39⅛ in. (30.5 x 99.5 cm)

Packaging

| | |
|---|---|
| TYPOGRAPHY/DESIGN | Takeshi Kusumoto, Kitaku, Osaka, Japan |
| CALLIGRAPHER | Takeshi Kusumoto |
| TYPOGRAPHIC SOURCE | Sha-Ken Co., Ltd. |
| AGENCY | DENTSU, Inc. |
| STUDIO | Packaging Create, Inc. |
| CLIENT | TANABE SEIYAKU CO., LTD. |
| PRINCIPAL TYPES | EM-A-OKL and handlettering |
| DIMENSIONS | Various |

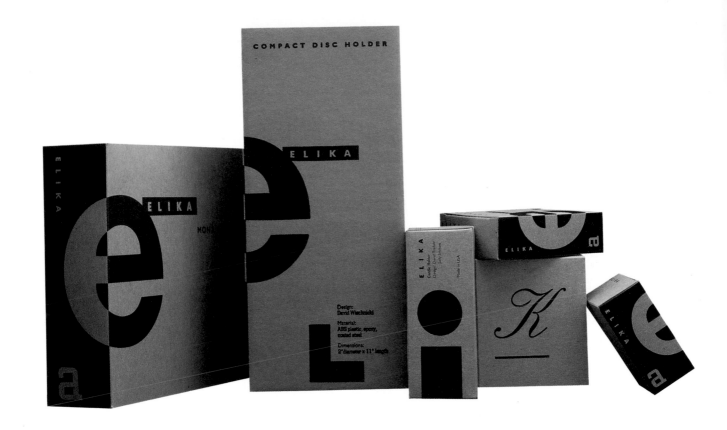

Packaging
TYPOGRAPHY/DESIGN Clive Piercy and Michael Hodgson, Santa Monica, California
TYPOGRAPHIC SOURCE In-house
STUDIO Ph.D
CLIENT ELIKA
PRINCIPAL TYPE Gill Sans and City
DIMENSIONS Various

Book Cover

| | |
|---|---|
| TYPOGRAPHY/DESIGN | Louise Fili, New York, New York |
| CALLIGRAPHER | Tony Di Spigna |
| STUDIO | Louise Fili Ltd. |
| CLIENT | William Morrow Publishing |
| PRINCIPAL TYPE | Handlettering |
| DIMENSIONS | 4 x 3¾ in. (10.2 x 9.5 cm) |

We continue to explore the ever-emerging opportunities offered a company with the diverse capability and capacity that EG&G possesses. We continue to explore the ever-emerging opportunities offered a company with the diverse capability and capacity that EG&G possesses. We continue to explore the ever-emerging opportunities offered a company with the diverse capability and capacity that EG&G possesses. We con-

Annual Report

TYPOGRAPHY/DESIGN  Harold Burch, New York, New York
TYPOGRAPHIC SOURCE  Cromwell Type-Ad Service, Inc.
STUDIO  Pentagram Design
CLIENT  EG&G Inc.
PRINCIPAL TYPES  Trump and Copperplate
DIMENSIONS  8½ x 11 in. (21.6 x 27.9 cm)

Packaging

TYPOGRAPHY/DESIGN   Carol Bobolts, New York, New York
TYPOGRAPHIC SOURCE   Expertype/The Graphic Word
STUDIO   Red Herring Design
CLIENT   Atlantic Records
PRINCIPAL TYPES   Bodoni Antiqua and Italic, Helvetica Condensed, Helvetica Demibold, and Helvetica Ultra Compressed
DIMENSIONS   6¼ x 12⅛ in. (15.9 x 30.8 cm)

Stationery

TYPOGRAPHY/DESIGN Joe Parisi and Tim Thompson, Baltimore, Maryland
LETTERER Joe Parisi
TYPOGRAPHIC SOURCE In-house
STUDIO Graffito
CLIENT Kapcom, Inc.
PRINCIPAL TYPES Kapcom Extended, Industria, and Franklin Gothic
DIMENSIONS 8½ x 11 in. (21.6 x 27.9 cm)

Brochure

TYPOGRAPHY/DESIGN   Morton Jackson, Tim Thompson, and Joe Parisi, Baltimore, Maryland
TYPOGRAPHIC SOURCE   In-house
STUDIO   Graffito
CLIENT   Active8, Inc.
PRINCIPAL TYPES   OCR-A, Stymie Bold Extended, Helvetica Extended, and Helvetica Compressed
DIMENSIONS   8½ x 13 in. (21.6 x 33.2 cm)

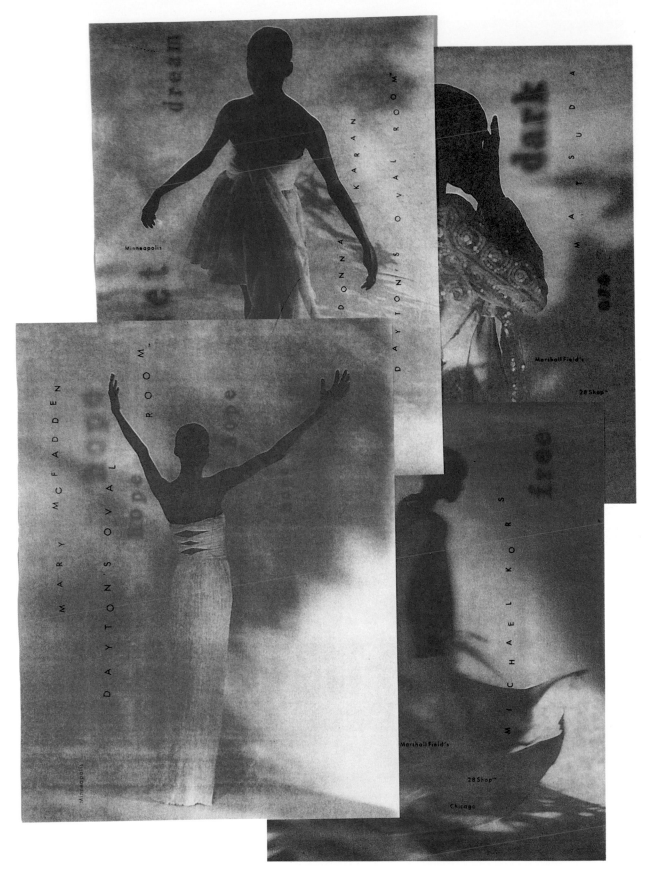

Campaign

TYPOGRAPHY/DESIGN Bill Thorburn, Minneapolis, Minnesota
TYPOGRAPHIC SOURCE In-house
AGENCY Dayton's Hudson's Marshall Field's
CLIENT Dayton's Hudson's Marshall Field's
PRINCIPAL TYPES Bodoni and Futura
DIMENSIONS 8¼ x 11 in. (21 x 27.9 cm) and 9 x 12 in. (22.9 x 30.5 cm)

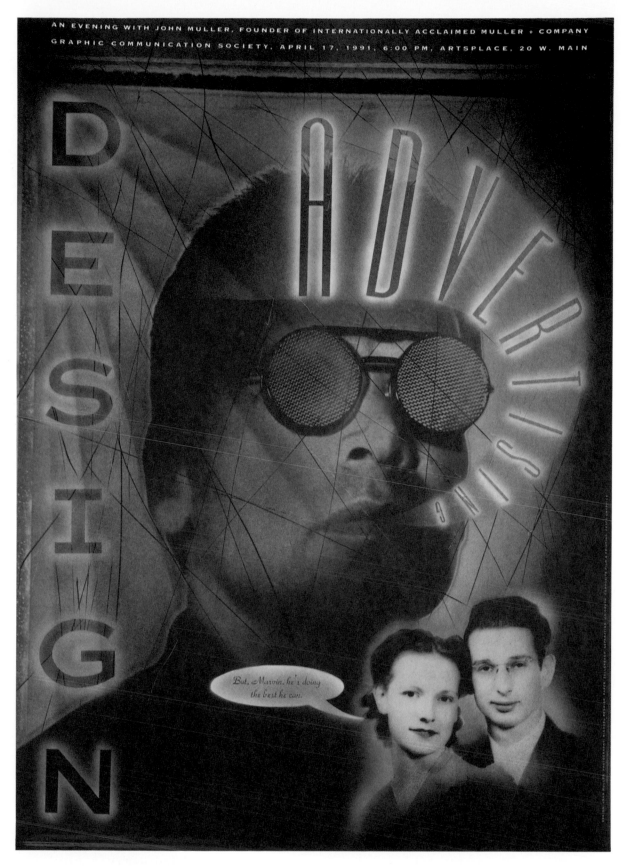

Poster
TYPOGRAPHY/DESIGN John Muller, Kansas City, Missouri
LETTERERS John Muller and Sal Costello
PHOTOGRAPHER Michael Regnier
TYPOGRAPHIC SOURCE In-house
AGENCY Muller + Company
CLIENT Graphic Communication Society
PRINCIPAL TYPES Empire and handlettering
DIMENSIONS 2¹⁄₁₆ x 1½ in. (5.2 x 3.8 cm)

215

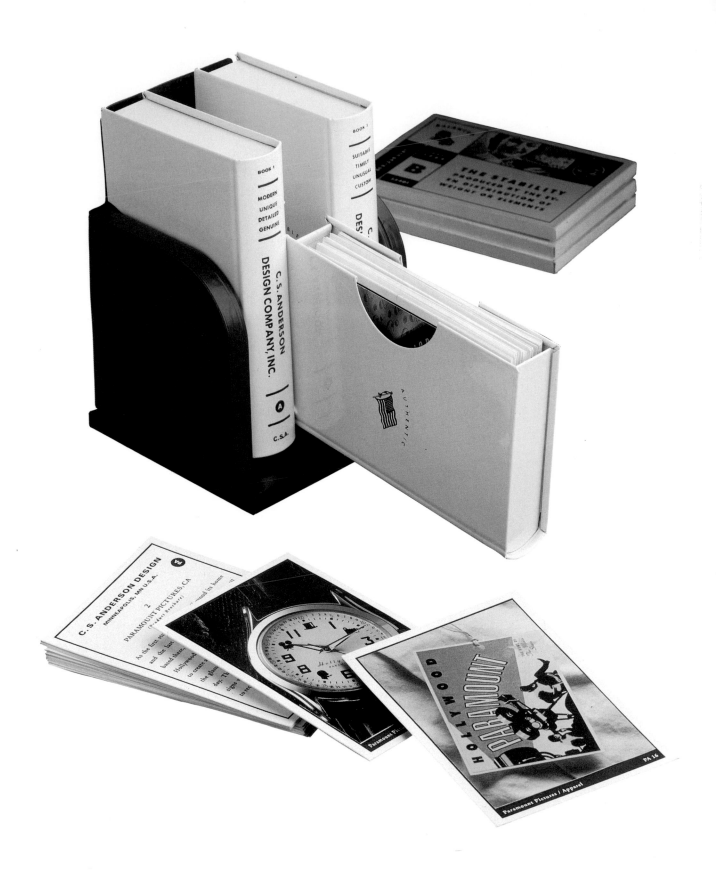

Promotion

|  |  |
|---|---|
| TYPOGRAPHY/DESIGN | Daniel Olson and Charles S. Anderson, Minneapolis, Minnesota |
| TYPOGRAPHIC SOURCE | Linotypographers, Fort Worth, Texas |
| STUDIO | Charles S. Anderson Design Company |
| CLIENT | Charles S. Anderson Design Company |
| PRINCIPAL TYPE | Spartan |
| DIMENSIONS | 4½ x 6 in. (11.4 x 15.2 cm) |

TYPE
DIRECTORS
CLUB

## OFFICERS 1991/92

| | |
|---|---|
| PRESIDENT | Ed Benguiat |
| VICE PRESIDENT | Allan Haley |
| SECRETARY/TREASURER | Kathie Brown |
| DIRECTORS-AT-LARGE | Peter Bain |
| | Brian O'Neill |
| | B. Martin Pedersen |
| | Roy Podorson |
| | Howard Salberg |
| | Mark Solsburg |
| | Ilene Strizver |
| CHAIRPERSON, BOARD OF DIRECTORS | Jack Odette |

## OFFICERS 1992/93

| | |
|---|---|
| PRESIDENT | Allan Haley |
| VICE PRESIDENT | Kathie Brown |
| SECRETARY/TREASURER | B. Martin Pedersen |
| DIRECTORS-AT-LARGE | Ed Colker |
| | Mara Kurtz |
| | Roy Podorson |
| | Dirk Rowntree |
| | Howard Salberg |
| | Mark Solsburg |
| | Ilene Strizver |
| CHAIRPERSON, BOARD OF DIRECTORS | Ed Benguiat |

## COMMITTEE FOR TDC38

| | |
|---|---|
| CHAIRPERSON | Allan Haley |
| DESIGNER | Daniel Pelavin |
| COORDINATOR | Carol Wahler |
| ASSISTANT COORDINATOR | Klaus Schmidt |
| CALLIGRAPHER | Robert Boyajian |
| ASSISTANTS TO JUDGES | Ed Benguiat, Kathie Brown, Laurie Burns, Robert Fink, Adam Greiss, Scott Kelly, Erica Kightlinter, Tara Kudra, Mara Kurtz, Marilyn Marcus, Eric Neuner, Ilene Strizver, Katherine Topaz, Ed Vadala, and Allan Wahler. |

## TYPE DIRECTORS CLUB PRESIDENTS

Frank Powers, 1946, 1947

Milton Zudeck, 1948

Alfred Dickman, 1949

Joseph Weiler, 1950

James Secrest, 1951, 1952, 1953

Gustave Saelens, 1954, 1955

Arthur Lee, 1956, 1957

Martin Connell, 1958

James Secrest, 1959, 1960

Frank Powers, 1961, 1962

Milton Zudeck, 1963, 1964

Gene Ettenberg, 1965, 1966

Edward Gottschall, 1967, 1968

Saadyah Maximon, 1969

Louis Lepis, 1970, 1971

Gerard O'Neill, 1972, 1973

Zoltan Kiss, 1974, 1975

Roy Zucca, 1976, 1977

William Streever, 1978, 1979

Bonnie Hazelton, 1980, 1981

Jack George Tauss, 1982, 1983

Klaus F. Schmidt, 1984, 1985

John Luke, 1986, 1987

Jack Odette, 1988, 1989

Ed Benguiat, 1990, 1991

Allan Haley, 1992

## TDC MEDAL RECIPIENTS

Hermann Zapf, 1967

R. Hunter Middleton, 1968

Frank Powers, 1971

Dr. Robert Leslie, 1972

Edward Rondthaler, 1975

Arnold Bank, 1979

Georg Trump, 1982

Paul Standard, 1983

Herb Lubalin, 1983
   (posthumously)

Paul Rand, 1984

Aaron Burns, 1985

Bradbury Thompson, 1986

Adrian Frutiger, 1987

Freeman Craw, 1988

Ed Benguiat, 1989

Gene Federico, 1991

## SPECIAL CITATIONS TO TDC MEMBERS

Edward Gottschall, 1955

Freeman Craw, 1968

James Secrest, 1974

Olaf Leu, 1984, 1990

William Streever, 1984

Klaus F. Schmidt, 1985

John Luke, 1987

Jack Odette, 1989

## INTERNATIONAL LIAISON CHAIRPERSONS

Ernst Dernehl

Dernehl & Dernehl

Design Consultants

Box 150 60

S 400 41 Goteborg

SWEDEN

Japan Typography Association

C C Center

4-8-15 Yushima

Bunkyo-ku

Tokyo 113

JAPAN

Christopher Dubber

FACE Photosetting

4 rue de Jarente

75004 Paris

FRANCE

Bertram Schmidt-Friderichs

Universitatsdruckerei und

Verlag

H. Schmidt GmbH & Co.

Robert Koch Strasse 8

Postfach 42 07 28

D 6500 Mainz 42

GERMANY

David Quay

Studio 12

10-11 Archer Street

SoHo

London W1V 7HG

ENGLAND

David Minnett

President

Australian Type Directors Club

P. O. Box 1887

North Sydney 2060

AUSTRALIA

Gordon Tan

The Fotosetter

41 Middle Road #40-00

Singapore 0718

REPUBLIC OF SINGAPORE

## TDC EXECUTIVE DIRECTOR

Carol Wahler

Type Directors Club

60 East 42d Street

Suite 721

New York, NY 10165

212 983-6042

FAX 212 983-6043

For membership information
please contact the
Type Directors Club offices.

Mary Margaret Ahern '83
Victor Ang '91
Peter Bain '86
Nick Ballard '91
Don Baird '69
Colin Banks '88
Clarence Baylis '74
Felix Beltran '88
Ed Benguiat '64
Jesse Berger '92
Anna Berkenbusch '89
Peter Bertolami '69
Godfrey Biscardi '70
Roger Black '80
Anthony Bloch '88
Susan Cotler Block '91
Sharon Blume '86
Art Boden '77
Karlheinz Boelling '86
Friedrich Georg Boes '67
Garrett Boge '83
Bud Braman '90
Ron Brancato '88
Ed Brodsky '80
Anthony Brooks '91
Kathie Brown '84
Werner Brudi '66
Bill Bundzak '64
Jason Calfo '88
Ronn Campisi '88
Matthew Carter '88
Ken Cato '88
Art Chantry '91
Kai-Yan Choi '90
Alan Christie '77
Robert Cipriani '85
Ed Cleary '89

Travis Cliett '53
Mahlon A. Cline* '48
Elaine Coburn '85
Tom Cocozza '76
Angelo Colella '90
Ed Colker '83
Freeman Craw* '47
James Cross '61
David Cundy '85
Rick Cusick '89
Susan Darbyshire '87
Ismar David '58
Cosmo De Maglie '74
Josanne De Natale '86
Robert Defrin '69
Ernst Dernehl '87
Ralph Di Meglio '74
Claude Dieterich '84
Lou Dorfsman '54
John Dreyfus** '68
Christopher Dubber '85
Rick Eiber '85
Nick Ericson '92
Joseph Michael Essex '78
Leon Ettinger '84
Leslie Evans '92
Florence Everett '89
Bob Farber '58
Gene Federico** '91
Sidney Feinberg** '49
Janice Prescott Fishman '91
Kristine Fitzgerald '90
Mona Fitzgerald '91
Yvonne Fitzner '87
Norbert Florendo '84
Tony Forster '88
Dean Franklin '80
Carol Freed '87

H. Eugene Freyer '88
Adrian Frutiger** '67
Patrick Fultz '87
Andras Furesz '89
Fred Gardner '92
Christof Gassner '90
David Gatti '81
Stuart Germain '74
John Gibson '84
Lou Glassheim* '47
Howard Glener '77
Jeff Gold '84
Alan Gorelick '85
Edward Gottschall '52
Norman Graber '69
Diana Graham '85
Austin Grandjean '59
James Jay Green '91
Adam Greiss '89
Jeff Griffith '91
Rosannae Guararra '92
Kurt Haiman '82
Allan Haley '78
Mark L. Handler '83
William Paul Harkins '83
Sherri Harnick '83
John Harrison '91
Knut Hartmann '85
Reinhard Haus '90
Bonnie Hazelton '75
Elise Hilpert '89
Michael Hodgson '89
Fritz Hofrichter '80
Alyce Hoggan '91
Cynthia Hollandsworth '91
Kevin Horvath '87
Gerard Huerta '85
Donald Jackson** '78

Helen Kahng Jaffe '91s
John Jamilkowski '89
Jon Jicha '87
Allen Johnston '74
R. W. Jones '64
Scott Kelly '84
Michael O. Kelly '84
Steven J. Kennedy '92
Renee Khatami '90
Zoltan Kiss '59
Robert C. Knecht '69
Steve Kopec '74
Bernhard J. Kress '63
Madhu Krishna '91
Pat Krugman '91
John Krumpelbeck '91
Tara Kudra '91a
Mara Kurtz '89
Sasha Kurtz '91s
Gerry L'Orange '91
Raymond F. Laccetti '87
Jim Laird '69
Guenter Gerhard Lange '83
Jean Larcher '81
Kyung Sun Lee '92s
Yoo-mi Lee '92s
Judith Kazdym Leeds '83
Olaf Leu '66
Jeffery Level '88
Mark Lichtenstein '84
Clifton Line '51
Wally Littman '60
Sergio Liuzzi '90
John Howland Lord** '47
Gregg Lukasiewicz '90
John Luke '78
Sol Malkoff '63
Marilyn Marcus '79

Michael Marino '91
Stanley Markocki '80
Adolfo Martinez '86
Rogério Martins '91
Les Mason '85
Jack Matera '73
Douglas May '92
James L. McDaniel '92
Roland Mehler '92
Frederic Metz '85
Douglas Michalek '77
John Milligan '78
Michael Miranda '84
Oswaldo Miranda (Miran) '78
Barbara Montgomery '78
Richard Moore '82
Ronald Morganstein '77
Minoru Morita '75
Tobias Moss* '47
Richard Mullen '82
Antonio Muñoz '90
Keith Murgatroyd '78
Erik Murphy '85
Jerry King Musser '88
Louis A. Musto '65
Alexander Nesbitt '50
Robert Norton '92
Alexa Nosal '87
Brian O'Neill '68
Gerard O'Neill '47*
Jack Odette '77
Thomas D. Ohmer '77
Bob Paganucci '85
Mike Parker '92
Luther Parson '82
Rosina Patti '91a
B. Martin Pedersen '85
Robert Peters '86

Roy Podorson '77
Will Powers '89
Vittorio Prina '88
Richard Puder '85
David Quay '80
Elissa Querze '83
Robert Raines '90
Erwin Raith '67
Adeir Rampazzo '85
Paul Rand** '86
Hermann Rapp '87
Jo Anne Redwood '88
Hans Dieter Reichert '92
Bud Renshaw '83
Edward Rondthaler* '47
Robert M. Rose '75
Herbert M. Rosenthal '62
Dirk Rowntree '86
Erkki Ruuhinen '86
Gus Saelens '50
Howard J. Salberg '87
Bob Salpeter '68
David Saltman '66
John Schaedler '63
Jay Schechter '87
Hermann Schmidt '83
Klaus Schmidt '59
Bertram Schmidt-Friderichs '89
Werner Schneider '87
Maria Luz Schneider '91
Eileen Hedy Schultz '85
Eckehart Schumacher-Gebler
    '85
Robert A. Scott '84
Michael Scotto '82
Paul Shaw '87
Mark Simkins '92
Dwight D. A. Smith '92

George Sohn '86

Martin Solomon '55

Jan Solpera '85

Mark Solsburg '89

Jong-Hyun Song '92s

Ronnie Tan Soo Chye '88

Erik Spiekermann '88

Vic Spindler '73

Walter Stanton '58

Rolf Staudt '84

Mark Steele '87

Sumner Stone '88

William Streever '50

Ilene Strizver '88

Hansjorg Stulle '87

Ken Sweeny '78

Gordon Tan '90

Dian Tanmizi '91s

Michael Tardif '92

William Taubin '56

Jack Tauss '75

Pat Taylor '85

Anthony J. Teano '62

Bradbury Thomson '58

Paula Thompson '91

D. A. Tregidga '85

Susan B. Trowbridge '82

Paul Trummel '89

Lucile Tuttle-Smith '78

Edward Vadala '72

Diego Vainesman '91

Roger Van Den Bergh '86

Jan Van Der Ploeg '52

James Wageman '88

Jurek Wajdowicz '80

Robert Wakeman '85

Tat S. Wan '91

Julian Waters '86

Janet Webb '91

Jessica Weber '88

Prof. Kurt Weidemann '66

Seth Joseph Weine '90

Sue Wickenden '91

Gail Wiggin '90

James Williams '88

Conny J. Winter '85

Bryan Wong '90

Hal Zamboni* '47

Hermann Zapf** '52

Roy Zucca '69

Adobe Systems, Inc. '90

Arrow Typographers, Inc. '75

Boro Typographers '89

Characters Graphic Services, Inc. '85

CT Photogenic Graphics '86

International Typeface Corporation '80

Letraset USA '91

Linotype-Hell Company '63

Monotype Typography, Inc. '91

PDR/Royal Inc. '76

Photo-Lettering, Inc. '75

Sprintout Corporation '88

Typographic House '60

Typographic Images '86

TypoVision Plus '80

\* Charter member

\*\* Honorary member

s Student member

a Associate member

Membership as of June 15, 1992

# INDEX

### TYPOGRAPHY/DESIGN